A PHOTOGRAPHIC HISTORY OF
P&O CRUISES

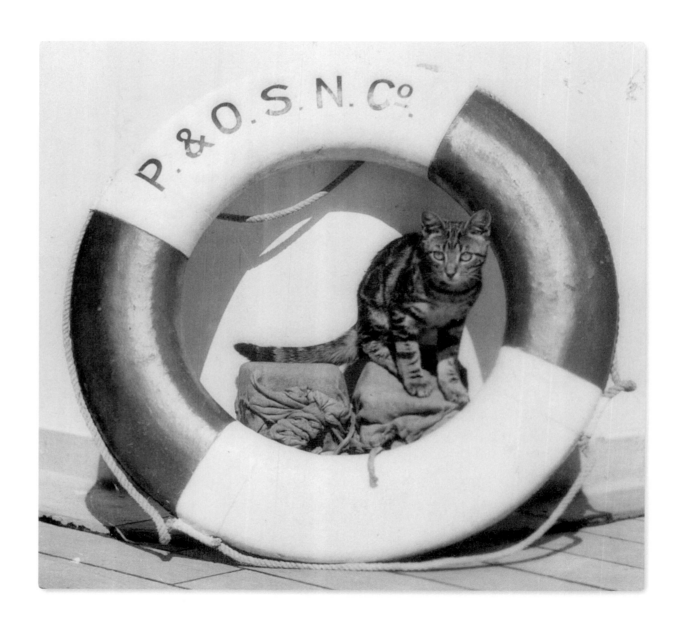

A PHOTOGRAPHIC HISTORY OF
P&O CRUISES

**ROB HENDERSON, DOUG CREMER (OAM),
CHRIS FRAME & RACHELLE CROSS**

The
History
Press

First published 2015

The History Press
The Mill, Brimscombe Port
Stroud, Gloucestershire, GL5 2QG
www.thehistorypress.co.uk

British Library Cataloguing in Publication Data.
A catalogue record for this book is available from the British Library.

ISBN 978 0 7524 8901 8

Typesetting and origination by The History Press
Printed in India

Front Cover Pic: *Mooltan* passing under the yet to be completed Sydney Harbour
Bridge. Henderson & Cremer.
Back Cover Pic: *Pacific Jewel* anchored on another cruise. Jess O'Brien.
Inside Cover: The Ship's Cat. Henderson & Cremer.
Chapter Headings: P&O Ships, *Surat* (left) and *Deccan* at Port Said. Henderson &
Cremer.

P.5: *Strathmore*. (Henderson & Cremer)

CONTENTS

ACKNOWLEDGEMENTS

We would like to thank everyone who helped us create this book.

Our gratitude to Ann Sherry, CEO Carnival Australia for the beautiful foreword. Her words are full of passion for P&O Cruises.

We are grateful to Ian Boyle for granting us access to the extensive Simplon Post Card collection (www.simplonpc.com.uk) and his ongoing support of our work is much appreciated.

We are thankful for the help of Katie Flack from the State Library of Victoria, Australia and Kevin Leamon, State Library of New South Wales, for their assistance in accessing P&O imagery from their collection.

Access to the P&O ships to take photographs of their public rooms has been essential for the latter chapters of this book and to that end we are very thankful for the help from Jess O'Brien from Carnival Australia for the tour of Pacific Jewel, Peter Taylor and Elisa Monorchio from Carnival Australia for the tour of Pacific Pearl, Leighton Schembri from Cruise Guru for the tour of Arcadia and Jenny Hedley P&O UK PR Executive for the tour of Azura. Our thanks also to Anna Goddard from P&O UK Enrichments for her support of our maritime lectures.

Our thanks go to the following for additional photographic assistance: Andrew Cooke, Andrew Sassoli-Walker, Andy Fitzsimmons, James D. Morgan/P&O Cruises, Gavin Harper, Patricia Dempsey and William H. Miller Jr.

Finally, we continue to enjoy a wonderful working relationship with Amy Rigg, Chrissy McMorris and Declan Flynn from The History Press, and thank them for supporting this idea and bringing the book to publication.

HENDERSON & CREMER | FRAME & CROSS: THE COLLABORATION

During a voyage aboard Cunard's *QM2* in 2012, Rob Henderson and Doug Cremer (noted Australian P&O historians) attended maritime lectures by Chris Frame and Rachelle Cross (best known for their work on ocean liner history). Henderson & Cremer approached Frame & Cross after one of their lectures, and arranged to meet for a drink that evening to discuss ocean liner history. Hours later, and after much discussion about ocean liners, passenger ships and cruising, the seeds of this book were sown with an agreement to collaborate on a P&O book formed during that voyage.

This work is a collaboration of decades of study and the vast majority of the imagery in this book has been carefully curated and cared for by Henderson & Cremer.

FOREWORD

The history of modern Australia spans little more than two centuries and, for much of this period, just one shipping line – P&O – has played a key and continuous role in nation building. At almost every turn, P&O has been central to the positive forces that have shaped the Australia we know today and, in doing so, struck a deep emotional chord with many thousands of Australian families that only becomes stronger with time.

Whether it was the nineteenth-century pioneering mail steamer *Chusan*, bridging the tyranny of distance delivering the mail to colonial Sydney in just weeks rather than months, or the arrival of more than a million post-war 'Ten Pound Poms' in the assisted passage migration scheme, P&O has contributed in no uncertain terms to Australia's rich cultural and maritime heritage.

P&O ships of the line, such as *Oriana*, *Himalaya*, *Oronsay* and *Canberra* linked Australia to the rest of the world; presenting a picture of glamour, a certain refinement and all the romance of the high seas, which still resonates.

The P&O name and legacy continues in the most contemporary fashion, with the current fleet introducing a new generation to the pleasures of cruising to the South Pacific; more recently to Papua New Guinea and to an increasing number of Australian and Asian destinations. When it comes to cruising and its position as the most successful segment of the tourism sector over the past decade, P&O has been pivotal to its resurgence as a holiday choice for hundreds of thousands of Australians and New Zealanders each year.

Cruising from Australia began more than eighty years ago with P&O *Strathaird*'s 1932 cruise to Norfolk Island. P&O continues to lead with its fleet of ships that personify the modern face of sea travel. In thirty-two years of cruising from Australia, P&O's much-loved *Fairstar* carried 700,000 passengers. P&O Cruises now carries more than this in a single year.

As a nation we owe a debt of gratitude to Rob Henderson, Doug Cremer, Chris Frame and Rachelle Cross for documenting the P&O story as a pictorial record in this magnificent book. I commend *A Photographic History of P&O Cruises* to every family whose life has been touched in some way by P&O, perhaps the most revered name in shipping through the broad sweep of Australia's relatively short but richly diverse history.

As operator of P&O Cruises, Carnival Australia is proudly taking one of the world's most renowned shipping brands into a bright future.

Ann Sherry, AO
CEO Carnival Australia

INTRODUCTION

Like so many historic shipping companies, the Peninsular and Oriental Steam Navigation Company (P&O) had humble beginnings. Formed by partners Willcox and Anderson to operate on a single route, it grew to become arguably the most influential shipping company in the British Empire.

As it has for over 100 years, today P&O Cruises offers passengers a variety of cruise itineraries from Great Britain and Australia, but, despite their long history as a cruise line, P&O was, for the majority of its history, known more for its mail services and passenger line voyages.

From its inception in 1837, P&O was instrumental in maintaining regular steam-driven mail services between Great Britain and her empire. The very act of offering reliable mail delivery meant that P&O became beloved in the countries and outposts it visited. The arrival of a P&O ship was a much-anticipated event, with the reliability and timing of P&O sailings leading to it being said that 'you could set your watch by the arrival and departure of P&O Royal Mail ships'.

The P&O services reduced the reliance on sail, which for many people offered the first reliable connection across the empire; cutting journey times for those travelling, while allowing for the mass transportation of passengers, mail and fine goods. For Great Britain, the line introduced a plethora of international delights. Goods from across the empire, as well as countries such as China and Japan, were brought into English homes thanks to the services offered by P&O. Tea, spices, silk, wool, bullion and opium formed the backbone of P&O's cargo services.

In addition to its successes on the line voyages, P&O diversified early, offering cruises in the off-peak seasons throughout the Mediterranean as well as out of Sydney. These cruises grew in popularity to become an integral part of the P&O business. P&O's cruise itineraries allowed holidaymakers to see new and exciting places, experience different cultures and embrace new experiences that were impossible before the line's move into cruising.

The line remained integral to Great Britain throughout most of its history. From the early days of establishing trade routes and communication services, P&O aimed to please the government in an effort to secure further contracts. During armed conflicts, the government turned to P&O, chartering their ships as troop transports and armed merchant cruisers. While this relationship was fruitful in the early years, it did come with risks. During the First and Second World Wars, the P&O fleet, most of which was requisitioned, was decimated, resulting in significant periods of rebuilding for the line.

During the subsequent dismantling of the empire, the British Government turned its attentions away from P&O. The line worked hard to avoid becoming irrelevant. Successive years of diversification saw the line involved in not only passenger shipping and cruises, but also containerisation, cargo and ferry services. This offered a reprieve for P&O, with the line becoming one of the largest and most influential transportation companies in the world.

However, the world had changed forever, and economic conditions played against P&O. By the 1990s the company was facing increased competition and shrinking markets. Something had to be done. The answer, it seemed, was to separate the cruising business from the rest of the company. To this end, the P&O-Princess line was formed, and entered into an extensive building programme, which produced some of the largest cruise ships of all time. But even this was not enough to secure P&O's future as an independent cruise line. Massive competition from America's Carnival Corporation and Royal Caribbean International took its toll, resulting in P&O-Princess merging with Carnival in 2003.

Today, as a division of the Carnival Corporation, P&O Cruises operates as two brands. A luxury brand operating a fleet of ships from Southampton, while in Australia casual cruising is offered by a smaller offshoot company.

While some regard P&O Cruises as an echo of its former self, lamenting its smaller size and less influential stature, there are many who rejoice in the continued existence of the brand. Having survived more than 175 years, the line is investing in new tonnage and improving services across its extensive cruise network. The resilience, heritage and legacy of this great company means that, against all the odds, P&O Cruises is perhaps more secure today than it ever has been. As a Carnival brand, its future seems bright, and with new ships being built, some of which are among the world's largest cruise ships, Willcox and Anderson's dream should be alive for decades to come.

I
ESTABLISHMENT

While undoubtedly the most famous and long-lasting of their ventures, P&O was not the first enterprise entered into by Brodie McGhie Willcox and Arthur Anderson.

Arthur Anderson was born into a poor family in 1792 at Lerwick in the Shetland Islands. His mother educated him, and at an early age he was employed cleaning fish on the Lerwick waterfront. Later, at the age of 12, he started work in a clerical office to help supplement his family's income. Aged 16, keen to expand his education, he enlisted in the Royal Navy who were calling for men to help fight Napoleon's forces. In 1815, he was involved in the Waterloo campaign. Following the end of the Napoleonic Wars the Royal Navy reduced its size and Anderson left the navy.

Brodie McGhie Willcox was born of English and Scottish parents. In 1815, he had started a ship-broking business and, following his discharge from the Royal Navy, Anderson began working in the firm as a clerk. In 1823, Willcox and Anderson entered a partnership to form Willcox and Anderson Co. and they began a cargo service to the Iberian Peninsula. Their new service also offered limited passenger accommodation.

While Willcox was a good businessman, it was soon clear that it was Anderson who had the true entrepreneurial spirit. In 1830, Willcox and Anderson Co. began to invest in the newly emerging steam technology. With assistance from honorary naval captain Richard Bourne, they chartered the *William Fawcett*, a steam-powered wooden paddle steamer of 206 tons. Their steam service proved so successful that they were able to purchase this ship, and another wooden paddle steamer, the 681 ton *Royal Tar*.

Operating in the Iberian Peninsula, they were not immune to the conflicts in the area. As they were trading with Portugal and Spain, they were caught up in the Carlist Wars from 1833. Willcox and Anderson threw their support behind Queen Isabella of Spain, and when Isabella was victorious Willcox and Anderson enjoyed the spoils.

In 1835, Willcox and Anderson renamed their company to reflect their modernised fleet. The new name was the Peninsular Steam Navigation Company. In 1835, the company had three steamships, *William Fawcett*, *Royal Tar* and *Jupiter*, and in 1836 they added to their fleet with *Iberia*, *Braganza* and *Liverpool*.

Despite their expansion, all was not well with the company, which lacked a government subsidy to ensure its ongoing success. Passengers weren't flocking to the ships, as travel by paddle-steamer was far from comfortable. With so much of the ships' machinery located high in the vessel the ships had a very high centre of gravity and would roll and pitch with great vigour, making the passage a miserable experience for passengers. In addition, the lack of a guaranteed cargo subsidy meant that holds were often not filled to capacity, which resulted in a loss of revenue.

Captain Bourne, who had provided financial backing to secure *William Fawcett*, had shown interest in assisting the partners in obtaining

• DID YOU KNOW? •

The flag of P&O takes its colours from the flags of Portugal and Spain; the yellow and red colours from the Spanish flag, and the blue and white from the flag of Portugal during the reign of Queen Maria II.

Iberia 1836–1856, 516 gross tons (wooden paddle steamer). The *Iberia* was constructed for Willcox and Anderson's Iberian Peninsula service to Spain and Portugal, and was the first vessel built to their order. (Orient Heritage Collection, 10322-RCH/Henderson & Cremer)

The Fleet for the First Contract

YEAR – 1837

Name	Tonnage	Horsepower
Don Juan	932 tons	300hp
Tagus (Britannia)	743 tons	268hp
Braganza	688 tons	264hp
Iberia	516 tons	180hp
Manchester (never entered service)	600 tons	220hp
Liverpool	350 tons	160hp

Masts and sails were a regular sight on the early P&O steamers. (Frame & Cross)

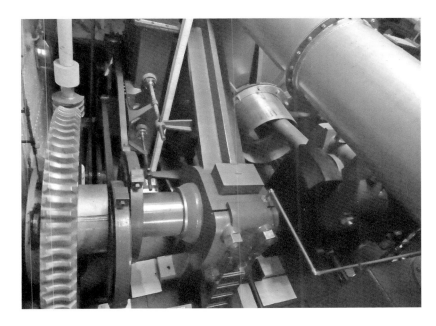

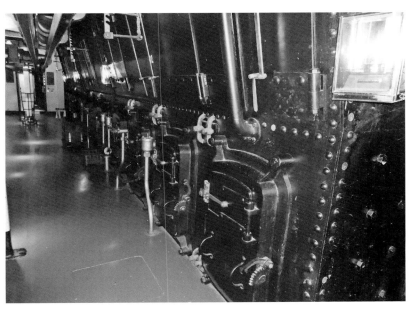

Mechanics made steam passage possible, which was essential for P&O's success. (Frame & Cross)

Rows of furnaces fed the boilers on early steamers. (Frame & Cross)

a government mail subsidy. His family owned the subsidy for Ireland, and he was able to offer both financial support and his expertise. Despite a rival bid by the Commercial Steam Navigational Company, on 27 August 1837 the Peninsular Steam Navigation Company signed a mail contract with the British Admiralty. The contract awarded them £26,000 per year for the passage of mail to the Iberian Peninsula. Although the company had already been in existence for some time, the date of this contract is generally considered to be the official start date of P&O.

Don Juan and *Tagus* had been purpose-built for the Iberian mail service. *Don Juan*, the first of the two, was 932 tons. Originally built for Captain Richard Bourne and others, she was constructed at Fletcher, Son and Fearnall, in Poplar for the sum of £40,000. She made the first voyage under the new contract on 1 September 1837, which started very successfully.

Her return voyage, however, almost crippled the company when, on 15 September, she ran aground off Tarifa, on the Spanish coast, in thick fog. She was carrying $21,000 in cash, as well as mail and passengers, including Arthur Anderson and his wife. Anderson bargained with a passing fishing boat, to take the mail and passengers from the wreck to Gibraltar. On arriving in Gibraltar, Anderson was able to gain assistance from a British warship, HMS *Madeira*, and a government packet vessel. They returned to *Don Juan* to find that the captain had ordered the crew to salvage what they could, as the ship was a total write-off. The money and other goods had been brought ashore at Tarifa. Despite attempts by the locals to plunder the goods, Anderson was able to recover the money and cargo.

To continue the mail service after the loss of *Don Juan*, the Peninsular Steam Navigation Company (PSN Co.) were required to charter vessels from the Dublin Steam Packet Company to run alongside *Tagus*. The next obvious stage of expansion for the mails was to the Far East. It would be far quicker for the mails to be taken by sea to France and then by land to Marseilles, and an agreement was reached in 1839 for this to happen. But, the British government was not comfortable with this reliance on France; there was a lot of tension between the countries and there was concern that official dispatches to the East might be tampered with whilst in transit through France.

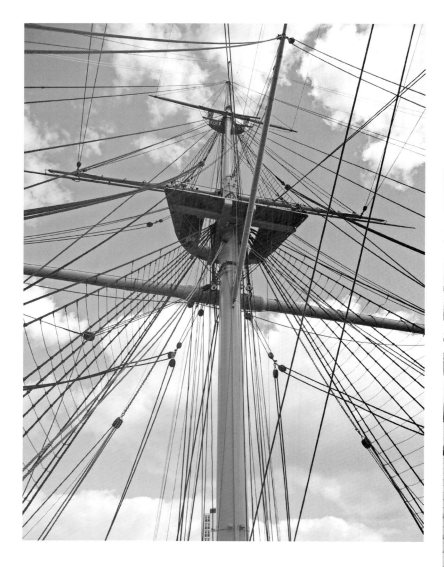

Sails were hoisted in good weather conditions to offer extra speed. (Frame & Cross)

Ropes and wood were the mainstay of the early P&O liners. (Frame & Cross)

• DID YOU KNOW? •

Tagus was originally planned to be named 'Britannia', but the name changed before launch.

The Governor of India, Lord Bentinck, was keen for a steamer service to India, and urged the Peninsular Steam Navigation Company to make an offer to undertake this service. They declined, being more interested in strengthening their Iberian operation. They did, however, furnish Bentinck with information on how a service between Egypt and India could and should be run. Bentinck appealed to the British government to start the service, supplying the information gathered from the Peninsular Steam Navigation Company. Bentinck gave credit to those who had given him the information, and the government asked PSN Co. for more plans on how to operate a service between England and Egypt, which they duly gave. Using this information, in 1840 the government called for tenders for a service from London to Alexandria.

Having completed the research on how to successfully run the service, PSN Co. opted to submit a tender. It proved to be the lowest of the four received, and as they already had the experience and had researched how best to do it, they were awarded the contract at a subsidy of £34,200 per year. The terms of the contract stipulated that the line had to provide a monthly service, utilising ships of at least 400hp. The ships were to depart Southampton, and travel via Gibraltar and Malta to Alexandria, with the expectation that they would reach Alexandria on the fifteenth day out.

On 31 December 1840, the Peninsular and Oriental Steam Navigation Company (P&O) was incorporated by Royal Charter. The name change reflected the company's growing network and future expansion plans, while the incorporation allowed the company to reorganise as a limited liability company which enabled them to raise capital from outside shareholders. The capital was then used to help the company to grow.

As a condition of the charter, P&O were obliged to establish a service between Egypt and India by 1842. They were promised a £20,000 annual payment by the East India Company as outlined in the first half-yearly general meeting of P&O, held on 27 May 1841:

The Court of Directors of the Honourable Company have granted £20,000 to this Company for the first year in which they have a Steam Vessel on the line between Suez and Calcutta. They have made a further grant of £20,000 for the second year, provided the Company's vessels perform six voyages during that period: and if circumstances admit of a monthly communication subsequently, the Court have guaranteed for the third, fourth and fifth year, an additional payment of £20,000 to forward this object.

2

THE EARLY YEARS

With such a short timeframe in which to get their services running, P&O purchased existing tonnage to begin their Alexandria service. For £80,000 worth of P&O shares, they acquired two ships from the Transatlantic Steamship Co. The ships were the 1,140 ton wooden paddle steamer *Liverpool*, which had formerly been in North Atlantic service, and was renamed *Great Liverpool* (to distinguish her from the smaller *Liverpool* of 1835) when she entered P&O service. She was paired with the *United States*, which was renamed *Oriental*.

These two ships were to form the beginning of the Far East service for P&O. On the first of each month either *Great Liverpool* or *Oriental* would sail from Southampton bound for Alexandria. The ships would travel via Gibraltar and Malta to Egypt.

P&O also established an onward route from Alexandria to Cairo, employing river steamers and a canal boat. The first P&O steamer on the Nile was the 55 ton *Lotus* which arrived in Alexandria on 16 April 1841. It was followed shortly thereafter by another steamer, named *Cairo*, of 46 tons. They also sent a light iron packet, capable of carrying seventy passengers, for use on the Mahmoudieh Canal.

The transit through Egypt took around sixty hours, which included a night's rest at Cairo and time for refreshment and rest at the central station between Cairo and Suez. The outward route from Egypt to India began with a 48-mile transit of the Mahmoudieh Canal, between Alexandria and Atfeh.

> ## • DID YOU KNOW? •
>
> The flag flown to signify voyages departing for China was originally yellow, which caused some confusion, as a yellow flag was also the signal for a smallpox outbreak!

The Mahmoudieh Canal met the Nile at Atfeh, and from here the 120-mile journey was made on the Nile by steamer. The 70 miles between Cairo and Suez, across the desert, was taken by carriage.

To service the onward journey to India, an order had been placed by P&O in February 1841 with Thomas Wilson and Co. (formerly Messrs, Fawcett and Mister Wilson) of Liverpool for a 1,800 ton and 520hp steamship, *Hindostan*. This order was followed, in April, with an order for a ship of the same specifications, to be known as *Bentinck*.

The *Hindostan* was the sensation of the age and attracted the interest of Queen Victoria and Prince Albert, who expressed a desire to inspect the ship:

The Royal party were received at the gangway by the deputation of the Directors viz Alderman Sir John Pirie Bart., Deputy Chairman, Arthur Anderson Esq MP and P.D. Hadow Esq. Her Majesty graciously taking the arm of Sir John Pirie was by him conducted over the vessel and after remaining on board for rather more than an hour the Royal Party left the vessel, the Queen and Prince Albert expressing themselves highly gratified with their visit.

Hindostan and *Bentinck* became the first ships on the Egypt–India leg of P&O's oriental service. *Hindostan* departed England on 24 September

1842, bound for Calcutta via Gibraltar, Cape Verde, Ascension, Cape Town, Mauritius and Point de Galle. The voyage took ninety-one days, including stops for coaling, of which sixty-three days were spent under steam.

The directors were happy with their new ship. Having budgeted £10,000 for the repositioning of *Hindostan* and *Bentinck*, the cost of *Hindostan*'s voyage after passage-money was £1,800. The *Hindostan* had also delivered speed beyond their expectation. In the board minutes of 30 May 1843 it was noted:

She left Suez 17 hours after the steamer for Bombay, and not withstanding a further delay of 30 hours on her voyage to Calcutta from unexpected circumstances, which are not likely to occur again, she arrived there before the express mail, via Bombay from England, had reached that place, giving an opportunity for those who sent duplicate letters by the 'Hindostan' to Madras, to answer them via return mail to England, a saving of one month in the correspondence.

Despite several 'highly respectable mercantile firms' expressing their desire to be appointed as P&O's agents in Calcutta, the line decided to instead

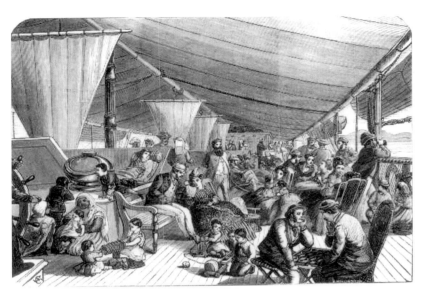

The Red Sea passage, in the days before air-conditioning, was the most difficult for passengers to bear. The suffocating heat and stillness of the air had ships' officers rigging up canvas, in an effort to capture the slightest breeze. (Orient Heritage Collection, RCH002/Henderson & Cremer)

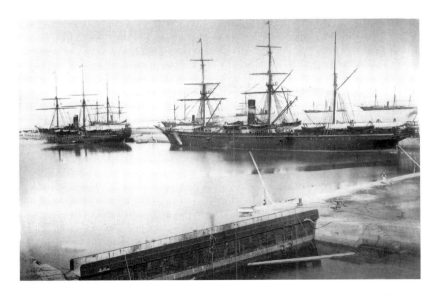

Surat (left) 1866–1894, 2,578 gross tons and iron, and *Deccan* 1868–1889, 3,128 gross tons and also iron. This unique image shows the two ships alongside in Suez Dock, Port Said, c. 1880. (Orient Heritage Collection, RCH001/Henderson & Cremer)

send one of their own. Captain J.R. Engledue was appointed by P&O to represent the company in Calcutta. This was decided because he had a long acquaintance with the company's way of doing business and of steam navigation, and had been in command of the ill-fated *Don Juan* in 1837. The directors felt that, by having their own representative to manage their affairs, they would have more control over what was happening and also would be able to maintain tighter budget controls. In the same vein they also sent agents to Madras, Point de Galle, Aden and Suez.

During their expansion into the Far East, P&O maintained and grew their services within the Mediterranean. The line continued to operate services to Spain and Portugal, and added a series of feeder routes and seasonal schedules to ports such as Valetta, Malta and Athens. At the same time that they were building *Hindostan* and *Bentinck*, they were also completing a 553 ton ship for the peninsular service, *Lady Mary Wood*.

Further services were added to Smyrna, Constantinople (now Istanbul) and Jaffa (now Tel Aviv). These voyages went onwards to Alexandria, where

Even as ships advanced, sails were maintained as auxiliary. (Frame & Cross)

Engine rooms aboard the early steamers were hot, cramped and dangerous. (Frame & Cross)

tourists could travel by P&O canal and river steamers to Cairo to see the pyramids.

As P&O's services developed throughout the Mediterranean, the company was wise to the opportunity of offering cruises. Ever the entrepreneur, Arthur Anderson saw the financial benefits of augmenting the usual cargo and passenger carriage with tourists. These cruises became known as the 'Grand Tour' and cruise berths were offered on ships that were already undertaking scheduled voyages. In March 1843, P&O placed an advertisement in *The Times* of London advertising a voyage on the 743 ton wooden paddle steamer *Tagus*, which read:

INTERESTING AND CLASSICAL EXCURSION
Steam to Constantinople, calling at Gibraltar, Malta, Athens, Syria, Smyrna, Mytilene and the Dardanelles.

This was the beginning of P&O's close association with cruising in its early form. From these early advertisements, P&O developed a demand for this new style of Grand Tour.

In 1844, P&O gave William Thackeray, already a well-established and popular author, tickets on their Grand Tour with the view of popularising their voyages. His ticket included excursions to Cairo and the pyramids, as well as Jerusalem. He wrote a book about his travels called *Notes on a Journey from Cornhill to Grand Cairo*. He dedicated the book to 'Captain Samuel Lewis of the Peninsular and Oriental Steam Navigation Company's Service'. Of the experience, Thackeray wrote:

> The Peninsular and Oriental Company has arranged an excursion in the Mediterranean by which, in the space of a couple of months, as many men and cities were to be seen as Ulysses surveyed and noted in ten years.

The Grand Tour involved changing ships at intervals. Thackeray, for example, cruised aboard *Lady Mary Wood* between Vigo, Lisbon, Cadiz and Gibraltar; *Tagus* on the next leg to Malta, Smyrna and Constantinople; and the rest of the tour to Jaffa and Alexandria aboard *Iberia*. In addition to changing ships regularly during the voyage, those returning from some foreign ports were required to undergo a quarantine period on their return.

Anticipating the need for further mail services in India and the East, P&O purchased the ship *Precursor* from the East India Company for £45,000. She had originally been offered to P&O some years earlier at £80,000, but the company had declined the offer. They also attempted to purchase Brunel's *Great Western*, but were unable to do so. P&O tendered for additional Indian services, including the service to Bombay, which was at the time held by the East India Company. The P&O proposed service would have been faster, more efficient and cost-effective, at £30,000 cheaper per year. However, the East India

Company strongly opposed the P&O tender, and the British government yielded to the East India Company's significant influence.

Instead, the British government asked P&O to prepare costings for a service onward from India to Penang, Singapore and Hong Kong. The service was due to start in 1846, but at the urging of the British government it was brought forward to August 1845. To this end, the P&O ships *Lady Mary Wood*, and *Braganza* were despatched to India.

The first service to Penang, Singapore and Hong Kong left Point de Galle on 27 July 1845, arriving at Singapore on 4 August, and Hong Kong on 13 August. The time allowed for the passages was eight days from Point de Galle to Singapore and seventeen days from Point de Galle to Hong Kong. The inaugural service was operated by *Lady Mary Wood*, and she was carrying with her mail that had left London forty-one days prior. This represented a great improvement in the speed of postal communications.

To run the new services, P&O placed orders for the construction of nine new ships of a combined tonnage of 9,575 tons. The success of their new China service prompted a desire for further expansion and it was noted in the minutes dated 5 December 1845 that:

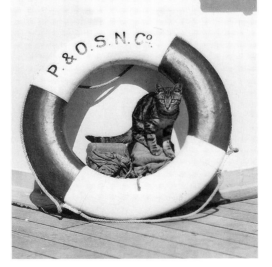

> A strong desire, it appears, is manifested by the local Colonial Authorities, as well as by the mercantile community connected with China &c., for the extension of Steam Navigation, not only to the Northern Ports, but also to the British Colonies in the East, Australia, Mauritius, &c. measures which, doubtless, will in due time, be carried out under sanction of Her Majesty's Government.

P&O liners, like most other ships, carried a cat aboard to handle rodents. Her name was Strathie, and she was a great favourite with passengers and crew on board the *Straithaird* in the early 1930s. (Henderson & Cremer)

3

AUSTRALIA

As early as 1843, when the Indian services were being established, there were calls within Australia for a similar service to aid their colony. In 1844 a submission was made to the legislative council of New South Wales requesting such a service be established, and it was unanimously passed.

Merchants in Britain made similar submissions in their country, owing largely to the import and export markets being each valued at £2 million per year. Despite these requests, it was not until 1847 that the British government made their first call for tenders for the establishment of a steamship connection with Australia. P&O submitted a tender, and despite their considerable experience at long-distance voyages, were unsuccessful. The Admiralty instead awarded the contract to the lowest bidder which proved disastrous, as the company in question lacked the expertise and the ships to operate such a service, later filing for bankruptcy.

Public interest in the resumption of steam services forced the government to request further tenders in 1849. P&O tendered again, this time offering to operate the service on the provision that they were also granted the Bombay service. However, the East India Company still refused to yield their service and, as a result, no company was successful in being granted the contract to Australia. This process resulted in a parliamentary inquiry, which had the effect of raising public awareness of the transit conditions on the route to Australia. The time by sail was, on average, 121 days, while a steamer would be able to complete the journey in just seventy.

An extract of a report written by Commodore Wilkes, who had led an American exploratory expedition to Sydney in 1839, was presented as evidence in the parliamentary inquiry. The report outlined how an American man-of-war steamship had arrived in Sydney, causing great astonishment. This added an extra level of pressure to the government, and to the East India Company. The increased public pressure following this embarrassment resulted in the East India Company loosening its stance and suggesting that two services could be run on the Bombay route, thus allowing P&O the foothold that they needed.

Tenders were called for yet again in 1851, and P&O submitted what would be their fourth tender for this service, which was accepted on 26 February 1852. P&O faced little competition, despite the government attempting to increase competitiveness by breaking the tender into smaller segments. The only other company to submit a tender to run the service was the Eastern Steam Navigation Company. Eastern had been created especially for the purpose of running this service. However, P&O was judged to be more capable of managing the route and, despite calls by Eastern for an inquiry into the decision to award the service to P&O, no such inquiry was ever held.

The first P&O ship to commence services to Australia was the 699 ton iron-screw steamer *Chusan*. The Australian contract called for P&O to establish a service from Sydney to Singapore and this was to connect with the P&O mail steamers operating on the Suez to Hong Kong (via Galle) service.

Chusan sailed from Southampton on 15 May 1852, for Port Phillip and Sydney, calling at St Vincent and Cape Town, and arriving at Melbourne on 29 July and Sydney on 3 August. At Cape Town she excited the interest of some wealthy merchants who offered to buy her on the spot, an offer that was refused. Her arrival at Melbourne and Sydney was a sensation, and

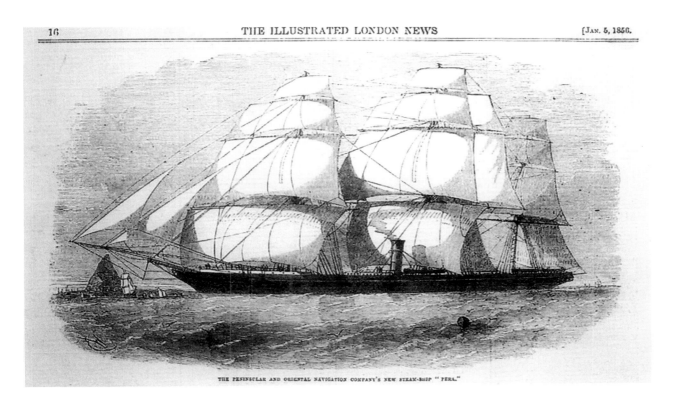

THE PENINSULAR AND ORIENTAL NAVIGATION COMPANY'S NEW STEAM-SHIP "PERA."

Pera 1855–1880, 2,126 gross tons. At the time, the *Pera* was the largest ship in the P&O fleet. Her career was served in various waters, which included five return voyages to Australia from Bombay and Point de Galle. (Orient Heritage Collection, ILN, RCH015/ Henderson & Cremer)

created enormous interest. In Sydney a grand ball was held to celebrate P&O's Captain Down and the *Chusan*. To mark the occasion a special piece of music, known as 'The *Chusan* Waltz', was composed and led the dancing for the night.

This service was initially very successful. *Chusan*'s inaugural Australian sailing departed Sydney on 31 August 1852 and arrived in Singapore on 13 October, having called at Melbourne, Adelaide, King George's Sound, and Batavia – the usual ports for this voyage. Initially, the Australian service was every alternate month, although calls were made to increase the frequency of the service over the coming decades.

By 1853, however, P&O was facing difficulties. The price of coal had increased over 400 per cent in parts of the P&O network. Furthermore, as coal was not available in all the ports that P&O visited, the line had to carry stores of coal on sailing ships to those ports. In Australia, the increase in coal prices was exacerbated by the gold rush. Miners abandoned the coalmines in favour of seeking their fortunes on the gold fields, and the resulting shortage made it far more difficult for P&O, and other companies, to source coal at reasonable rates. To try and stabilise their situation, P&O applied to the government for an increase in the mail contract subsidy, a request which was denied.

In 1853, the East India Company abandoned their Suez–Bombay and Bombay–Aden mail contracts, leaving them open for P&O to acquire, though the high price of coal made this acquisition a risky business.

P&O had commissioned a number of new, larger ships for their Australian and Indian services. However, in 1854, the Crimean War led to P&O ships being requisitioned by the British Admiralty for use in the conflict,

• DID YOU KNOW? •

In an 1850 British parliamentary inquiry, evidence was provided that it often took ten months for the sender of a letter to receive a reply from Australia.

thus removing them from P&O service. Over the course of twelve months, *Himalaya, Simla, Colombo, Manilla, Candia, Ripon, Rajah* and *Nubia* were called into military service, and by April 1855 eleven of P&O's ships, most of them their newest builds, had been requisitioned by the government. This added further strain to the line.

The withdrawal from regular service of so many ships forced P&O to reconsider the mail services and their priority. As a result, the company withdrew from the Australian service as it could not find suitable ships to continue. This action left Australia without a regular steamship mail service, and caused considerable upset in the colonies. In Australia, there were significant complaints about the lack of both postal and passenger services and the mounting pressure led to the British government requesting that P&O restart the service. Unable to accomplish this immediately, owing to their ships being in use in the Crimean conflict, the original contract was retracted and P&O was required to tender for the contract again.

> **• DID YOU KNOW? •**
>
> Florence Nightingale travelled on the P&O ship, *Vectis,* during the Crimean War.

In 1856, the P&O tender for the Australian mail contract was rejected and the British government awarded a new contract to the European and Australian Royal Mail Company. P&O lodged a complaint as they believed that they had provided the better offer, and had the proven ability to accomplish the service. The government argued that the European and Australian Royal Mail Company would have the service up and running faster than P&O. European and Australian had also tendered for the entire contract, from Southampton to Sydney, while P&O had only tendered for the Suez to Sydney route.

The reasons given were hotly disputed by P&O, and they argued that the tenders had been called for a service from Suez to Sydney, and that they had not been advised that the government wanted to include the tender from Southampton. Furthermore, the P&O tender was for a lesser price, and the ships that would run the service were soon to be released from war service, at which time they would be available to resume the mail contract. P&O's arguments were to no avail, and the European and Australian Royal Mail

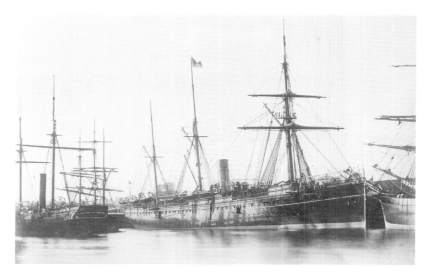

Ellora 1859–1876, 1,574 gross tons. The *Ellora* was originally owned by Spanish and French interests, before being purchased by P&O for their Mediterranean service. She was then sent to the East, and made five return voyages from Point de Galle to Australia. (The Pictures Collection, State Library of Victoria)

Peshawur 1871–1900, iron, 3,782 gross tons. The *Peshawur* brought the 1882 English XI team to Australia. Their captain, the Hon. Ivo Bligh, was presented with the original Ashes, the sacred symbol of cricket between Australia and England. (The Pictures Collection, State Library of Victoria)

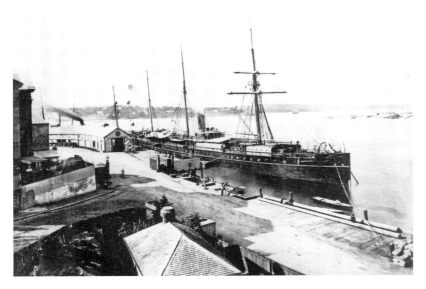

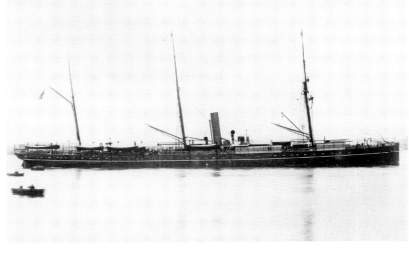

Cathay 1872–1895, 2,983 gross tons. The *Cathay* was one of a number of ships built for the through-Suez Canal service to the East and Australia. She made five voyages on the Australian trade between 1880 and 1884. Her sister ship was the *Hydaspes*. This rare image shows the *Cathay* alongside the P&O wharf, on the west side of Sydney Cove, the present site of the overseas passenger terminal. (Orient Heritage Collection, 10301-RCH/Henderson & Cremer)

Hydaspes 1872–1898, 2,984 gross tons. The *Hydaspes* made eight mail voyages on the Australian service, and also served on the Indian route and as a transport during the 1882 Egyptian campaign. (Orient Heritage Collection, P&O_295-RCH/ Henderson & Cremer)

Company commenced their service in 1856. Ironically, in order to complete their service they chartered P&O's ship *Simla*, which had been built for the original P&O service and had recently been released from the Crimean War service.

Despite losing the mail contract for Australia, P&O was still a major presence on the Mediterranean, the Red Sea and the Indian Ocean. They continued to make advancements for the comfort and transport of passengers transiting through Egypt, and maintained strong contacts with the British government.

In 1855, responding to complaints from their passengers that accommodation in Cairo was hard to come by, P&O purchased and fitted out a 'Transit Hotel'. Passengers had previously had difficulties in procuring accommodation in the Egyptian city, as hoteliers preferred to offer their rooms to guests who were intending a long stay, rather than those who required only a night or two between ocean voyages. Additionally, P&O continued to petition the Khedive of Egypt for reductions in the transit tariffs

that were being charged; success here allowed P&O to reduce the prices for berths on their ships.

P&O was also expanding their network of routes. They had long been in discussions with the British government to be able to provide a postal service to Mauritius, and in 1858 the terms were finally agreed. This coincided with the European and Australian Royal Mail Company's service failing. From the beginning European and Australian's service had faced a series of accidents and delays and this culminated in a change of management, which led to the eventual winding up of the company.

The tender for the Australian service was once again awarded to P&O in 1859, with P&O now running a monthly service. At first P&O considered that it would prove more profitable to run the Australian mail service via Mauritius, but within a year they had changed the service to go via Point de Galle, as the Mauritian route was not proving profitable. The Mauritius service was continued as a separate route.

4
TROOPING AND CHANGING

To the British government, the ships of P&O had proved their worth as transports during the Crimean War. This set the company on the path of augmenting, in emergencies, the transport of government forces to areas of conflict across the Empire.

In 1857, the Indian Mutiny required troops to be sent from Britain to India as reinforcements. P&O assisted the British government by carrying the troops to the conflict and repatriating them once their service was completed. The first troops were sent to Bombay by P&O steamers, comprising of the 13th and 33rd regiments from Cape Town. Reinforcements were despatched from England via P&O and overland routes. During this time, over 230 officers and 5,170 men were sent to India by P&O, while the line offered discounted fares for returning servicemen, an offer which was also extended to the widows and children of those who died in the conflict.

P&O's network was now becoming more and more complex. P&O ships were based in ports around the world, and the line employed agents in all of their major ports. They had an important system for the movement of provisions and fuel for their ships, were able to affect repairs in many different ports and carried passengers, mails and cargos for many different companies.

P&O carried tea by steamer for the first time from China to the UK in 1859. In that year they also made their first call to Japan, further expanding their network of services.

In 1862, Brodie McGhie Willcox, one of the founders of the line, died. He had resigned his

position as managing director in December 1854, although he remained on the board of general directors, and had at the same time given up his share of fees from the profits. Arthur Anderson had also relinquished the greater proportion of his entitlements, though he continued on as a managing director. A special committee was set up, on the relinquishment of the fees, to find a way to thank the two men for their sacrifice, which in the case of Mr Willcox, amounted to £8,000 per year. The chairman of the committee, W.M. Dent, summarised the situation thusly:

> Gentlemen, it is scarcely credible – positively, there is no instance, in modern times, of a gentleman so entitled, in the full vigour of life, and fully capable of performing his duties, voluntarily relinquishing such emoluments, particularly in this every-day, money-making City of London, and in these times, when wealth is so much coveted.

The changing management was matched by a changing business strategy for the company. By 1866, P&O no longer relied so heavily on mail contracts for the bulk of their income. They still held contracts for India, Australia and China, but now they were more focussed on cargo and passenger shipping. Their inventory included fifty-three steamers, which collectively travelled 1.5 million nautical miles per year and they had 12,000 employees across ten countries.

• DID YOU KNOW? •

In 1873 the P&O steamer *Nubia* carried W.G. Grace and the English XI cricket team from Point de Galle to Australia.

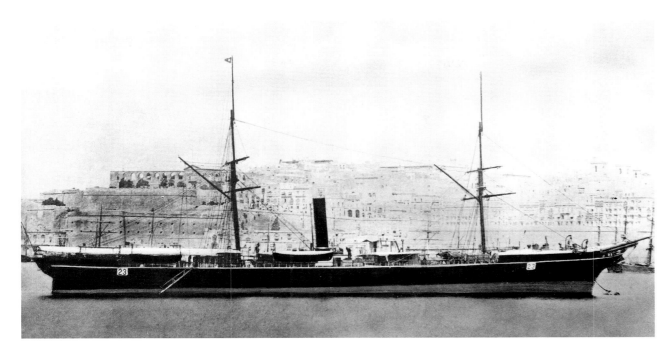

Bengal 1853–1870, 2,185 gross tons. Initially used in the Mediterranean, the *Bengal* made a voyage around the Cape of Good Hope to take up the Calcutta Suez service in 1853. The *Bengal* was active during the Abyssinian War in 1868 as a transport. (Orient Heritage Collection, P&O_265-RCH/Henderson & Cremer)

P&O were able to aid the British government again in 1867 and 1868. Six P&O steamers and a steam tug were chartered to transport troops from the British Indian Army to Ethiopia for the Abyssinian Expedition. In addition to providing ships for the transportation, they were also able to supply coal to the government vessels and water from their condenser in Aden.

The Abyssinian Expedition was a retaliatory expedition by the British Army against the Ethiopian Empire, for imprisoning British missionaries and representatives of the British government. P&O were eager to prove their loyalty to the Crown, while also showing the value of their vast network to the British government. Thus the line was agreeable to offering assistance to the government, which went further than borrowed tonnage, which was primarily used because of its location near to the warzone. It also included the supply of 150,000 tons of coal from P&O's eastern depots, while the condensers aboard the ships were used to create over 500,000 gallons of distilled water for the army.

• DID YOU KNOW? •

Every P&O mail steamer had a bullion room, a strong room under the charge of a senior officer, where bullion and specie (coins) were stored when they were being carried.

In 1868 Arthur Anderson, the last of P&O's founders, died. With his death the remuneration of managing directors and of the chairman of the board were changed. These positions were now paid a salary, rather than a percentage of the profits, as had been the custom for the original managing directors. The duty of chairman had previously not attracted any additional remuneration, but to ensure the commitment of the appointed chairman it was felt that it was necessary to now pay a salary. On Anderson's death, the company appointed Patrick Douglas Hadow as the new chairman.

From its inception, the founders of P&O had wanted the board to contain people of expert knowledge. This was not limited to knowledge in shipping; just as important was knowledge and expertise in the mercantile world of India and the East. Hadow was such a man. His family had a long association with India, and maintained close contacts in the business community there. Hadow had been supportive of P&O from its beginnings and, as a shareholder, had joined the board in 1849.

5

SUEZ CANAL

In 1869 the Suez Canal opened. This event was to dramatically change the way freight and passengers travelled from Europe to the East, and vice versa, and had a huge impact on P&O. The 100-mile (160km) long Suez Canal, which connects the Mediterranean with the Red Sea, allowed shipping companies to make significant changes to the way they operated their fleets, and also to their profitability.

Prior to the opening of the Suez Canal, P&O had invested a lot of money, resources and manpower in maintaining and servicing their fleet, including both the ships based on services to Alexandria, and the ships based in eastern waters. This investment also covered special barges and tugs for the Mahmoudieh Canal and steamers on the Nile, as well as a hotel and farm in Cairo. Their facilities in Alexandria were extensive, with offices, warehouses, wharfs, storage barges and coal provisioning.

Prior to the opening of the canal, the costs of sending a ship based in eastern waters back to England, when repairs or upgrades were required, was prohibitive. Thus, P&O had invested heavily in dockyards, repair facilities and all the necessary materials, associated workshops and trained personnel to affect these repairs. With the opening of the canal it suddenly became more affordable and more practical to simply send the ships to repair yards in Great Britain. As a result, a large portion of P&O's assets became obsolete almost overnight. This meant there was a significant write-down on the company's value. At the same time, P&O was facing a need to build new ships, suitable for

the new, direct passage and a sudden increase in competition on the new route.

New lines were starting and along with increased traffic from existing European lines, the prices that could be charged for carriage of freight began to fall dramatically. As a result, P&O's income was dropping by around £100,000 per year. In the September 1873 board minutes it was noted that prior to 1869 the 'only steamers employed in the Eastern Trade were those of this company (P&O), and the Messageries Impériales, in the present day for every steamer despatched by this company from England, probably ten are despatched by other shipowners.'

To make matters worse for P&O, the British government flatly refused to allow the mails to be carried through the Suez Canal, unless P&O would accept a reduction of £30,000 in the mail contract. They were able to insist on this as the original contract, which still had several years to run, had specified the overland route as the method of transport. Not being in a financial position to agree to such a reduction, P&O instead put the mails off in Alexandria, from where they were sent by rail to Suez, whilst the ship and its passengers travelled through the canal. The ship then collected the mails in Suez and continued on the journey. At the time the canal transit took longer than the rail route, and was considered to be less safe for the passage of mails.

Throughout 1872 and 1873, P&O were occupied with rebuilding their older tonnage using new compound engines. This was

• DID YOU KNOW? •

The first P&O ship to make a westbound transit of the Suez Canal was the 2,200 ton *Nubia* on 3 April 1870.

important, not just for their ships transiting the Suez Canal, but also those plying other routes since competition was increasing everywhere. The compound engines allowed for exhaust steam to be recycled and used to drive extra pistons through the use of expansion chambers, greatly increasing the efficiency of the vessels. Such was the impact of the compound engine on the running of their ships that the directors noted, in the September 1872 board meeting, that it 'may be said to have caused almost a revolution in steam navigation'. The new tonnage they were building at the time was also given this technology.

The activities conducted by P&O in the Far East and India had, in the years leading up to 1876, become diminished due to the falling value of silver. With a business that was run on multiple currencies around the world, they were susceptible to fluctuations in the world market. Both the Indian and the Chinese currencies were pegged on the price of silver, so when the price for silver fell, so too did the monies P&O earned on services to these countries. This issue added strain to P&O's already stretched financial position.

The fortunes of the line were not all bleak though; P&O's Australian service received a boost in viability in 1873 when a new contract was signed. The contract was drawn up for six years, with an annual subsidy of £90,000. Due to ongoing challenges with the Australian Imperial government, the new contract was signed between P&O and the Victorian government.

A feud between the governments of Victoria and New South Wales meant that a direct service to the more northern state could not be secured and to overcome this, a branch line was established between Melbourne and Sydney. That same year, a parcel-post contract was signed, allowing the carriage of parcels and large mails between Great Britain and India. This valuable contract, which utilised cargo holds aboard existing liners, also added valuable funds to the company's coffers.

On 5 August 1874, the British government finally agreed to allow the mails to be sent through the Suez Canal, though P&O had to accept a reduction in the levy of £20,000. This agreement was facilitated in part by P&O's new managing director, Thomas Sutherland.

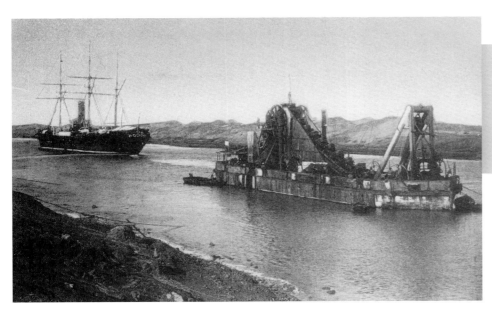

Shipping and the Suez Canal

In 1871, 700,000 tons of shipping transited the Suez Canal.
In 1872, 1,250,000 tons of shipping transited the Suez Canal.
In 1873, 1,660,000 tons of shipping transited the Suez Canal.

In its early years the canal was frequently blocked by dredges or ships grounding or colliding, sometimes blocking the waterway for days on end. (Orient Heritage Collection, 11305-RCH/Henderson & Cremer)

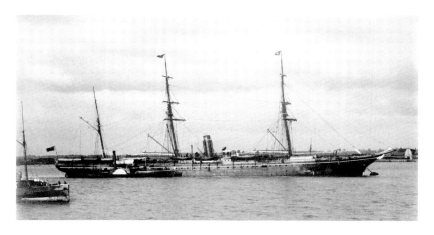

Australia 1870–1889, 3,648 gross tons. The *Australia* was the last P&O ship to have a clipper bow. Despite her name, she made only three return voyages to Australia, spending most of her time in Eastern and Indian waters. (The Pictures Collection, State Library of Victoria)

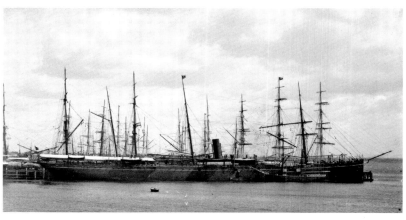

Rohilla 1880–1900, 3,511 gross tons, iron. The *Rohilla* was one of three sisters, the others being *Ravenna* and *Rosetta*. The *Rohilla* is shown here alongside Williamstown Pier in Melbourne. (The Pictures Collection, State Library of Victoria)

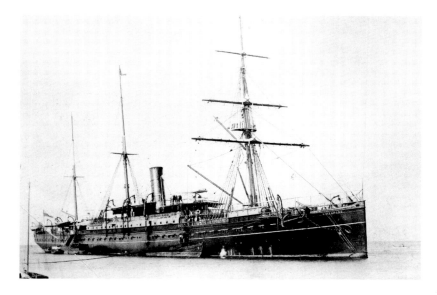

Mirzapore 1871–1897, 3,763 gross tons, iron. The *Mirzapore* was built for the through-Suez Canal service to the East, and also made five voyages to Australia 1881–1884. (Orient Heritage Collection, P&O_276-RCH/Henderson & Cremer)

• DID YOU KNOW? •

Prior to 1871, alcoholic beverages were included in the passage fare aboard P&O ships. In 1871 P&O removed alcohol from the cost of the passage fare, and instead offered it for sale aboard at 'reasonable prices'.

Sutherland had begun his career with P&O as an 18-year-old and at age 20 was sent to China Station. He had learnt the business from the bottom up and was very familiar with all aspects of it. He had been instrumental in starting a service with Japan in 1859 – a great achievement as Japan had very little outside contact at the time. He had also impressed those in the London office by sending frequent reports and suggestions for improvement and, having returned to London in 1866, had been appointed by Arthur Anderson as an assistant manager in 1868, shortly before Anderson's passing.

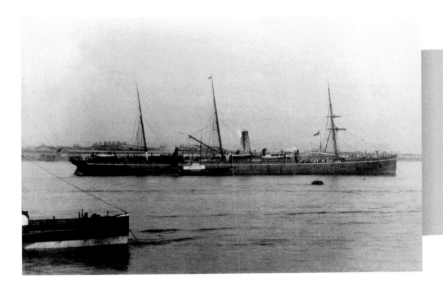

Rosetta 1880–1900, 3,502 gross tons, iron. *Rosetta* made six return voyages to Australia between 1880 and 1879; her most famous moment came in 1885 when she served as an armed merchant cruiser during a period of tension with Russia. (Orient Heritage Collection, RCH003/Henderson & Cremer)

Don't look down!

In 1875, the celebrated tightrope walker, Blondin, made a tightrope crossing aboard the *Poonah*, whilst en route from Aden to Point de Galle. The tightrope spanned from the mainmast to the mizzen mast, and was secured with guy ropes to try and prevent lateral motion. Unfortunately, there was little that could be done to relieve the swell. Despite several close calls, the return walk was completed, much to the delight of the passengers travelling aboard.

Sutherland's ability to negotiate the Suez contract, along with his knowledge of Japan and the Far East, meant that the board appointed him managing director in 1872. Sutherland was well aware of the competitive threat that loomed in Japan, and set about implementing plans to protect P&O from this. At a board meeting, Sutherland highlighted the threat to Britain and P&O by Japan, years before other organisations took true notice of their Asian competitor:

Japan has been and always will be one of the most determined competitors of the commerce of this country, and all western countries, and Japan, by means of subsidies and bounties, by means of cheap labour – so cheap we can hardly apprehend it – will strain every nerve whenever she has the opportunity to make herself felt in all the commercial markets of the world.

In 1874 P&O's British terminus was moved from Southampton to London, in response to competitors offering a direct service into the capital. The ships still called at Southampton on their inward journeys to let off passengers and cargo where required, but now were able to offer a through service to London which was of great benefit to the merchants in London. The trip up the Thames offered additional risk for the company, as the journey was in closer quarters with considerably more traffic, but it was considered to be worth it for the benefit of keeping the merchants happy.

In the 1877 board meeting, the directors reported that P&O's profits had suffered a dramatic decline of £300,000 per annum. This was attributed to the opening of the Suez Canal, a write-down in assets, the falling price of silver and lower tariffs on mail and cargo due to increased competition.

Shannon 1881–1901, 4,189 gross tons. *Shannon* was the first P&O ship to have a hurricane deck. Her maiden voyage was on the Australian service, in which she eventually made sixteen return voyages between 1882 and 1899. (Orient Heritage Collection, RCH007/Henderson & Cremer)

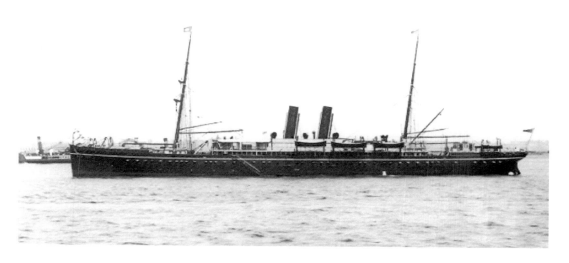

Parramatta 1882–1903, 4,771 gross tons. The *Parramatta* was one of the most popular earlier ships on the Australian service, in which she made thirty-five return voyages between 1883 and 1897. Her sister ship was the *Ballaarat*. (Orient Heritage Collection, 10049-RCH/Henderson & Cremer)

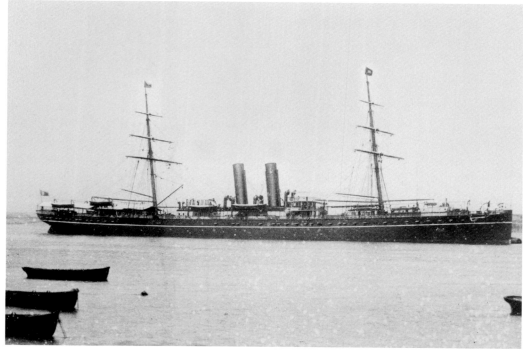

• DID YOU KNOW? •

On one voyage in 1876, *Avoca* left Australia with her strongroom bulging with over 40,000oz of gold, plus £55,000 in specie, and a staggering total of 325,000 sovereigns, boxed!

POST-SUEZ P&O

As the 1870s drew to a close, things were not all bleak for P&O. As they began to introduce new ships, passengers once again flocked to them, preferring the P&O experience to that which any other line offered.

In 1877, P&O moved their liner *Australia* on to the Australian service. She had been built in 1870, and was the first steamer built by P&O on the new high- and low-pressure principles adopted for compound engines. This advance in technology allowed exhaust steam to be reused in low-pressure cylinders, thus improving the efficiency of the engines. This, in turn, improved profitability of the new tonnage.

In 1881, Thomas Sutherland was appointed chairman of the board at P&O. That same year P&O officially transferred their headquarters to London, and ceased calling at Southampton on their journeys to the city. This had become necessary due to the Suez Canal adoption and the changing economies associated with this, which were taking their toll on P&O. With the Southampton port calls dropped, a number of staff in this port had to be let go, whilst in Alexandria many more staff were laid off as the line consolidated its resources.

A cholera outbreak in Egypt resulted in a mandated avoidance of its ports for six months, over the end of 1881 to the beginning of 1882, and caused mass disruption to P&O's passengers and cargo shipping. This, plus the increased traffic on the canal, resulted in the length of time required to transit the canal increasing from an average of two days to up to ten days in extreme cases. This caused major delays for P&O services, and also a marked increase in expenses as canal pilots now had to be paid for the multiple extra days they

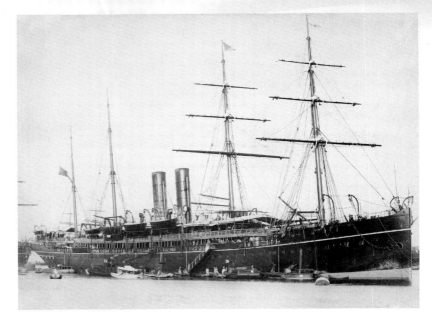

Rome 1881–1912, 5,010 gross tons, iron. One of the most famous ships in the history of P&O. The *Rome*, and her sister ship *Carthage*, heralded a significant change in accommodation layout when first class was positioned amidships, rather than aft. Between 1881 and 1903 the *Rome* made forty-eight return voyages to Australia. In 1904, after a refit and conversion, the *Rome* entered service as P&O's first cruise ship, *Vectis*. (Orient Heritage Collection, P&O_334-RCH/Henderson & Cremer)

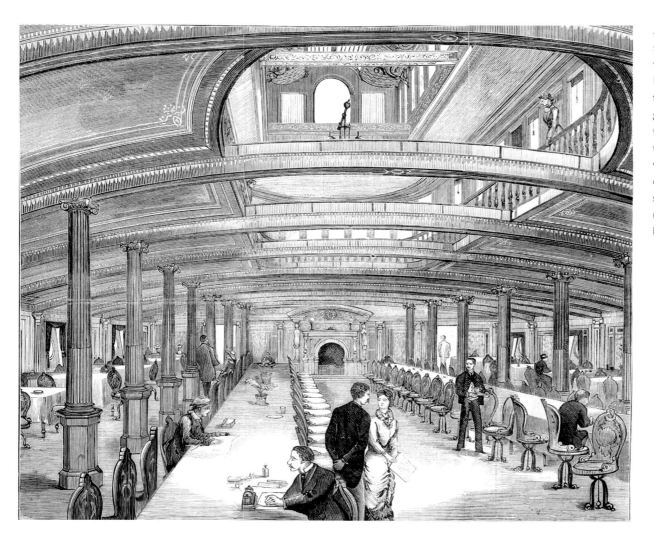

An interesting sketch of the first class saloon on board P&O's *Carthage*. This view is typical of the ships at the time. Between meals the saloon was used for events from writing letters to social gatherings, or just relaxing. Notice the centre well, which often rose up two or three decks to a huge skylight which allowed light and air to circulate down below. The gallery area above the saloon was often the music or ladies room. (Orient Heritage Collection, RCH005/Henderson & Cremer)

spent on board the ships. Even after the quarantine was over the Suez transit continued to prove lengthy, and in 1883 P&O increased the transit period from two to three days.

A further cholera outbreak in Egypt in 1883 again led to a quarantine in Egypt, and this time in Italy too, making things even more difficult for P&O. Their ships were not allowed to dock in Italy, as it was believed that they may be carrying the cholera epidemic, even when those ships had not docked in Egypt. Italy would not allow P&O ships to board or disembark passengers

• DID YOU KNOW? •

Victoria, *Britannia* and *Oceana* were fitted with gun platforms even during regular service. This meant that if the ships were ever called into military service, it was simply a case of installing the guns alongside, rather than having to place the ship into a lengthy refit.

The hurricane deck, in some ways the forerunner of today's promenade deck, it was obviously a windy deck, hence its name, but it allowed passengers room to stroll and escape the often cramped and stuffy conditions below decks. (Orient Heritage Collection, RCH006/ Henderson & Cremer)

HURRICANE DECK OF THE P. & O. CO.'S S.S. CARTHAGE: LOOKING AFT.

• DID YOU KNOW? •

Triple-expansion engines are a form of compound reciprocating engine. High-pressure steam is recycled into secondary and tertiary cylinders resulting in greater efficiency. These engines are still among some of the largest machinery ever put to sea.

or cargo in their country, and the only port that would allow them to land mails was Venice, and here the procedure was tedious.

The cholera outbreak and subsequent quarantine eventually passed, and the service was able to go back to usual. However, the lack of cargo had cost P&O much in lost revenue during the period it was in force.

The company's services in the Suez Canal were further disrupted in 1882 with the outbreak of the nationalist Arabi Pasha revolt. The revolt was led by Arabi Pasha, who had risen through the ranks of the army to become a general and, in time, a leader of an opposition group against the rising European influence in Egyptian affairs fostered by the Khedive. Disquiet broke out as early as 1879, but by 1881 Arabi had assumed complete power. To restore control and to maintain their substantial interests, primarily the Suez Canal, British troops entered Egypt and, along with troops loyal to the Khedive, quickly put down the revolt. During the revolt, the maritime traffic

in the canal was seriously disrupted with the waterway clogged by British transports and naval craft, which had been sent into the canal to prevent it falling into the hands of Arabi. P&O's *Carthage* was also despatched to the canal for use during the conflict as a hospital ship.

In 1884, Thomas Sutherland was appointed to the Suez Canal Board which governed all decisions relating to the canal operations. The board was made up of Egyptian dignitaries and a number of people who had a large financial stake in the organisation. To qualify as a member of the Suez Canal Board of directors, a member needed to hold sufficient shares in the organisation. After P&O acquired shares in the canal they were allowed to nominate a member to join the Canal Board. Once appointed, Sutherland was able to influence decisions made by the Canal Board and this, in essence, allowed P&O a say in the running of the canal, which significantly improved the fortunes for P&O in this region. P&O gifted the shares to Sutherland in 1885, in recognition of his services.

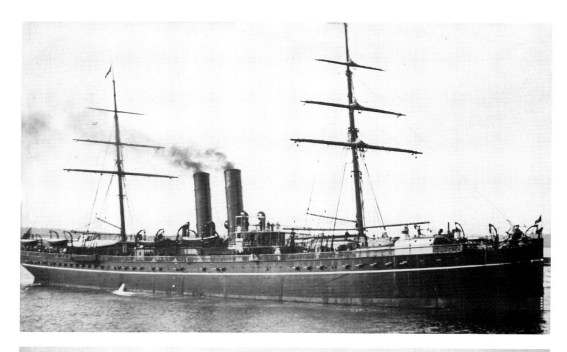

Ballaarat 1882–1904, 4,764 gross tons. *Ballaarat* was built for the Australian service and made thirty-six return voyages between 1882 and 1897, along with voyages in the East and as a troopship during the Boxer Rebellion in China. (State Library, New South Wales)

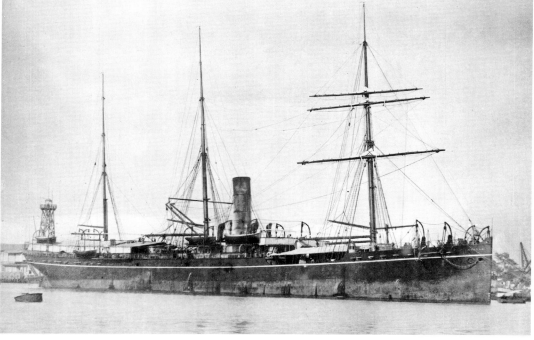

Chusan II 1884–1906, 4,636 gross tons. Designed for Indian and Eastern services, the *Chusan II* made three return voyages to Australia between 1885 and 1888. Her sister ships were *Tasmania*, *Coromandel* and *Bengal II*, the latter two having been constructed with triple-expansion engines. (Orient Heritage Collection, P&O_267-RCH/Henderson & Cremer)

Tasmania 1884–1887, 4,488 gross tons. It was an unfortunately short life for *Tasmania*, as she went aground and was wrecked in April 1887 off the south coast of Corsica. Her captain was killed by falling wreckage and other crew were washed overboard. The *Tasmania* made only four return voyages to Australia. (Orient Heritage Collection, RCH009/ Henderson & Cremer)

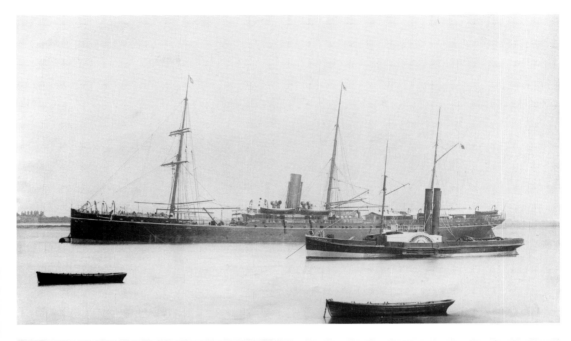

• DID YOU KNOW? •

In 1882 *Assam* carried a leopard, lioness, monkeys and many birds of showy plumage on a voyage to Australia. The passengers were kept at a respectful distance at all times to ensure that the animals, and passengers, remained safe.

Oceana 1888–1912, 6,610 gross tons. In 1887, P&O celebrated their 50th anniversary, which they shared with HM Queen Victoria. To celebrate the double occasion the company built four ships known as the 'Jubilee Ships'. *Oceana* was the third in the series, along with *Victoria*, *Britannia* and *Arcadia*. She made forty-six Australian voyages and also served on the Indian route. The *Oceana* was lost in a collision in the English Channel in 1912, with a cargo including a substantial amount of gold and silver bars which were mostly later salvaged. (Orient Heritage Collection, 10371-RCH/Henderson & Cremer)

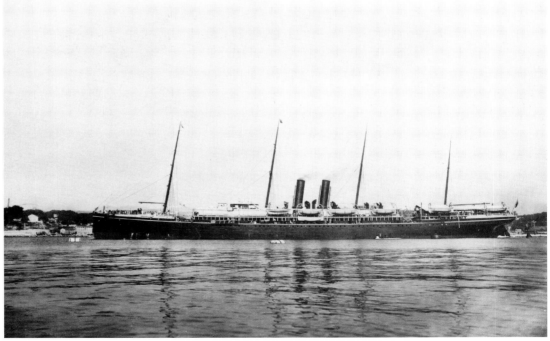

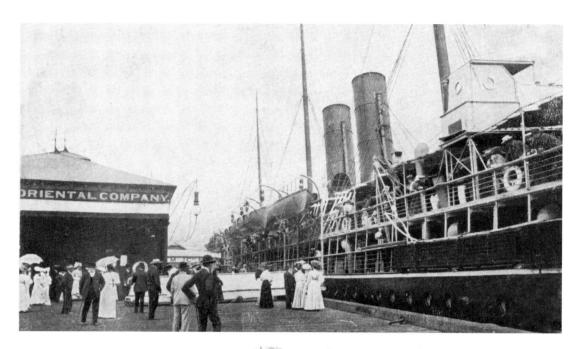

Victoria 1887–1909, 6,091 gross tons. The first ship in the 'Jubilee' quartet, in this historic view the *Victoria* is alongside the P&O wharf on the west side of Sydney Cove, and is about to depart. In all, the *Victoria* made forty-nine return voyages to Australia. (Orient Heritage Collection, 10684-RCH/Henderson & Cremer)

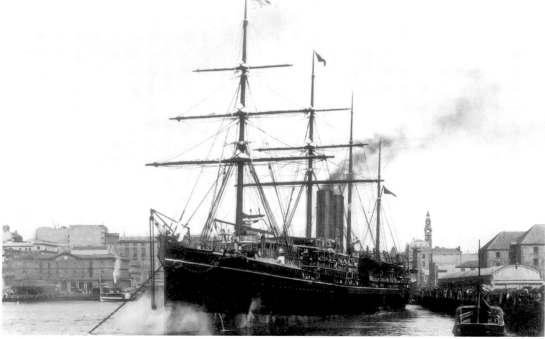

Britannia 1887–1909, 6,061 gross tons. The second of the four 'Jubilee' class ships, the *Britannia* made fifty-two return voyages to Australia between 1887 and 1908. She was also used for the transport of troops. (Orient Heritage Collection, RCH010/Henderson & Cremer)

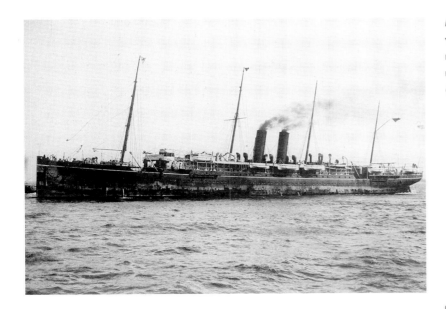

Himalaya II 1892–1922, 6,898 gross tons. *Himalaya II* and her sister ship, *Australia*, were improved versions of the 'Jubilee' class. In her long career the *Himalaya II* made forty-five return voyages to Australia. In 1916, while serving as an armed merchant cruiser, she was purchased by the Admiralty but later sold back to P&O. (The Pictures Collection, State Library of Victoria)

Swashbuckling Captain

During the Arabi Pasha revolt in Egypt in 1882, Captain Briscoe, while in command of a P&O ship, gained great notoriety. With the port of Alexandria under siege by Arabi's troops and the Khedive's forces crumbling, Captain Briscoe took it upon himself to organise and lead a small group of heavily armed crew from his ship to patrol the streets. They were able to suppress pillaging and maintain order until British forces arrived from Malta, whilst also rescuing some 500 fleeing refugees who were taken to the safety of their ship.

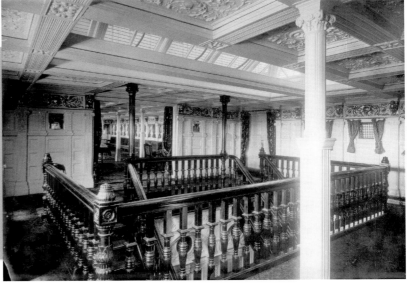

Since its inception P&O have employed the best available builders and designers of its ships, which also included master craftsmen as exampled in the image of the main staircase in the *Himalaya II*. The ornate ceilings and carved, wooden staircase which was situated beneath a large skylight to allow light to filter down to the lower decks. (Orient Heritage Collection, RCH010/Henderson & Cremer)

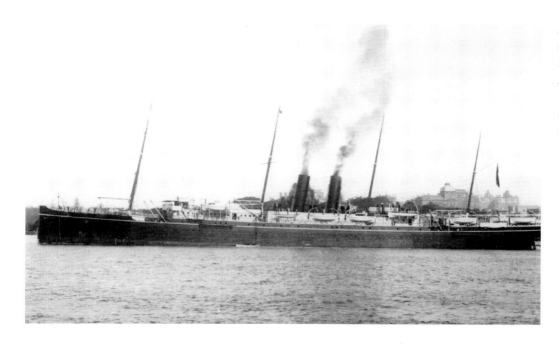

Australia II 1892–1904, 6,901 gross tons. A portside view of the *Australia* taken in Sydney Harbour. She and her sister, *Himalaya II*, were built for the Australian trade in which the *Australia* made thirty-three voyages. *Australia* was lost in June 1904 when, under the control of the pilot, she ran aground and was wrecked on Corsair Rock when entering Port Phillip. (Orient Heritage Collection, RCH011/Henderson & Cremer)

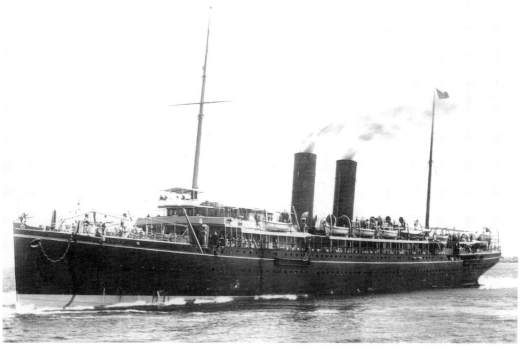

China II 1896–1928, 7,899 gross tons. Another ship of the 'India' class, the *China* was a great favourite on the Australian trade, making thirty-eight return voyages to Australia between 1896 and 1920. During the First World War the *China* was used as a hospital ship, and assisted in repatriating Indian and Australian troops. (Orient Heritage Collection, RCH012/Henderson & Cremer)

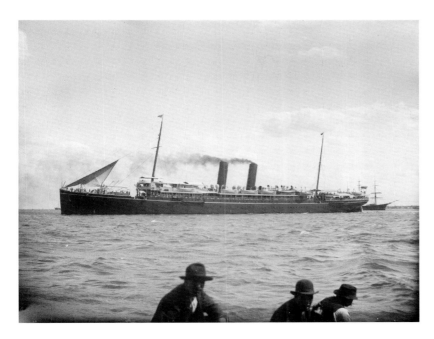

A remarkable view of *China II* making use of a strong breeze in Port Phillip Bay. (The Pictures Collection, State Library of Victoria)

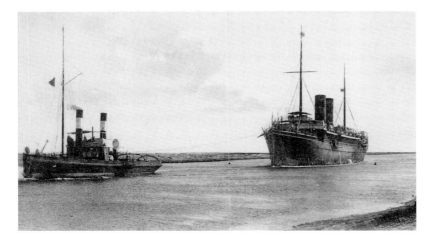

An interesting view of *China II* in charge of a tug being towed in the Suez Canal. (Orient Heritage Collection, 10310-RCH/Henderson & Cremer)

• **DID YOU KNOW?** •

In 1885 *Carthage* transported two lions to the Zoological Society in Melbourne. The lions were carried on deck in heavily fortified boxes.

In 1886, P&O's ship, *Carthage*, became the first ship to transit the Suez Canal at night, marking a new era for P&O, as their business adapted to the new operating environment of the post-Suez world. Night transits of the canal made a huge impact in reducing congestion in the canal and improving transit times.

That same year, the line was stuck with disaster when the 4,488 ton steel-hulled steamer *Tasmania* was wrecked off the coast of Corsica. The wreck resulted in the loss of fifty crew, including the captain and senior officers.

As 1886 drew to a close, P&O was on the road to recovery in Suez, with an expanding and more modern fleet. P&O vessels were chartered by the British government in the winter months to transport military personnel home, and the mail and parcel contracts were performing well. P&O now turned its attention to cargo and cruising.

The line celebrated its jubilee in 1887. This event coincided with Queen Victoria's golden jubilee and to commemorate the occasion, P&O commissioned four magnificent liners. Known as the 'Jubilee Class', the fleet consisted of *Victoria*, *Britannia*, *Oceana*, and *Arcadia*. Each over 6,000 tons, these ships were around 2,000 tons larger than their predecessors. All four liners of the Jubilee Class were placed on the Admiralty's Armed Merchant Cruisers List. This meant that the ships could be called into military service at short notice, and for this service P&O was compensated £13,500 annually.

As the line continued to invest in larger, faster and more luxurious ships, the passenger experience was greatly improved. The voyage between Great Britain and India was reduced to three weeks, and Australia was just forty-four days' travel. To further improve comforts, passengers could avoid the often rough and unpleasant Bay of Biscay by transiting the English Channel, then taking a P&O train across France to Marseilles. Here they would board the ship, and make the onward journey, avoiding what could often be some of the worst weather.

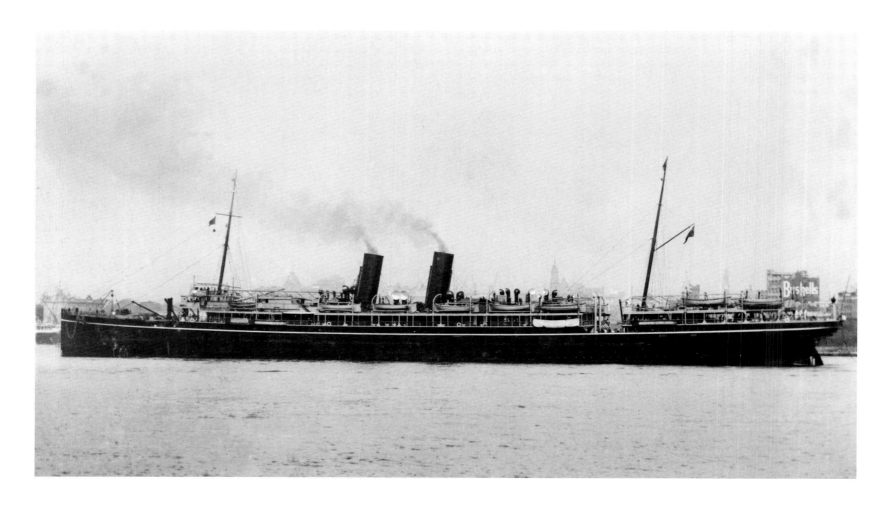

P&O was also pursuing a programme of retrofitting triple-expansion engines to its existing fleet. All new builds since 1884 had been fitted with this technology, but the older tonnage was updated over a period of many years.

In 1891, the steamer *Rome* was damaged when a fire erupted on board, while she was laid up being lengthened and having her machinery upgraded. The fire was serious, and it destroyed most of the accommodation, which had to be rebuilt, delaying her re-entry into service and causing disruptions to the refurbishment schedule.

Egypt 1897–1922, 7,912 gross tons. A great port side view of the *Egypt* in Sydney Cove. *Egypt* was the third steamer in the 'India' class and spent most of her career in Indian waters, making only four return voyages to Australia. *Egypt* was lost in the Channel when she collided with the steamer *Seine*, at the time she was carrying over a £1 million worth of gold and silver bars. (State Library of New South Wales.)

7
CARGO

As the nineteenth century drew to a close, P&O was itself an expanding empire. The line had become essential to the ongoing success of the British Empire and was operating voyages around the world, including to Egypt, India, Japan, Singapore, Hong Kong, China and Australia, as well as connecting to services for ports in America and New Zealand.

In 1892, P&O suffered embarrassment in Hong Kong, when the line's agent was arrested for forgery and the embezzlement of approximately £20,000. He was sentenced to six years' penal servitude, and P&O were forced to hire a new agent.

This embarrassment was overshadowed by the loss of the *Bokhara* that same year. The ship was sailing in the China Sea and was sunk during a cyclone. She had departed Shanghai on 8 October with a substantial cargo, including bales of silk, chests of tea and over £200,000 in specie. There was a large loss of life, including the captain and most of the Hong Kong cricket team.

1893 was also a tough year for P&O, with their Australian business brought almost to a standstill by financial disasters in the region. As always, with their business so heavily based on the conditions of the countries that they serviced, P&O were forced to endure lower than usual revenues on these services until conditions improved.

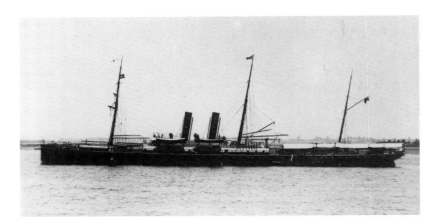

Ganges II 1882–1898, 4,196 gross tons. Five sister ships known as the 'River' class were built in 1881, principally for the Indian and Eastern services. They were *Clyde*, *Shannon*, *Thames*, *Sutlej* and *Ganges*. She was lost to a fire caused by a stewardess carelessly smoking under a mosquito net. (State Library of New South Wales)

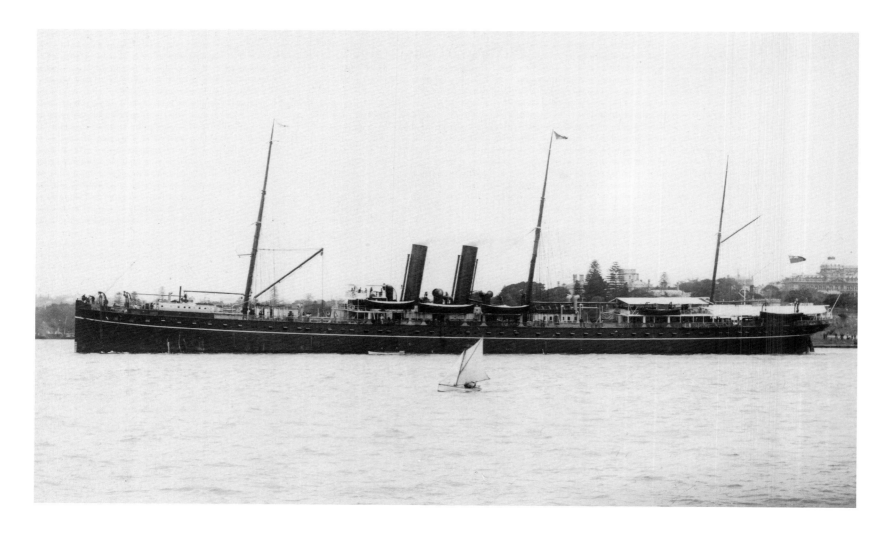

Massilia II 1884–1903, 4,908 gross tons. A sister ship to the *Valetta*, the *Massilia*, made thirty round voyage mail voyages to Australia, and cemented herself as a great favourite with the travelling public. She was in Sydney when requisitioned by the Admiralty as an armed cruiser in 1885, during a period of diplomatic tension with Russia. (State Library of New South Wales)

• DID YOU KNOW? •

The name *Ballaarat* is not a typo. P&O chose to name their first ship of this name with this unique spelling. A new *Ballarat* was placed into service in 1911 with the more traditional spelling.

During 1895, the P&O steamers *Coromandel* and *Manila* were chartered by the British government for the Ashanti Expedition, the third and final conflict in the Yaa Asantewaa War. The P&O vessels brought British troops and provisions to the west coast of Africa. *Coromandel* served as a transport and a hospital ship. *Manila* was usually a cargo ship, although she did carry thirty passengers. During the conflict, she became a transport. This chartering allowed for further government funds to be channelled into P&O's coffers.

P&O's services had often relied on a mail subsidy to remain profitable, as well as carrying limited cargo in the extra space aboard their vessels. As the shipping routes became more reliable, and the ships themselves more economical, P&O's directors were keen to invest further in the

burgeoning cargo market. To this end, the first ever purpose-built P&O cargo ship, *Candia*, was launched in 1896. Built by Caird & Co. Ltd, in Greenock, the ship was 6,482 gross tons and had a cargo capacity of 12,257 cubic metres (432,921 cubic feet). Crewed by ninety-nine men, she was a vast departure from P&O's previous ships as she was designed to carry no passengers. *Candia* also came with a substantial price tag, costing £83,495. She was employed on the Australian service and was joined by further cargo carriers in the coming years as P&O diversified its operations.

A plague and famine in India during 1897 resulted in serious financial implications for P&O. A marked drop in trade due to the horrific effects of disease on the local population meant the P&O services were significantly

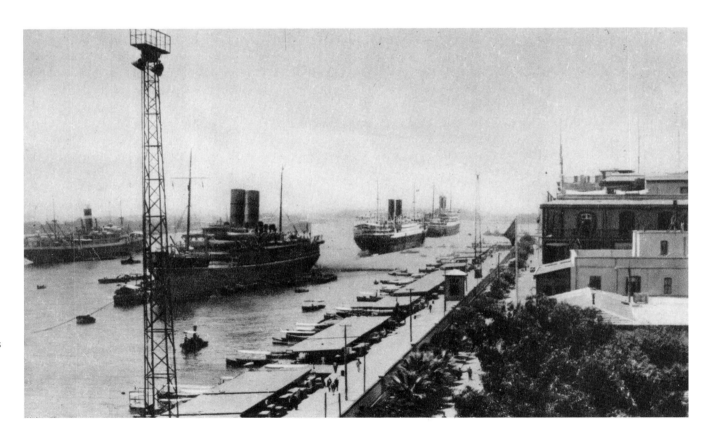

A rare photograph of the *Mooltan II* at anchor in Port Said. Astern of her are the Orient Line's 1911 *Orama* and the Messageries Maritimes' 1915 *Athos*. (Orient Heritage Collection, 10345-RCH/ Henderson & Cremer)

underutilised, putting their viability at risk. This year was further marred by the loss of the *Aden* while en route from eastern ports for London. The ship had stopped off at the Island of Socotra, and drifted on to rocks during rough seas. This resulted in three lifeboats being swamped and a total of seventy-eight lives were lost. The surviving forty-six people remained on board the wrecked *Aden* for eighteen days before being rescued.

Between 1899 and 1900, twelve P&O ships were employed for varying periods as troop transports for the British war effort in South Africa. The Boer War took a considerable toll on the British military, resulting in a number of reserves being sent in via P&O steamer.

In 1900, troops were sent from India to China during the Boxer Rebellion. P&O ships were chartered again to operate these trooping services, as the British military pressured the Chinese government to open up opium trades with the west. By December 1902, P&O had transported 150,000 troops to China and Africa as part of their military contracts. While the African conflict drew to a close in 1902, ongoing issues between China and Great Britain would endure for years to come.

That same year, P&O found themselves embroiled in a legal challenge over the pay and conditions of their Indian employees. The Indian Acts relating to 'Lascars', or Indian sailors, were a series of legal battles, which explored the rights of Indian crew, and the responsibilities of British ship owners. At that time, Indian sailors were afforded lower wages, less desirable living conditions and fewer provisions aboard passenger ships than their European counterparts. In Britain, an argument arose that, due to the British registry of the P&O fleet, Indian crew should come under the British employment acts, rather than those of India. Shipping lines, including P&O, argued that

the Indian crew, being of Indian citizenship, would fall under Indian labour laws, and they vigorously defended this position for fear of having increased costs if forced to pay Indian employees the same rates as those in Britain.

P&O faced further financial strain in 1900, when the British government changed the income tax laws relating to the depreciation of seagoing vessels. Traditionally, depreciation on ships was set at 5 per cent per annum, based on the original cost of the ship. Thus, over a twenty-year period, the ship was written off, reducing the asset value of the company.

In 1900, a change to a 6 per cent 'diminishing value' system meant write-offs were reduced to 6 per cent per annum of the value of the vessel at that time. Thus, it was impossible to write off the total value of the ship. This caused great upset for not only P&O but also other shipping owners. These organisations came together to lobby the government to reinstate the traditional system. That same year the government relented, with a caveat that the depreciation rate would be reduced to 4 per cent. Thus, it now took twenty-five years to fully depreciate a ship.

Having spent £8½ million on new tonnage over the past twenty years, by the turn of the twentieth century, further diversification was on the agenda for P&O. Cruises in the form of the Grand Tour to Mediterranean ports and Egypt had long been offered; however, the company now looked to invest in year-round cruising. To this end, *Rome* was pulled from service and refurbished. Marketed as a 'cruising yacht', she was renamed *Vectis* and set about establishing cruising itineraries. These early voyages, which commenced in 1904, included such destinations as Norway, the Baltic, the Canary Islands and the Adriatic Sea.

Cruising proved popular for the line and as a result, P&O sent some of their other liners cruising during the off-season, employing them on pleasure voyages across the P&O network.

8

CRUISES & CONFLICTS

Generally considered the first trans-continental war of the twentieth century, the bloody Russo-Japanese War engulfed the oceans around key P&O trading ports. During 1904, the Russian cruiser *Petersburg* seized two P&O vessels while they were in regular merchant service. *Malacca* and *Formosa* were accused of carrying munitions to Japan, and while the *Formosa* was released quickly, owing to British government intervention, *Malacca* was held captive from 13 July to 27 July 1904. On her release she was taken to Suez under a Russian flag and crew, where she was returned to P&O. In response to this event P&O demanded restitution to the sum of £25,000.

The high-profile nature of this incident meant that companies in Europe lost faith in P&O's ability to transport cargo safely. This resulted in a loss of forward bookings for P&O, making the services to Japan and the surrounding area unviable. As a result of this action, P&O suspended services to Japan. Although P&O were eventually awarded £10,000 in compensation from the Russian government via the Foreign Office for the *Malacca* incident, this sum failed to compensate for the considerable losses suffered from the reduction in cargo services, as well as the ongoing damage to P&O's reputation in the region.

In 1906, P&O commenced a programme of adapting some of their larger cargo steamers into refrigerated cargo vessels. Refrigerated chambers were first installed on P&O mail ships in 1883. These refrigeration chambers were for passenger provisions, and eliminated the need for the carriage of livestock aboard. By now widely adapted for passenger use, the move by P&O to offer refrigerated cargo spaces was one of the first major pushes into refrigeration technology on a mass cargo scale. Refrigerated cargo could be carried at higher prices and this meant greater revenue for P&O.

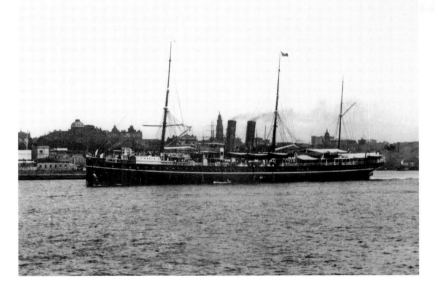

Valetta II 1884–1903, 4,911 gross tons. The *Valetta*, along with her sister *Massilia II*, was designed for the Australian and Eastern services. To *Valetta* goes the distinction of being the first P&O ship to be fitted with electric light, albeit in parts of first class only. *Valetta* was used as a transport during the Boxer Rebellion in 1900, and made thirty-three return voyages to Australia between 1884 and 1897. (Orient Heritage Collection, RCH008/Henderson & Cremer)

• DID YOU KNOW? •

Malaca served as a hospital ship for the Benin Expeditionary Force in 1897.

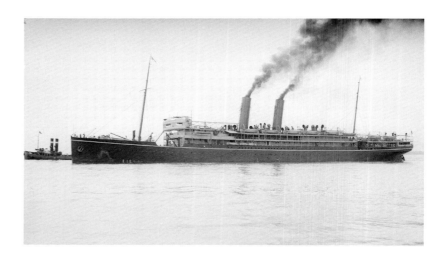

Marmora 1903–1918, 10,509 gross tons. The third of the 'M' class ships designed for the Australian service, the *Marmora* made twenty-four return voyages to Australia between 1904 and 1914. Serving in the First World War as an armed merchant cruiser, the *Marmora* was off the south coast of Ireland when she was torpedoed and lost on 23 July 1918. (The Pictures Collection, State Library of Victoria)

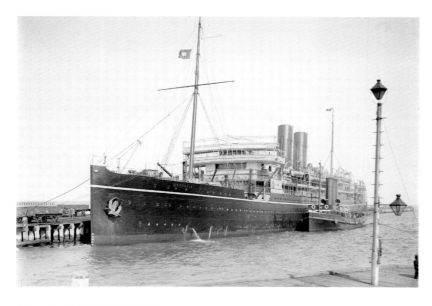

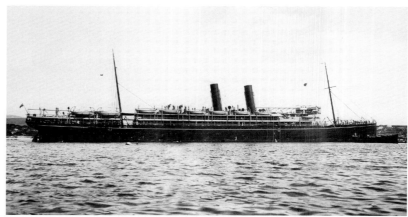

Mongolia II 1903–1917, 9,505 gross tons. The *Mongolia* was the second liner of the famous 'M' class of steamers, built by P&O between 1903 and 1911 for the Australian service. In June 1917, when approaching Bombay, the *Mongolia* was lost when she struck a mine laid by the *Raider Wolf*. Despite the fact that she sank quickly, efficient and constant boat drills enabled all but twenty passengers and crew to survive. (The Pictures Collection, State Library of Victoria)

Macedonia 1904–1931, 10,552 gross tons. A popular ship in the Australian service before the First World War, but after the war she served mostly in Indian and Eastern waters. (Orient Heritage Collection, P&O_273-RCH/Henderson & Cremer)

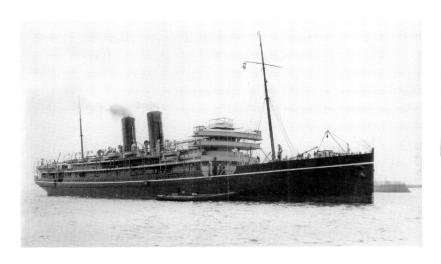

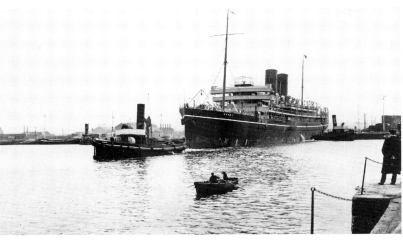

Morea 1908–1930, 10,890 gross tons. The striking *Morea* was considered the best-looking of the 'M' class. Throughout her career she retained a faithful following, particularly in the Australian service. (Orient Heritage Collection, RCH018/Henderson & Cremer)

During the First World War the *Morea* served in various capacities, from an Australian hospital transport to an armed merchant cruiser in the south Atlantic. (Orient Heritage Collection, 10890-RCH/Henderson & Cremer)

• DID YOU KNOW? •

In 1899 *Formosa* served as a troopship in the Boer war, and in 1900 was used for trooping to China.

An intriguing view of *Morea*'s bridge, taken from the fo'c'sle whilst transiting the Suez Canal. (Orient Heritage Collection, 10033-RCH/Henderson & Cremer)

In 1907, P&O commenced a cadetship programme aboard the *Worcester* training vessel with the view to training officers for the line. The continually changing and evolving nature of the ocean trade meant many changes for P&O, one of which was the need to find a new way of training officers. Previously, crewmembers had been trained aboard sailing vessels, working their way through the ranks to the level of junior officer. In the twentieth century, fewer sailing ships meant a new approach was needed. With the new programme, potential cadets underwent a test to determine their suitability and then training was undertaken aboard *Worcester*, before junior officers were sent to sea aboard regular steamers.

Throughout 1907, P&O's directors were preoccupied by a British government review of mail services and this led to an increase in expectations relating to the performance and speed of the P&O fleet, while the subsidy was reduced.

P&O's 5,800 gross ton *Salsette* was completed in 1908. Intended as an express mail steamer to operate between Aden and Bombay, she was initially sent on two cruises due to a lack of demand for line voyages on this route. These voyages took passengers to the northern capitals of Europe, as well as to the Dalmatian Coast.

Marconi wireless was first installed aboard P&O's liners in 1909. Invented by Italian scientist, Guglielmo Marconi, this system allowed vessels to

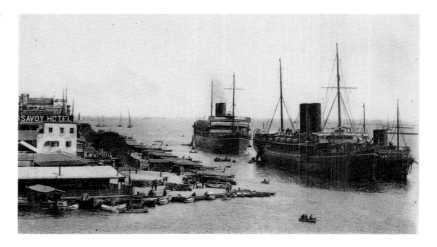

A rare image of three P&O mail ships together at Port Said. The *Mantua* standing astern of the *China II*, with one of the twin sisters, either *Osiris* or *Isis*, alongside the *China*. The twins were small express steamers built to carry the mails from the overland express train at Brindisi to the larger mail ships at Port Said en route to Australia, India or the East. (Orient Heritage Collection, 10885-RCH/Henderson & Cremer)

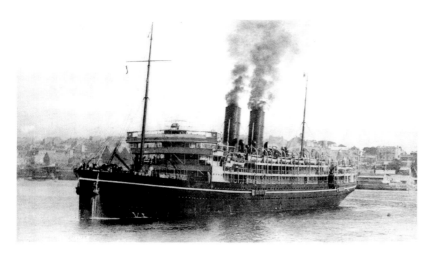

Mantua 1909–1935, 10,885 gross tons. An early image of the *Mantua* departing Sydney, believed to be *c.* 1910. (Orient Heritage Collection, RCH021/Henderson & Cremer)

communicate with land-based stations, as well as each other, utilising a radio signal known as Morse code. The first P&O ship to have wireless was *Mantua*; however, during the next few years the system was adopted for all P&O liners. The system had a range of 250 miles (402km) and was very popular with passengers, who were constantly sending messages.

P&O acquired the Blue Anchor Line in 1909. Blue Anchor Line had been operating services to Australia via the Cape of Good Hope since 1869. The purchase included the line, its fleet and the goodwill of the company, and the company was renamed the P&O Branch Line. New vessels were ordered for use on the P&O Branch Line routes. These ships, which were the first P&O vessels to carry third-class passengers, were of 11,000 gross registered tons, and replaced older tonnage on the same service. The first was *Ballarat* in 1911; followed in 1912 by the *Beltana*; *Benalla* in 1913; and the *Berrima* and *Borda* in 1914. They set the pattern of naming all Branch Line ships starting with the letter 'B' after Australian country towns and proved both popular and profitable for the line.

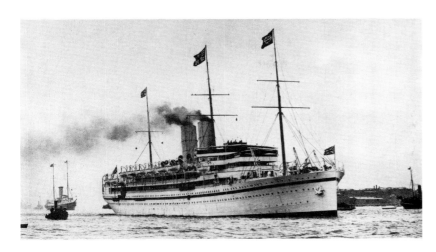

His Majesty's Yacht *Medina* departing Portsmouth in November 1911, with the King and Queen on board bound for Bombay. Painted white with a broad blue band around the hull, the *Medina* was fitted with a special mast, just behind the bridge, to conform to the defined style of flying royal flags. (Orient Heritage Collection, 10336-RCH/Henderson & Cremer)

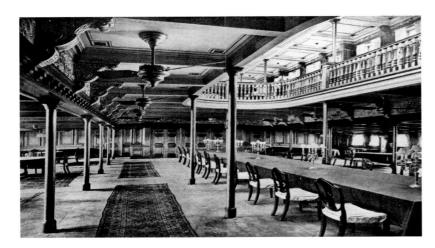

The state dining room, on board HMY *Medina* taking King George V and Queen Mary to the Delhi Durbar in 1911. (Orient Heritage Collection, RCH025/Henderson & Cremer)

A great honour was bestowed upon P&O in 1911 when their 12,350 ton vessel *Medina* was chartered to take the newly crowned King George V and his wife Queen Mary to Delhi for the Durbar. The ship was refurbished as HMY *Medina*. She was re-masted, painted white with a broad blue band around the hull, and her interior was changed to reflect her new duty as His Majesty's Yacht. She sailed from Portsmouth on 11 November 1911 under escort from the cruisers *Argyll*, *Natal*, *Cochrane* and *Defence* and arrived at Bombay on 2 December. *Medina*'s sister ship, *Maloja*, was sent on a special passenger trip, following *Medina* to India with travellers aboard who wished to observe the king and queen during their tour. The voyage attracted fewer passengers than expected, owing to scarcity of accommodation in Delhi.

Towards the end of that year, dock strikes in London led to P&O vessels being unable to load and unload cargo, bringing the services to a halt, while on a more positive note, in New Zealand, a branch line was established connecting Auckland with Sydney, Australia.

During the 1912 board meeting, the directors discussed the loss of two liners, *Delhi* and *Oceana*. *Delhi* had run aground in fog off the coast of Cape Spartel, Morocco, in November 1911. She was, at the time, carrying the Princess Royal and her husband the Duke of Fife as well as their daughters. Having sent distress calls using the newly installed wireless, she received aid from royal naval vessels, HMS *Duke of Edinburgh* and HMS *London*, and passengers and crew along with baggage and mail were successfully retrieved.

Also in 1912, *Oceana* had collided with the German barque *Pisagua* off Beachy Head. Despite the efforts of the pilot and officers, including the use of watertight doors, the ship foundered, with an unfortunate loss of life. She was on a voyage to Bombay with a cargo of gold and silver bars worth nearly £250,000.

The year 1912 turned out to be a difficult one for P&O on more than one front. Adding to the loss of *Oceana*, a coal strike in March and April was followed by a transport workers' strike in June and July. Then, in October 1913, an officers' strike added further strain to an already damaged industry, resulting in the failure of a number of smaller, less profitable competitors. The strike was eventually settled at a cost to P&O of £20,000 annually. Sir Thomas Sutherland, presiding at a meeting of P&O, referred to the recent strike of officers by saying that he regretted that officers and gentlemen had resorted to the methods of workmen in recently enforcing their demands by 'downing tools'. The strike, he declared, was 'a beautiful example of decadent manners'. The company, he added, was diminishing the slowness of promotion by retiring commanders and chief engineers earlier. Fortunately, P&O's size and scale allowed it to survive these turbulent years.

A port side view of HMY *Medina* looking magnificent with her white livery and third mast, every bit a long, sleek greyhound of the sea. (Orient Heritage Collection, P&O_291-RCH/Henderson & Cremer)

Benalla 1913–1930, 11,118 gross tons. The second 'B' class ship built by the P&O Branch Line, the class took their name from Australian towns beginning with the letter B. The *Benalla* made twenty-seven commercial return voyages to Australia, in addition to her wartime service as a transport. (The Pictures Collection, State Library of Victoria)

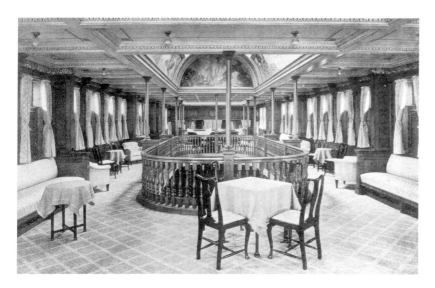

The music room on board the *Medina*, from the open well in the centre you looked down into the dining room, and above was the traditional light-filled skylight. (Orient Heritage Collection, RCH026/Henderson & Cremer)

Berrima 1913–1930, 11,137 gross tons. The P&O Branch Line was established when the company purchased Wm Lund's Blue Anchor Line in 1910, and began a programme of building ships for the purpose of carrying emigrants and cargo to Australia. The *Berrima* is one of the 'B' class Branch Line ships, unattractive perhaps, but very useful for their purpose. (Orient Heritage Collection, RCH022/Henderson & Cremer)

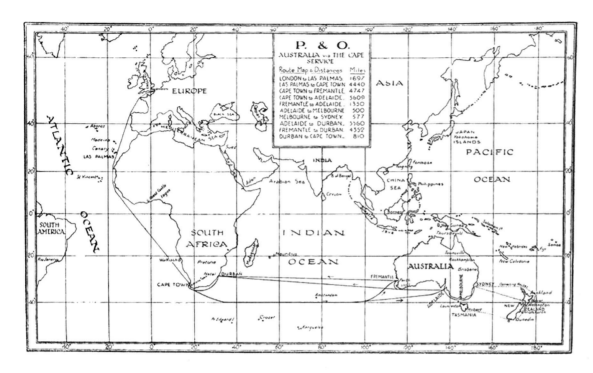

The new P&O Branch Line operated on the return route to Australia via the Cape of Good Hope. (Orient Heritage Collection, 00243-RCH/Henderson & Cremer)

Borda 1914–1930, 11,136 gross tons. An usual view of the *Borda*, built by the P&O Branch line but still showing the Blue Anchor Line funnel marking. The *Borda* made twenty-two commercial return voyages to Australia. (Orient Heritage Collection, 10278-RCH/Henderson & Cremer)

• DID YOU KNOW? •

Chess games were frequently played via the Marconi system between ships.

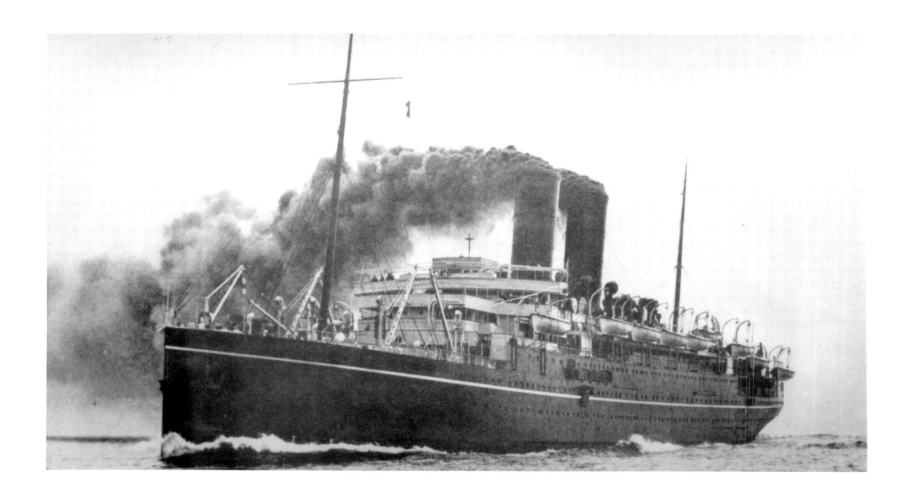

Kaisar-I-Hind II 1914–1938, 11,430 gross tons. Meaning 'Empress of India' in Hindi, the *Kaisar-I-Hind* made two return voyages to Australia during the First World War, but mainly served on the Bombay mail run. (Orient Heritage Collection, RCH027/ Henderson & Cremer)

In 1914, P&O gained a significant acquisition when it purchased the British India Company. Once major independent rivals, the two lines continued to be operated as separate entities. The shareholders of British India had their stock exchanged for P&O stock, and British India directors were appointed to sit on the P&O board to represent their interests.

At the same time, Thomas Sutherland signalled his intention to retire. At the end of 1914, despite objections from the board (who wished for Sutherland to continue as managing director and chairman), Lord Inchcape, the chairman of British India, became the new head of P&O. A self-made man and successful entrepreneur, Lord Inchcape was born James Lyle Mackay in 1852. The son of a sea captain, he had been offered a job in India in 1874 with Mackinnon Mackenzie & Co. which owned British India Steam Navigation Company. By the time he returned to London in 1893, he was the most senior figure in Mackinnon Mackenzie & Co. and was held in high esteem both in England and India. He was raised to the peerage in 1911, becoming Baron Inchcape.

1909 'Yachting Cruises' Itineraries

Cruise aboard SS *Malwa*

7 August 1909	Depart London 2.51 p.m. with 335 passengers, bound for Ymuiden
8 August 1909	Arrive Ymuiden 8.54 a.m.
	Depart Yumiden 8.07 p.m. bound for Christiania
9 August 1909	At sea
10 August 1909	Arrive Christiania 2.57 p.m.
11 August 1909	Depart Christiania 6.19 p.m.
12 August 1909	Arrive Gothenburg 6.17 a.m.
	Depart Gothenburg 6.15 p.m. bound for Copenhagen
13 August 1909	Arrive Copenhagen 5.16 a.m.
14 August 1909	Depart Copenhagen 7.39 p.m. bound for Stockholm
15 August 1909	Arrive Stockholm 5.35 p.m.
16 August 1909	Stockholm
17 August 1909	Stockholm
18 August 1909	Stockholm
19 August 1909	Depart Stockholm 7.10 a.m. bound for Cronstadt
20 August 1909	Arrive Cronstadt 9.29 a.m.
21 August 1909	Cronstadt
22 August 1909	Cronstadt
23 August 1909	Cronstadt
24 August 1909	Cronstadt
25 August 1909	Depart Cronstadt 9.13 p.m. bound for Tilbury, London
26 August 1909	At sea
27 August 1909	At sea
28 August 1909	At sea
29 August 1909	At sea
30 August 1909	Arrive Tilbury, London 8.32 a.m. Disembark passengers

Cruise aboard SS *Vectis*

25 September 1909	Depart Marseilles 4.30 p.m., with 114 passengers, bound for Palermo
26 September 1909	At sea
27 September 1909	Arrive Palermo 6.45 a.m.
	Depart Palermo 6.30 p.m. bound for Catania
28 September 1909	Arrive Catania 6.55 a.m.
	Depart Catania 6.50 p.m. bound for Smyrna
29 September 1909	At sea
30 September 1909	At sea
1 October 1909	Arrive Smyrna 6.55 a.m.
	Depart Smyrna 6.10 p.m. bound for Constantinople
2 October 1909	Arrive Constantinople 3.55 p.m.
3 October 1909	At sea
4 October 1909	At sea
5 October 1909	Depart Constantinople 5.45 a.m. bound for Mudania
	Arrive Mudania 8.55 a.m.
	Depart Mudania 8.40 p.m. bound for Piraeus
6 October 1909	At sea – pass the Dardanelles
7 October 1909	Arrive Piraeus 6.05 a.m.
8 October 1909	Piraeus
9 October 1909	Depart Piraeus 6.00 a.m. bound for Kalamaki
	Arrive Kalamaki 8.25 a.m.
	Depart Kalamaki 6.30 p.m. bound for Nauplia
10 October 1909	Arrive Nauplia 6.05 a.m.
	Depart Nauplia 6:30 p.m. bound for Naples
11 October 1909	At sea
12 October 1909	At sea
13 October 1909	Arrive Naples 5.40 a.m.
14 October 1909	Depart Naples 6.10 p.m. bound for Marseilles
15 October 1909	At sea
16 October 1909	Arrive Marseilles 5.50 a.m. Disembark passengers

9

THE GREAT WAR

With the outbreak of the First World War, on 18 July 1914, Britain, Europe and the world were ushered into the most horrific and bloody conflict ever seen at that time. The British Admiralty commandeered nearly half of the P&O fleet for use in the conflict. The ships were employed as armed merchant cruisers, hospital ships and troop transports.

By 1915, thirty-one P&O ships were in government service. With a good portion of their fleet out of regular service P&O were faced with a series of significant issues that needed to be addressed. Firstly, the lack of ships available to P&O meant that the mail contracts were under strain. Despite requestioning their ships for military use, the government still expected P&O to maintain the mail services, which was near impossible given the lack of vessels at their disposal. Slower steamers were placed on the mail service to pick up the slack; however, in 1917 the mail system collapsed due to a lack of available ships to service the network.

A significant reduction in income was caused by the collapse of the freight market during the war years. This issue was twofold: firstly, there was a worldwide reduction in freight demand, while for P&O even the reduced demand was difficult to manage due to the lack of tonnage. Thus, even those ships still employed in regular service were sailing with emptier holds than usual, as they were unable to service the required number of ports to fill the holds aboard. To add to this issue, costs skyrocketed. A shortage of coal, which had been redirected to the

war effort, meant that fuel costs were significantly higher than usual. Wages increased, largely due to the 'danger pay' mandated for crews sailing into waters affected by the war. P&O were also struggling with costs incurred from the delays in loading and unloading of cargo due to understaffing at the docks, while 'war insurance' premiums were sucking more than £250,000 from the company's bank account each year!

On 8 August 1915, P&O's *India*, which was in use as an armed merchant cruiser, was sunk off the coast of Norway by *U-22* (a German submarine). A government crew was operating the 7,900 gross ton vessel, and her sinking resulted in a significant loss of life.

It wasn't just the ships in government service that were in danger, though – in 1915, the *Nile* and *Nubia* both sunk whilst in merchant service. The 5,914 ton *Nubia* ran aground less than a mile from Colombo, while the 6,694 ton *Nile* collided with rocks in the Inland Sea of Japan, while en route to Kobe.

The ongoing strain on P&O was exacerbated by the line's inability to replace lost tonnage. They had two mail steamers laid down at British shipyards, but work on these ships had been put on hold due to military contracts having automatic priority during the war. They sat, slowly rusting, until work recommenced with the 15,825 ton *Naldera*, launched as a troopship in December 1917 at the yards of Caird & Co., at Greenock. Her sister ship, which was built by Harland & Wolff in Belfast, was the *Narkunda*. She was eventually launched in April 1918, but did not enter P&O service until 1920.

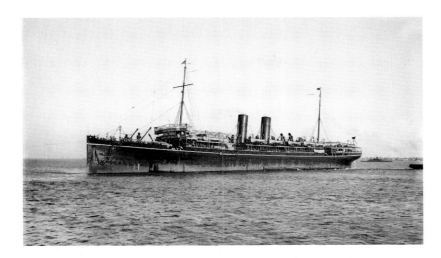

India II 1896–1915, 7,911 gross tons. The first of a new class of ship built between 1896 and 1900 were the sisters, *India II*, *China II*, *Egypt*, *Arabia* and *Persia*, constructed for the Indian and Australian trade. The class were the last single-screw steamers built by P&O. Serving as an armed merchant cruiser in the First World War, the *India* was lost in August 1915 when torpedoed by *U-22* near Bodo, Norway. (The Pictures Collection, State Library of Victoria)

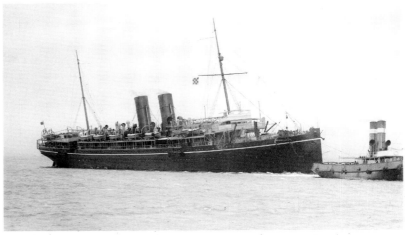

Arabia 1898–1916 and her sisters *India II*, *China II*, *Egypt*, and *Persia* were built between 1896 and 1900 for the Indian mail and passenger service. *Arabia* made three return voyages on the Australian service during the First World War, but was lost on her last return voyage when torpedoed off Greece on 6 November 1916. Her sinking brought outrage from America and an exchange of correspondence with Germany. (The Pictures Collection, State Library of Victoria)

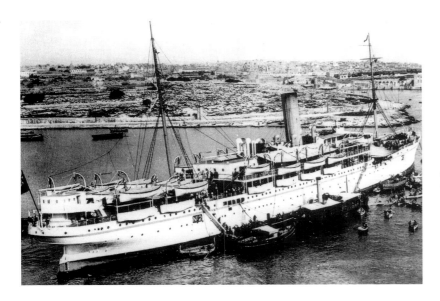

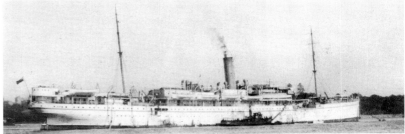

Above: A fine view of the *Dongola* in Sydney Harbour. She made two return voyages to Australia, one in 1919 and the other in 1925. (Orient Heritage Collection, RCH014/Henderson & Cremer)

Left: *Dongola* 1905–1926, 8,038 gross tons. The *Dongola* was one of four sisters launched in 1905, along with *Delta III*, *Delhi II* and *Devanha*. *Dongola* was the second launched and she was used principally in Indian and eastern waters and for seasonal trooping. (Orient Heritage Collection, RHC020/Henderson & Cremer)

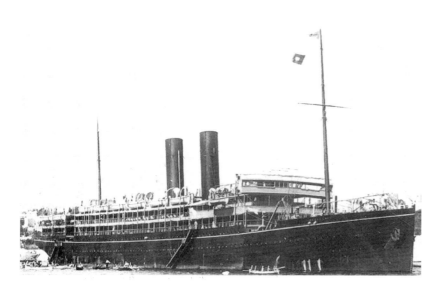

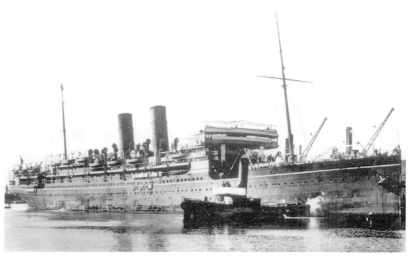

Macedonia 1904–1931, 10,512 gross tons. The fourth ship of the 'M' class, and a close sister to the *Marmora*, rather than the first two 'M' class ships. *Macedonia* made twenty-one return voyages on the Australian service between1904 and 1913, and served throughout the First World War as an armed merchant cruiser. (Orient Heritage Collection, RCH016/Henderson & Cremer)

Mooltan II 1905–1917, 9,621 gross tons. The fifth 'M' class ship served on both the Indian and Australian services. In the First World War the *Mooltan* remained in the mail and war service, and in July 1917, en route for Marseilles at the end of an Australian voyage, she was torpedoed by *UC-27* and sank south of Sardinia. (Orient Heritage Collection, RCH024/Henderson & Cremer)

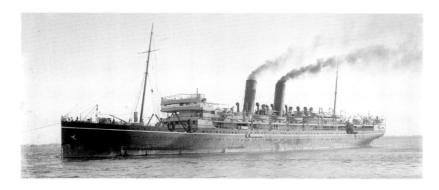

Mooltan II. P&O ships have long had a distinguished association with the famous – in 1908 the *Mooltan* carried the Empress Eugenie to Colombo and back. In 1911 she carried P&O guests to the coronation Review of the Fleet at Spithead and, at the start of the First World War in 1914, she carried Lord Kitchener and his staff to Port Said. (The Pictures Collection, State Library of Victoria)

As the war escalated, the Admiralty took up four further ships, leaving P&O in a dire situation, Under the leadership of Lord Inchcape, the line looked outside of Europe for opportunities to grow new revenue. As such, in 1916 P&O acquired almost all of the ordinary shares of the New Zealand Shipping Company. The next year, the Union Steamship Company of New Zealand was added to the fold while, in a joint venture with the British India Steamship Company, the line purchased the Hain Steamship Company, with British India purchasing the Nourse Line.

By the end of the war, P&O had lost twenty-five steamers, with a combined tonnage of 186,703 tons. These losses were attributed to enemy action, as well as 'other causes' associated with the conflict. Worse still was the loss of 258 P&O staff who had worked on both the land and at sea.

In November 1919, twelve of P&O's ships remained under government requisition, and P&O was already planning new passenger steamers. These new ships were to burn oil, rather than coal, and included those already laid down during the war years.

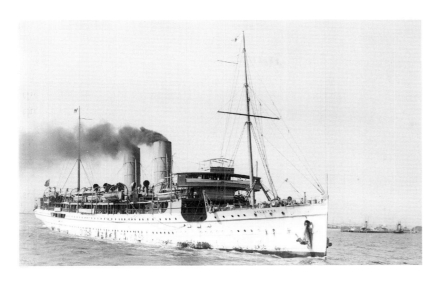

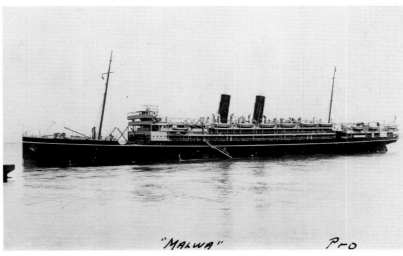

Salsette II 1908–1917, 5,842 gross tons. In her time she was the fastest ship in the fleet, and believed to be the finest looking. She was built for the express Aden–Bombay service, and *Salsette* made two return voyages to Australia during the First World War when the growing loss of ships brought her into the service. (The Pictures Collection, State Library of Victoria)

Malwa II 1908–1932, 10,883 gross tons. Another of the popular 'M' class ships on the Australian mail service, in which she made thirty return voyages. During the First World War she had three encounters with submarines and torpedoes and survived. (Orient Heritage Collection, 10031-RCH/Henderson & Cremer)

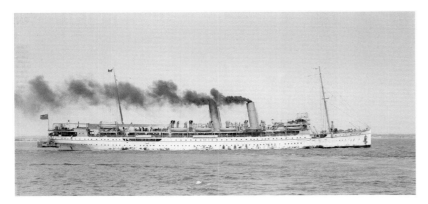

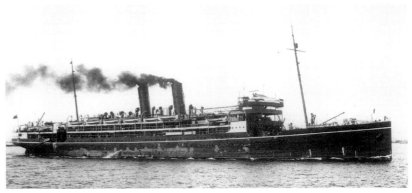

Salsette II showing all her attributes of fine design, in Port Phillip Bay in 1917 on her second and final Australian voyage. In July of that year she was torpedoed by *UB-40* and lost in the English Channel. (The Pictures Collection, State Library of Victoria)

A fine starboard view of the *Malwa*. (Orient Heritage Collection, RCH019/Henderson & Cremer)

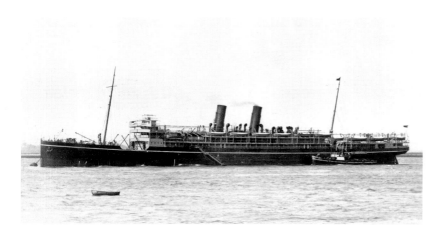

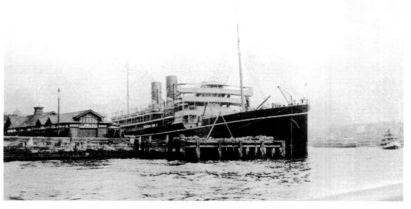

Mantua 1909–1935, 10,885 gross tons. The longest serving of the 'M' class ships, the *Mantua* had an eventful career which included many cruises in northern waters and only eleven return voyages to Australia. She served throughout the First World War as an armed merchant cruiser. (Orient Heritage Collection, 10035-RCH/Henderson & Cremer)

Maloja 1911–1916, 12,431 gross tons. The penultimate ship in the 'M' class, *Maloja* was designed for the Australian mail service, in which she made twelve return voyages. The *Maloja* was taken over by the Admiralty in 1911 to accompany her sister ship *Medina* to the Delhi Durbar in 1912. In February 1916, the *Maloja* had just started from London on a voyage to Bombay when she struck a mine off Dover and sank with a great loss of life. (Orient Heritage Collection-RCH030/Henderson & Cremer)

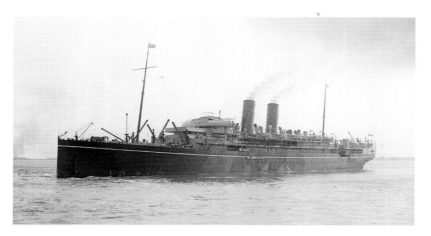

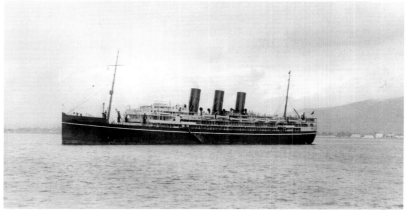

Medina 1911–1917, 12,350 gross tons. Majestic *Medina* was the last built steamer of the 'M' class. In 1911 she was taken over by the Admiralty and commissioned into the Royal Navy as HMY *Medina*, and converted to carry King George V and Queen Mary to the Durbar in Delhi. (The Pictures Collection, State Library of Victoria)

Naldera 1920–1938, 15,825 gross tons. Ordered by the company in 1913, the *Naldera* was not completed until 1918 as a troopship, and eventually entered commercial service in 1920. (Orient Heritage Collection, 10061-RCH/Henderson & Cremer)

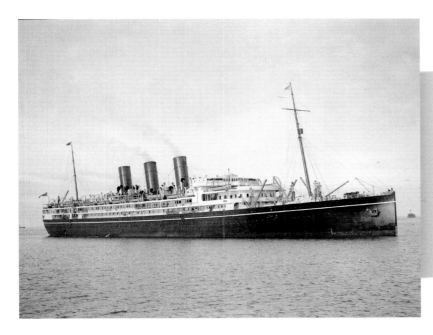

Narkunda 1920–1942 16,227 gross tons. As with her sister ship *Naldera*, the *Narkunda* was ordered before the First World War, but did not enter commercial service until 1920. (The Pictures Collection, State Library of Victoria)

Don't miss the post!

In Australia, fast trains to connect with the British-bound steamer at either Melbourne or Adelaide carried the last mail for the return service. At the major ports of call, connections were made with other P&O ships to pass mail onto the returning vessel. Trans-shipments occurred at Marseilles, where mail was transferred to the same mail vans that brought the mail from London, for the Australia-bound P&O steamer. In this manner, the mail sent by rail from Marseilles would arrive in London at least one week before the ship's arrival.

Throughout 1918 P&O acquired a controlling interest in the Orient Line. The Orient Steam Navigation Co. (Orient Line) was formed in 1877, for the purpose of trading on the Australian route using fully powered steam ships. The Orient Line was the first major rival to P&O on the Australian services, which led to the two companies forging a partnership in 1919, to reduce direct competition between the lines. Realising the popularity of Orient Line in the trade, P&O continued to allow Orient Line to operate as a separate entity.

During 1919, the Khedivial Mail Company was added to the portfolio. Like the Orient Line, it continued to be run as a separate business.

In 1920 P&O acquired a controlling interest in the General Steam Navigation Company, which they also ran as a separate concern, while the line

• DID YOU KNOW? •

In the earlier years of carrying mails, an Admiralty agent was attached to all the contracted mail ships. His was the responsibility of ensuring that the ships carrying the mails adhered to the contracted times and schedules.

further diversified by establishing the P&O Bank. As the world recovered from the war years and entered the early years of the roaring twenties, P&O began to recover from what had been one of the most strenuous periods in its history. That same year, P&O acquired eight ships from the British government. Ranging in size from 1,500 tons to 8,000 tons, the acquisitions included *Peshawur*, *Lahore*, *Nagpore*, *Alipore*, *Jeypore*, *Kidderpore*, *Redcar* and *Eston*, and several former German liners that had been confiscated by the British government.

By this time, *Assaye* was the only vessel remaining under full government control, with the *Egypt* and *Macedonia* still being reconditioned by the government. Each of the ships returned to P&O required extensive, lengthy and costly refurbishment before they could return to regular

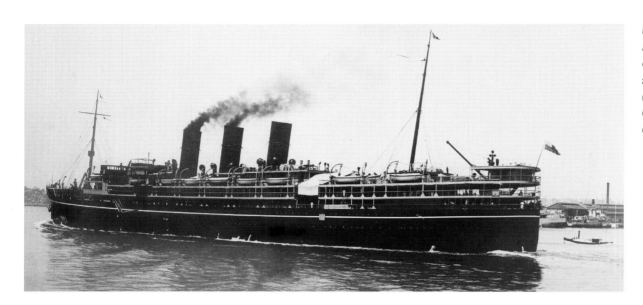

Narkunda 1920–1942, 16,227 gross tons. An interesting view of the *Narkunda* departing her Pyrmont berth in Sydney at the start of another of her fifty-five mail voyages to London. (Orient Heritage Collection, 10012-RCH/Henderson & Cremer)

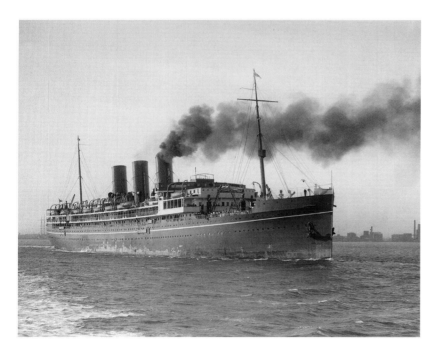

The *Narkunda* in Port Phillip Bay. (The Pictures Collection, State Library of Victoria)

service, and by the end of 1920, only five of their fleet had been refurbished, due largely to a shortage of materials and a bottleneck at shipyards. By the end of 1921, all of the surviving mail ships were back in P&O service.

P&O suffered a post-war loss two years later, when the *Egypt* sank in the English Channel. The 7,900 ton liner had been sailing in fog off the island of Ushant when she collided with the French steamer *Seine*, with a loss of eighty-six passengers and crew. The *Seine* had an ice-strengthened bow and the impact of her ramming the *Egypt* was so serious that *Egypt* sank within twenty minutes. She was carrying £1.1 million in gold and silver bars, which resulted in an extraordinary salvage operation to recover the treasure.

P&O embraced the turbine engine with the introduction of *Moldavia* in 1922. Delivered on 19 September, the 16,534 gross ton liner was able to carry 237 first-class and 525 second-class passengers, as well as 708,311 cubic metres of cargo. *Moldavia* was originally ordered in December 1916, but had been placed on hold due to the war. She was followed by the 16,385 ton *Mongolia* in April 1923, the 20,847 ton *Mooltan* in September 1923 and the 20,837 ton *Maloja* in October 1923. All four ships were used primarily on the Australian mail service, with occasional cruising in northern and Australian waters.

It wasn't until 1923 that the P&O mail service was back to normal. Even so, on the Australian section of this service, the two-weekly P&O schedule had to be rearranged to a four-weekly service, with the subsidiary, Orient Line, operating alternating four-weekly services.

ROARING TWENTIES AND GREAT DEPRESSION

By 1925, the operating environment was looking good for P&O. The fleet was now well and truly being revitalised, which included the construction of four new vessels for the P&O Indian mail and passenger service. Named *Rampura*, *Ranchi*, *Rawalpindi* and *Rajputana*, the 16,651 gross ton ships were built with small refrigeration chambers for the conveyance of fresh fruit, fish and other produce. All four ships were constructed for the Indian mail service, with occasional cruising from Britain. Later in the decade, as new ships came into service and included Bombay in their Australian voyages, the four ships were used on the eastern service.

That same year the *Cathay*, *Comorin* and *Chitral* were introduced on the Australian service. Custom-built for this long voyage, the inclusion of these ships on the service to Australia improved P&O's position there, and allowed for the restoration of the fortnightly services which had ceased during the war. The new 'C' class liners were faster than the ships they replaced, and allowed the company to include Bombay on the Australian service.

However, progress was slow, with an unofficial strike in Australia resulting in serious financial losses. Adding to this was unrest in China, owing to the beginning of an anti-foreign movement in Shanghai. While homeward trade from India was picking up, the tariffs were not generating sufficient returns, making this route financially strained. In further efforts to reduce operating costs, P&O stepped up its programme to convert their liners to burn oil.

> ● **DID YOU KNOW?** ●
>
> The *Strathmore* was launched by HRH the Duchess of York, who later became Queen Elizabeth the Queen Mother, and the name *Strathmore* was derived from the Duchess' father, the Earl of Strathmore.

Narkunda was converted to oil in 1927, while *Mongolia* and *Moldavia* were converted in 1928.

Cruising became more important to the line during the 1920s, particularly in light of the issues being faced in other sectors of the business. The 1920s and 1930s saw a big growth in the number of passengers cruising. However, to a great extent, cruising still remained the preserve of a select few. First class was by far the predominant class for cruise passengers, although from the 1930s tourist class was offered on select ships. The *Ranchi* completed six cruises to the Mediterranean and North Sea ports in the 1926 summer, which were noted as being 'very successful' in the 1926 board meeting. The success of these voyages saw *Ranchi* continue to be used for cruises from 1926 to 1929, during the summer months.

P&O committed to a 19,648 gross registered ton liner, *Viceroy of India*, in 1927. This passenger ship, delivered in early 1929, utilised the revolutionary turbo-electric power plant, which offered many benefits over traditional steam engines. There was no need for complex gears, and it was also able to provide electricity direct to the vessel's hotel services. In addition, she used twenty fewer engine-room crew than an oil-burning ship of comparable size, and 100 fewer crew than a coal-burning ship. Her accommodation was unique too, as all cabins were single berth with interconnecting doors and extra accommodation for the servants who often travelled with passengers.

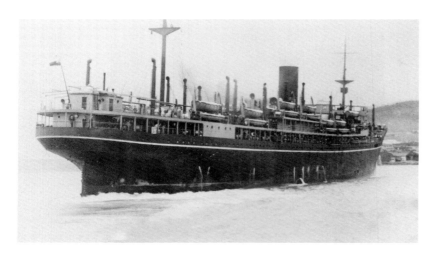

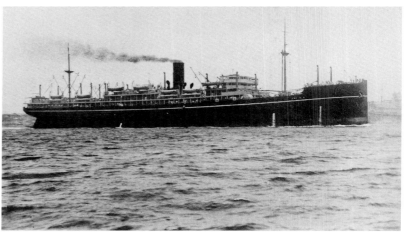

Barrabool 1922–1936, 13,148 gross tons. One of the first post-First World War new-builds for the Branch Line, in 1930 the *Barrabool* switched to the Suez Canal route and her accommodation was reduced to 586 in one class. (Orient Heritage Collection, 10279/Henderson & Cremer)

Bendigo 1922–1936, 13,039 gross tons. Built for the Branch Line, the *Bendigo* had the distinction of making three voyages in the early 1930s carrying mail. (Orient Heritage Collection, P&O_197/Henderson & Cremer)

Baradine 1921–1936, 13,144 gross tons. The *Baradine* was the first new-build for the Branch Line after the First World War and made thirty-five return voyages to Australia. (The Pictures Collection, State Library of Victoria)

Moldavia II 1922–1938, 16,449 gross tons. The *Moldavia* and her sister ship, *Mongolia III*, were the last P&O mail ships to have a counter-stern. (Orient Heritage Collection, 041/Henderson & Cremer)

In addition to maintaining the Bombay service, the *Viceroy of India* was a frequent and very popular cruise ship.

The same year that *Viceroy of India* was delivered, five vessels of the P&O Branch Line, *Balranald*, *Ballarat*, *Baradine*, *Barrabool* and *Bendigo*, were converted to burn oil and, to increase efficiency, were fitted with Bauer-Wach exhaust turbines and Wyndham heaters. This technology offered a speed increase of 10–15 per cent, as well as similar fuel reductions.

The following year, *Viceroy of India*, *Ranchi* and *Rawalpindi* were sent cruising in the summer months, and *Ranchi*, *Chitral* and *Comorin* were retrofitted with Bauer-Wach exhaust turbines and Wyndham heaters. P&O had also commenced construction on a number of new liners, including the 22,500 gross ton *Strathnaver* and *Strathaird*, which were being constructed with turbo-electric engines and the more efficient high-pressure water tube boilers. Up to 500 first-class and 668 tourist-class passengers could be carried by these liners, with the public rooms aboard being 'on a generous scale'. Each liner could carry 8,000 tons of cargo, of which 3,000 tons could be refrigerated, adding further to their money making capability.

Known as 'the white sisters', the ships featured the new P&O livery of white overall with buff funnels. Company publicity at the time remarked that the white hull decreased the internal temperature of the ship by up to 4 degrees, a decided benefit in tropical waters before the introduction of air-conditioning. The ships each had three funnels, with the first and third being dummies. This was a hangover from the days when passengers put a lot of faith in multiple funnels and the assumption that such ships had greater power.

Other orders included the 14,300 gross ton *Corfu* and *Carthage*, which were built to operate on the London to Bombay and Shanghai route, and each carried 177 first-class passengers, and 214 second-class passengers.

Finally, two fast cargo steamers were ordered. The 6,677 ton *Sudan* and 6,809 ton *Somali* were placed on the China service, and held 1,000 tons of insulated cargo. Surprisingly, these vessels were completed with reciprocating machinery, though Bauer-Wach exhaust turbines were also fitted.

As the Great Depression set in, P&O's services began to feel the bite. There was a decrease in shipments across almost all of the company's trades, resulting in lower income. However, as the company had spread its interests all over the world, they were still able to pay a dividend in the 1930 annual general meeting.

During 1931, *Strathnaver*, *Corfu* and *Somali* were delivered to the company. In fact, *Strathnaver* was the first P&O vessel to introduce tourist class, which was a great success for the line, and replaced the former 'second class' offering.

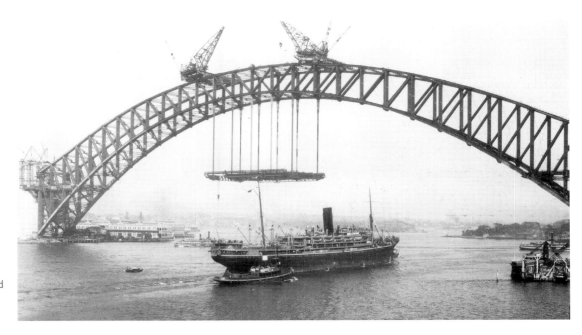

Mongolia III 1923–1938, 16,504 gross tons. A rare view of the *Mongolia* passing under the (still under construction) Sydney Harbour Bridge in 1930. In 1938 the *Mongolia* was chartered to the New Zealand Shipping Company and renamed *Rimutaka*. (Orient Heritage Collection, 034/ Henderson & Cremer)

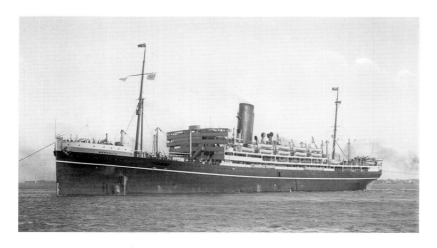

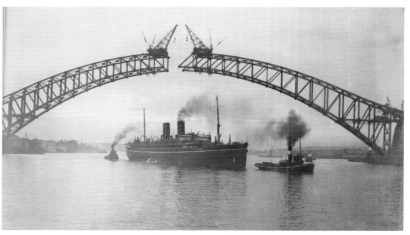

Mongolia III 1923–1938, 16,504 gross tons. *Mongolia* making her approach to a Melbourne berth. (The Pictures Collection, State Library of Victoria)

An August 1930 view of the *Mooltan* being guided by tugs passing under the bridge to a berth at Pyrmont. (Orient Heritage Collection, P&O_351/Henderson & Cremer)

• DID YOU KNOW? •

Some passengers were unable to accept the idea that cruising should be open to all comers. P&O received a letter in the 1920s from a passenger who had just returned from a P&O cruise, horrified by the type of passenger he was forced to travel with. He suggested to the company that passengers wishing to travel should be vetted for their suitability; perhaps the man should be a member of a 'good' London club and that the ladies should at least have been presented at Court.

Mooltan III 1923–1954, 20,847 gross tons. An exciting view of the *Mooltan* pulling away from her Melbourne berth, following a traditional Australian streamer farewell. (The Pictures Collection, State Library of Victoria)

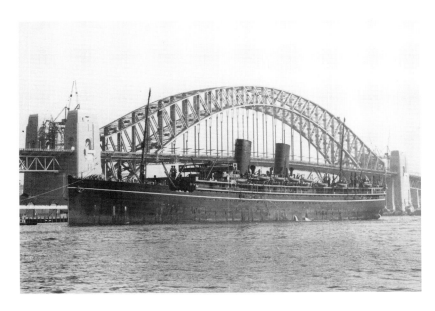

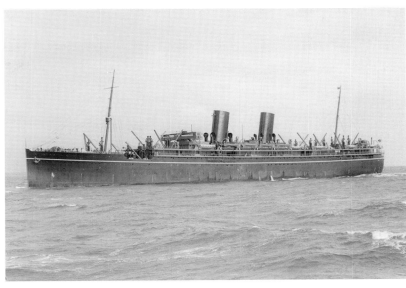

Mooltan III 1923–1954, 20,847 gross tons. An impressive image of the *Mooltan* approaching her berth in Sydney Cove with an incomplete Sydney Harbour Bridge as a backdrop. (Orient Heritage Collection, 10704/Henderson & Cremer)

An imposing port side view of the *Mooltan* in Port Phillip Bay. (The Pictures Collection, State Library of Victoria)

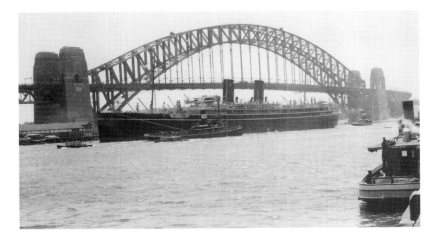

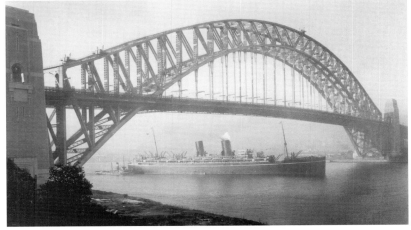

The *Mooltan* and her sister, *Maloja II*, were the first P&O ships to exceed 20,000 gross tons. (Orient Heritage Collection, 10686/Henderson & Cremer)

Maloja II 1923–1954, 20,837 gross tons. An early morning arrival in Sydney, shrouded in mist, shows the first rays of the sun breaking through to strike the starboard side of the *Maloja* and the bridge. (Orient Heritage Collection, 035/Henderson & Cremer)

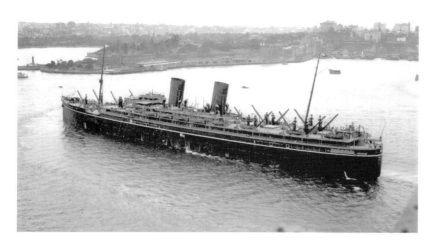

Maloja II 1923–1954. An impressive view of the *Maloja* about to pass Bennelong Point in Sydney, now the site of the Sydney Opera House. (Orient Heritage Collection, 047/Henderson & Cremer)

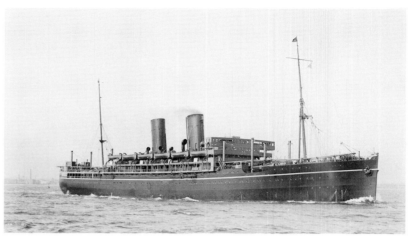

Cathay II 1925–1942, 15,104 gross tons. The first of the three 'C' class intermediate liners for the Australian service. *Cathay* and her sisters, *Comorin* and *Chitral*, were great favourites with young Australian travellers to England before the Second World War. (The Pictures Collection, State Library of Victoria)

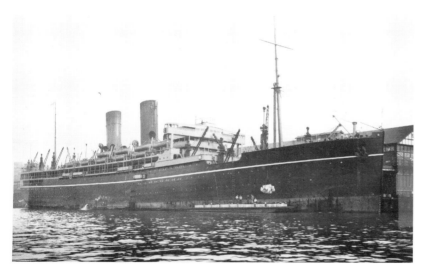

Ranpura 1925–1944, 16,610 gross tons. The *Ranpura* was the first of the popular 'R' class, which included the *Ranchi*, *Rawalpindi* and *Rajputana*. The *Ranpura* served on the Indian and eastern routes, and made her only return voyage to Australia in 1929. (Orient Heritage Collection, 10598/Henderson & Cremer)

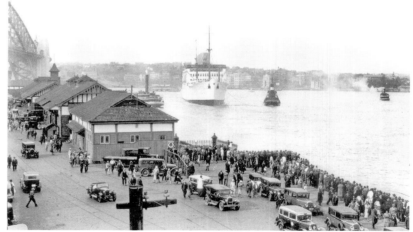

Strathnaver 1931–1962, 22,547 gross tons. In her gleaming white livery and buff funnels, the *Strathnaver* makes her triumphal maiden arrival at the passenger terminal in Sydney on 12 November 1931. (Orient Heritage Collection, 029/ Henderson & Cremer)

Despite this influx of new steamers, and the success of tourist class, the company was feeling the effects of the Great Depression, and the directors opted to reduce employee rates of pay by 10 per cent.

Irrespective of the Depression, cruising continued to perform well, with four of the line's steamers offering cruise itineraries during 1931. On the line voyages, the tourist-class offering, which was now being retrofitted to existing tonnage as well as being introduced on new vessels, continued to exceed expectations, albeit at the expense of first class. As the world economy shrank and the depression set in, the more affordable tourist class was the only option available for most travellers.

The effects of the Great Depression were not limited to just P&O. It hit shipping owners hard across the world. During 1930, over 5 million tons of shipping worldwide was laid up. This figure doubled the following year, to 10.5 tons. By 1932, a staggering 15 million tons of shipping, or approximately 20 per cent of the world's entire sea-carrying capacity, were laid up. For P&O, not only were a large number of their vessels laid up, but seven of their ships were sent to the breakers.

Industry, both shipping and land based, was being further effected by the ongoing fallout of the First World War, namely in the repayment of war debts. As the victors (such as the United States of America and Great Britain) could no longer sell their goods and services, the war debts that were being repaid with goods from other nations became worthless. Thus, the United States were not receptive to payment of war debts in the form of goods from Europe, as the effects of the Depression meant there was no market for their sale in America. Furthermore, the large gold reserves in America meant that the US government was also unwilling to take war debt payment in gold. Hence, there was a stalemate, resulting in less inbound or outbound shipping. This further damaged cargo carriers including P&O.

During the 1932 board meeting, Lord Inchcape summarised the dire situation in an impassioned speech:

In America as well as in Europe, war debts tend to stop the wheels of industry, interchange and distribution earning – with all that means dislocations and distress.

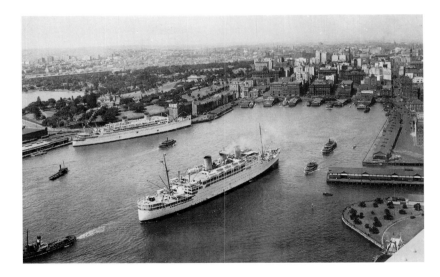

February 1932, and two liners salute each other in Circular Quay. *Strathnaver* is approaching Berth 4, whilst the American mail liner *Mariposa* is alongside on the eastern side. (Orient Heritage Collection, P&O_179/Henderson & Cremer)

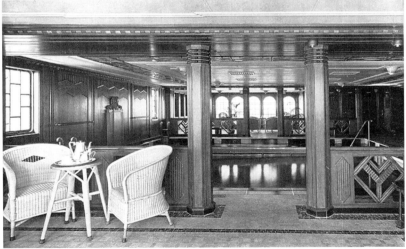

The magnificent tile and timber panelled indoor swimming pool and café of *Strathnaver*, a favourite rendezvous spot. (P&O Heritage Collection/Henderson & Cremer)

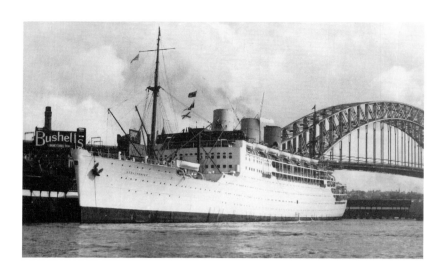

A port side view of *Strathnaver* alongside in Sydney's Circular Quay. (Orient Heritage Collection, P&O_167/Henderson & Cremer)

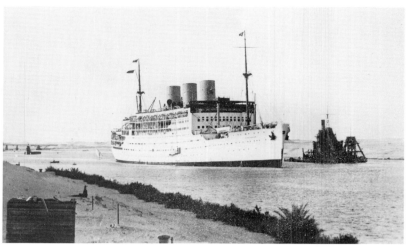

Strathnaver briefly shares the Suez Canal with one of the ubiquitous canal dredgers. (Orient Heritage Collection, P&O_182/Henderson & Cremer)

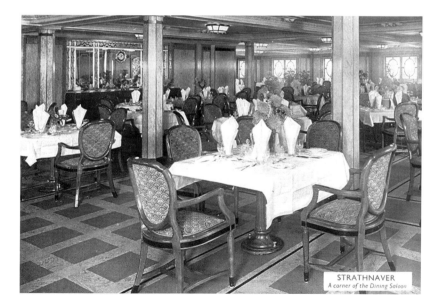

The first-class dining saloon, with its magnificent polished timber panelling and tapestry upholstery. (P&O Heritage Collection/Henderson & Cremer)

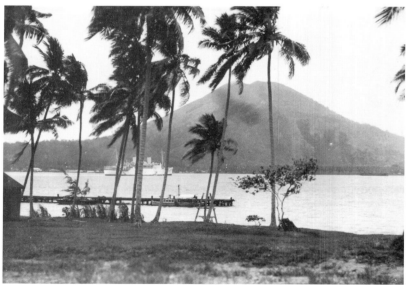

Strathnaver riding at anchor at Rabaul during her 1939 cruise, with the volcano looming behind. (Orient Heritage Collection, 10251/Henderson & Cremer)

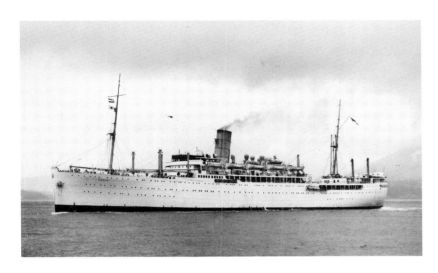

Corfu 1931–1961, 14,293 gross tons. A view of the *Corfu* after her Second World War refit, now with only one funnel and white livery. (Orient Heritage Collection, 10297/Henderson & Cremer)

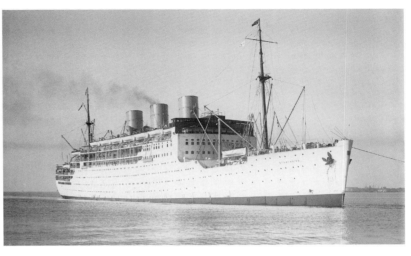

Strathaird 1932–1961, 22,544 gross tons. To *Strathaird* goes the distinction of introducing big-ship cruising by P&O to Australia, when she made a cruise to Norfolk Island in December 1932. (The Pictures Collection, State Library of Victoria)

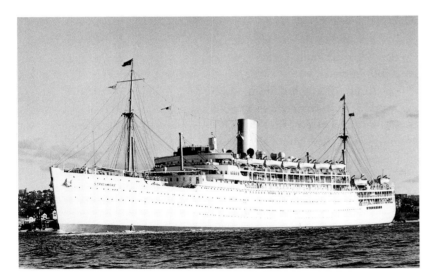

Strathmore 1935–1963, 23,428 gross tons. The stunning *Strathmore* shown in Sydney Harbour. (Orient Heritage Collection, P&O_290/Henderson & Cremer)

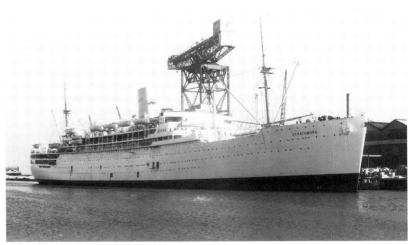

A fine starboard view of the *Strathmore*. (Orient Heritage Collection, a Sankey postcard, 031/Henderson & Cremer)

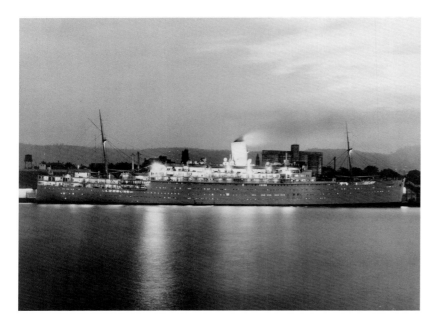

Strathmore at dusk, alongside at Hobart in January 1959. (Orient Heritage Collection, 10633/Henderson & Cremer)

A striking night time view of *Strathmore* illuminated. (Orient Heritage Collection, 10632/Henderson & Cremer)

Across P&O's network, port and canal fees were increased, adding to costs. 1932 was one of the few years that P&O did not pay a dividend on its deferred stock, due to their shrinking profits – though at no time was the company insolvent. P&O's management was concerned that rival companies, particularly those in Europe, were being supported financially by their respective governments. P&O on the other hand, was only paid government fees for mail carriage which was, by this time, payment for services rendered rather than a subsidy.

However, despite the Depression, P&O ensured that their passenger amenities and on-board services were maintained at the highest level, even though the 10 per cent reduction in salaries still remained in effect. Throughout 1932, holiday cruises continued to be popular, as the public sought affordable ways to escape the rigours of everyday life. Five ships, *Strathnaver*, *Strathaird*, *Viceroy of India*, *Moldavia* and *Mongolia*, were sent on no less than twenty-one cruises. Whilst in Australia, the company introduced deep-sea cruising on the iconic mail steamers when, in December 1932, they despatched the *Strathaird* on a six-day cruise to Norfolk Island. The next

year, in response to the growing demand for cruising, twenty-eight pleasure voyages departed from London, while in Australia, there were five cruise itineraries offered.

For decades P&O had been involved in shipping conferences around the world. These conferences saw shipping companies come together to negotiate agreed cargo prices on specific goods such as tea and opium, and the proportion these goods that would be carried between operators. The purpose was to protect shipping companies, as well as the merchants, from fluctuations in prices. In effect, the agreements kept prices of key goods at steady levels, while stopping competitors lowering prices and making the services unviable. The benefits for the merchants included price stability and an assurance that the goods would be shipped in a timely manner. Therefore, it didn't matter whether a P&O ship, British India or any other line was available for the shipment, the cost of carriage would remain stable.

For a line to access these conferences, years or sometimes decades of courting the existing lines was required. In some cases, a financial buy-in was needed. The power was held by the large shipping firms, such as P&O, while

smaller operators with lower overheads were often paid by the larger firms to exit the market so as not to upset the price stability.

In the United States, local shipping companies were complaining, because they were excluded from the conferences which were dominated by British and European operators. To counter this, the US Congress passed the White Jones Act, which offered American shipping owners a series of subsidies which effectively allowed them to bypass the conferences, and offer passage of goods and cargo at comparable rates to those of the European operators. This move added extra competition to routes on which P&O were operating, and sent a clear signal to British operators of America's intent to be taken seriously in the post-war markets.

P&O's cruising profits continued to grow, with twenty-four cruises from British ports in 1934 and ten from Australia. On the Australian cargo and line voyages, improvements in refrigeration technology meant that chilled (rather than frozen) beef was carried aboard the ships. This cargo was carried at significantly higher rates and was, therefore, a great money-maker for P&O.

The following year, 23,428 ton *Strathmore* was delivered to P&O. Of the 'Strath' class, she was a fast ship, achieving 22.277 knots in her sea trials. She was added to the Australian mail roster, and undertook cruising in northern

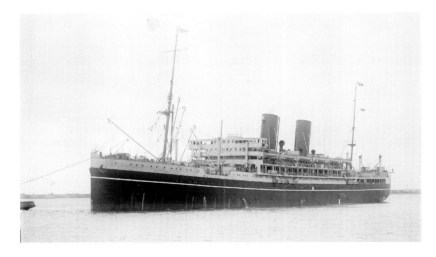

Cathay II 1925–1942, 15,104 gross tons. *Cathay* in her new livery in Port Phillip Bay. (The Pictures Collection, State Library of Victoria)

and southern waters. A total of thirty-six pleasure cruises were offered by P&O in 1935, with twenty-nine departing from Britain, and seven from Australia.

Meanwhile, the introduction of new tonnage meant the retirement of older ships. The P&O Branch Line, which had been suffering a considerable drop-off in earnings for many years, due to the decrease in emigrant traffic, was wound up in 1936. The *Ballarat* was retired in 1935, and the *Balranald*, *Baradine*, *Barrabool* and *Bendigo* were all scrapped in 1936.

As early as the mid-1930s, P&O's directors had identified the increasing competition of aviation as a strategic issue. While the directors were aware of the potential of aircraft, at this time passenger aeroplanes were driven by piston engines and were far slower than today's jets. It was felt, at the time, that there would be some loss of passenger revenue to airlines, but mails and cargo would be safe for the foreseeable future.

Across the world, P&O had entered into a number of strategic alliances through other shipping lines that it owned or had a relationship with. By 1936, this network spanned the globe. That same year, the mandatory 10 per cent wage cut was reduced to 5 per cent, giving a welcome boost in payments to those working for the line. Twenty-eight cruises were undertaken in 1936, with twenty-one from Britain and seven from Australian ports.

Thirty cruises were undertaken the following year, with the majority from British ports and P&O's reputation as the leader in cruise itineraries became embedded during this time, with travel agencies in Britain and Australia establishing themselves off the back of P&O cruise sales.

II

THE SECOND WORLD WAR

On 1 September 1939, in defiance of threats from Great Britain and France, Nazi Germany invaded Poland. This led the world into the Second World War. For the second time in a generation, shipping lines, including P&O, found themselves struggling to survive, as the war consumed Europe and most of Asia.

P&O had already started to feel the effects of the tensions in Europe as early as the mid-1930s. Two conflicts in 1937 had impacted P&O services in Europe and Africa. The Spanish Civil War had erupted when nationalists, under the leadership of General Franco, began capturing Spanish land, towns and cities occupied by the republican faction. This led to a series of bloody battles that extended into the oceans off Spain. While in Ethiopia, an ongoing feud between the kingdom of Italy and the Ethiopian empire resulted in fighting during a conflict which became known as the Abyssinian Crisis. Both events resulted in merchant shipping being bombed and torpedoed. While P&O did not lose any ships to the conflict, they were impacted by the lack of cargo carried due to the uncertainty in the region. The line also took precautions, such as avoiding Spanish ports on cruises, including the popular cruise port of Tangiers, in Spanish Morocco.

Despite growing tensions in Europe, particularly between Nazi Germany, Great Britain and France, P&O's cruises remained popular, albeit in reduced numbers during the 1930s. In 1938 there were fifteen cruises from Britain, carrying 10,539 passengers, while in Australia nine cruises carried 6,933 passengers.

At the official outbreak of the Second World War, P&O's entire passenger fleet was requisitioned by the Admiralty for use in the conflict. Unfortunately, three older P&O ships had just been sold to breakers at the outbreak of the war, including *Naldera*, the last of the coal-burning mail ships. P&O passenger services ground to a halt. Furthermore, a large proportion of cargo vessels were also taken up from trade. The requisitioning of ships was supplemented by 49 per cent of P&O staff entering into navy service.

While some of the P&O liners were used as troop transports, others were converted into armed merchant cruisers for direct military use. The 16,619 ton *Rawalpindi*, one such converted armed merchant cruiser, was lost early in the war while patrolling waters between Iceland and the Faroes. She had gone to investigate smoke, and encountered the German battle-cruisers *Scharnhorst* and *Gneisenau*. Captain Kennedy of the *Rawalpindi* refused to acknowledge the order to surrender and went into battle against enormous odds, and was reportedly heard to say 'We'll fight them both, they'll sink us, and that will be that. Good-bye'. The battle lasted for no more than a quarter of an hour before the *Rawalpindi*, ablaze and wrecked, sank. The captain, along with 264 officers and crew, went down with the ship, whilst thirty-seven were rescued by the German or friendly ships.

The 16,000 gross ton *Rajputana* was also lost in 1939, when operating as an armed merchant cruiser. She was torpedoed twice by the German submarine *U-108*, and although she opened fire, she sank with the loss of forty-one lives. A destroyer picked

> • **DID YOU KNOW?** •
>
> Mail carried aboard P&O vessels was colour-coded, based on destination.

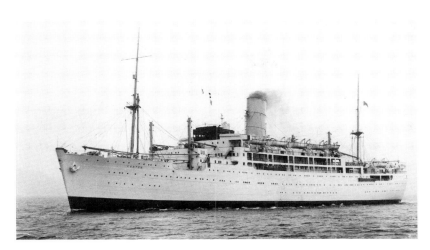

Canton III 1938–1962, 15,784 gross tons. Built for the Indian and Eastern service, the *Canton* originally had the traditional black hull livery but, after an extensive post-war refit she adopted the white overall and buff funnel. (Orient Heritage Collection, 10294/Henderson & Cremer)

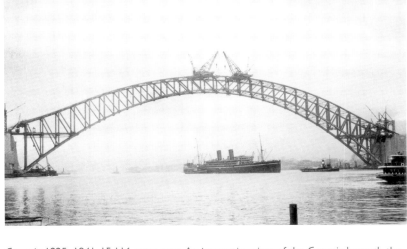

Comorin 1925–1941, 15,116 gross tons. An impressive view of the *Comorin* beneath the arch of the Sydney Harbour Bridge. (Orient Heritage Collection, 042/Henderson & Cremer)

Comorin served both on the Australian and eastern routes. Her loss in the Second World War and the rescue of most of her crew was one of the many heroic exploits of the war. (The Pictures Collection, State Library of Victoria)

Strathnaver 1931–1962, 22,547 gross tons. *Strathnaver* with a single funnel. She was constructed with three funnels to reflect the popular view that this presented power and strength, but the first and third funnels were dummies, and were removed in the post-Second World War refit. (Orient Heritage Collection, 10646/Henderson & Cremer)

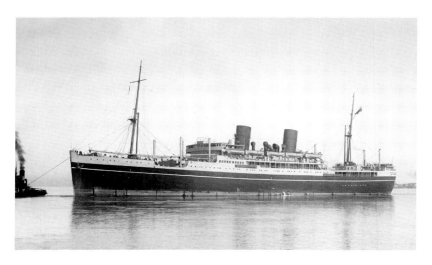

Corfu 1931–1961, 14,293 gross tons. Built for the Indian and eastern routes, the *Corfu* made only three return voyages to Australia. She is shown here in Port Phillip. (The Pictures Collection, State Library of Victoria)

Carthage II 1931–1961, 14,304 gross tons. *Carthage* spent most of her time in eastern waters and during the Second World War served as an armed merchant cruiser and a troopship. (The Pictures Collection, State Library of Victoria)

In her post-Second World War refit, the *Carthage* joined her sister ship *Corfu* in adopting the white hull and superstructure, and in having her second funnel removed. (Orient Heritage Collection, 10295/Henderson & Cremer)

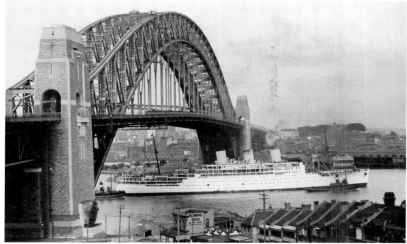

Strathaird 1932–1961, 22,544 gross tons. A striking view of the *Strathaird* as she is guided beneath the bridge to her berth at Pyrmont. (Orient Heritage Collection, 10043/Henderson & Cremer)

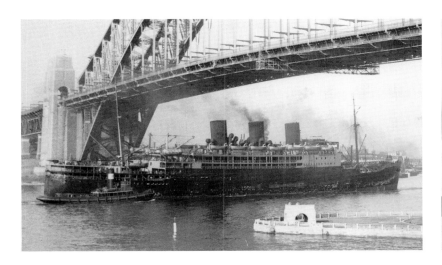

A very rare view of the *Strathaird* in her role as a troopship during the Second World War, in a clear contrast to her usual white hull. Look closely at her stern, and you can see her defensive armament. (Orient Heritage Collection, P&O_181/Henderson & Cremer)

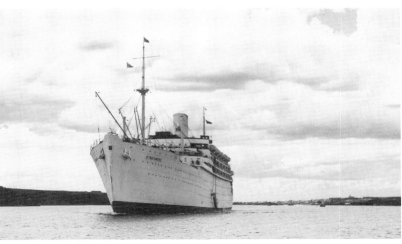

Strathmore 1935–1963, 23,428 gross tons. An interesting view of the *Strathmore* in Sydney Harbour with her accommodation ladder down. (Orient Heritage Collection, 10173/Henderson & Cremer)

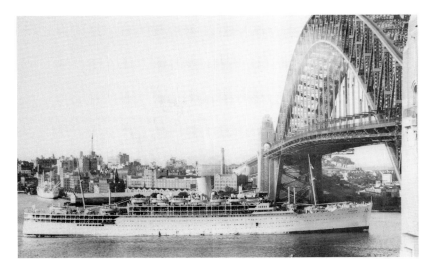

A late 1930s view of *Strathmore* passing under the Sydney Harbour Bridge. (Orient Heritage Collection, 10023/Henderson & Cremer)

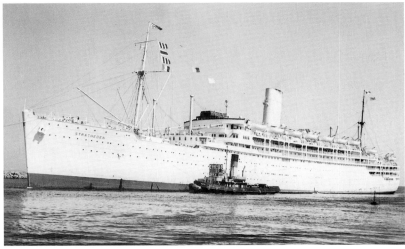

Stratheden 1937–1964, 23,722 gross tons. *Stratheden* and her sister, *Strathallan*, were reputed to be the best looking of the five Strath liners, but only *Stratheden* survived the Second World War. (Orient Heritage Collection, 10060/Henderson & Cremer)

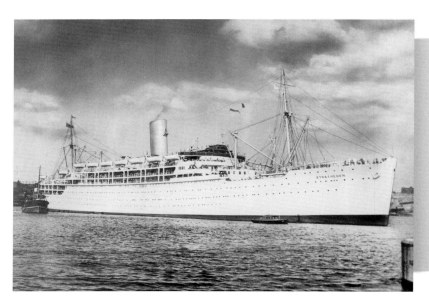

A fine starboard view of the *Stratheden*. (Orient Heritage Collection, 10062/ Henderson & Cremer)

Mail Protocol

At each Australian port, there was a strict protocol for the mail service. The first port of call was initially King George's Sound (later, from 1900, the new port of Fremantle), where local mail was landed. Express mail was transferred to the trans-Australia railway (or via air) to the eastern states. However, the great majority of mail, including parcel post, would remain with the ship until arrival at Adelaide. Here, a vast proportion was landed directly into waiting rail vans for immediate dispatch to Melbourne and Sydney. Items destined for New Zealand and Tasmania would be trans-shipped at Melbourne, whilst mail for Queensland and the Pacific Islands would wait for trans-shipment at Sydney.

Strathallan 1938–1942, 23,722 gross tons. *Strathallan*, just launched and in her natural element. The last of the Straths, she was lost in the Second World War after an all-too-brief life. (Orient Heritage Collection, a Sankey postcard, 044/ Henderson & Cremer)

up 283 survivors, whilst another thirty-four were adrift for some time before being picked up and taken on to Canada.

Comorin was lost while acting as an armed merchant cruiser. She had entered service for the Royal Navy in 1939 and, after having a refurbishment that saw her aft funnel removed as well as the installation of guns and machinery, was placed into war service. The vessel unexpectedly caught fire in the north Atlantic in 1941 and was burnt out, before being shelled and sunk by HMS *Lincoln*.

During the brutal years of British North African operations, P&O vessels of a combined tonnage of 86,000 tons, including *Strathallan*, *Viceroy of India*, *Cathay*, *Narkunda* and *Ettrick*, were all sunk by the enemy while acting as troop transports.

In Australia, the requisitioning of P&O vessels to the European conflict meant that the majority of P&O vessels on Australian and Asian services were no longer in the region, so most P&O ships avoided the brutal conflict as the empire of Japan advanced on British-held territories in Malaya and Singapore.

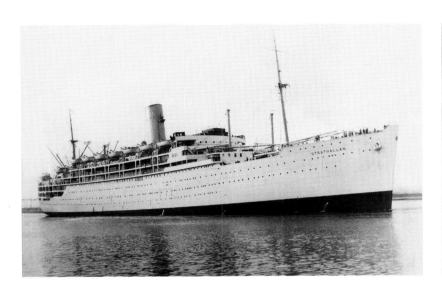

A fine view of *Strathallan*, believed to have been taken in Port Phillip. (Orient Heritage Collection, 10604/Henderson & Cremer)

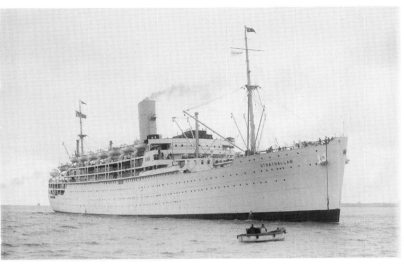

Our final view of *Strathallan*, in Port Phillip Bay proudly flying the prestigious Royal Mail pennant. (The Pictures Collection, State Library of Victoria)

Eleven of P&O's pre-war cargo ships were lost to enemy action, leaving only four cargo ships in P&O service at the end of the war. The line's refrigerated cargo vessels survived the conflict and entered direct P&O service (having previously been operated by one of the subsidiary companies), along with two cargo vessels built during the war years to government specifications, while an additional cargo vessel was purchased from the government. These ships, plus one passenger vessel, were returned to P&O during the latter part of 1946, though all vessels needed extensive refurbishment. This meant that for the whole of 1946, there were no P&O passenger vessels in regular service.

The first P&O ship to return to passenger duties was the *Stratheden*, in June 1947, followed by the *Canton* in September. Seven further liners were reconditioned during this period, including the *Strathaird*, while four cargo ships were purchased and added to the fleet. It wasn't until 1948 that the reconditioned vessels returned to passenger service, while *Strathmore* and *Strathnaver* remained under government contract. By 1949, *Corfu* had returned to P&O service and *Strathmore* and *Strathnaver* were undergoing refurbishment. By the middle of that year the line had fourteen cargo vessels in service, while all four of their surviving 'Strath' class vessels were operating passenger services by the end of 1949.

In the years following the conflict, 124 P&O employees were recognised by the British government for their bravery and dedication during the war years. This included one knighthood, two George Medals, two Distinguished Service Orders, seventeen Distinguished Service Crosses, one DFL, two Distinguished Service Medals, nine Lloyds Medals for bravery, one Military Cross and fifty-nine British Empire Medals.

THE ASSISTED PASSAGE SCHEME

It took P&O years to re-establish services following the cessation of hostilities at the end of the Second World War. While the war in Europe ended on 8 May 1945, it endured in the Pacific realm until September, making any return to normality impossible on the Asian and Australian services for most of 1945.

As P&O re-established itself, Australia was eagerly looking to boost its population. Shocked at the ability of Japan to have captured so much of the Pacific during the war years, Australian Prime Minister John Curtin and the Labor government began negotiations with the British government for an increase in British migration into Australia. This policy, which was signalled by Curtin's 'populate or perish' speech, was designed to ensure that Australia had a population that could sustain not only the viability of the nation as a standalone country, but also defend Australia from any future attack.

Interestingly, despite the reliance on Britain for migrants, Australia had, by this time, moved its strategic military alliances away from Great Britain, building closer ties with the United States. While this move did see a gradual

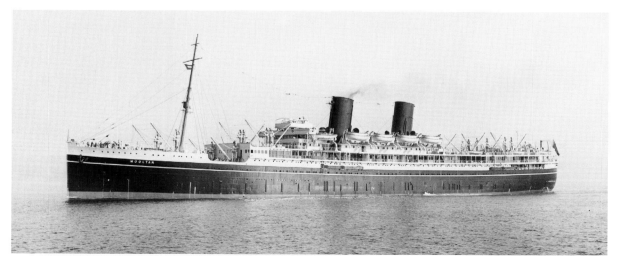

Mooltan III 1923–1954, 21,039 gross tons. In her post-Second World War livery, the *Mooltan* brought many thousands of emigrants to Australia after the war. (Orient Heritage Collection, 10057/ Henderson & Cremer)

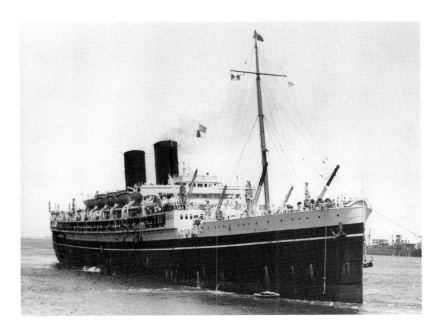

'Americanisation' of Australian culture and behaviours, the majority of immigrants originated in Great Britain, and British shipping remained the dominant means of transport to and from Australia.

To lure emigrants, an 'assisted passage scheme' was established, whereby passengers could relocate to Australia for the low sum of £10, with the government making up the balance of the cost to shipowners like P&O. These emigrants became known as the 'ten pound poms'.

P&O had a number of vessels that had survived the war without regular refits but were too old to be completely refitted for regular service, and the demand for passenger space on the route to Australia was now so great that P&O gave these old vessels a token refit and put them into service on the emigrant trade. These vessels included the 1923-built *Mooltan* and *Maloja*, each at 21,000 tons, as well as the 1925-built 16,650 ton *Ranchi* and 15,200 ton *Chitral*.

As the four remaining Strath liners were returned to the Australian service they were also brought in to assist with the emigrant trade, as was the newly built 28,000 ton *Himalaya*. In 1949, the P&O liners *Ranchi* and *Chitral* carried 3,597 Australian settlers under the assisted passage scheme. By 1950, nine P&O passenger ships were operating on the Australian emigration service.

Maloja II 1923–1954, 20,837 gross tons. A fine post-Second World War view of the *Maloja* coming into port in her emigrant ship livery. (Orient Heritage Collection, 050/ Henderson & Cremer)

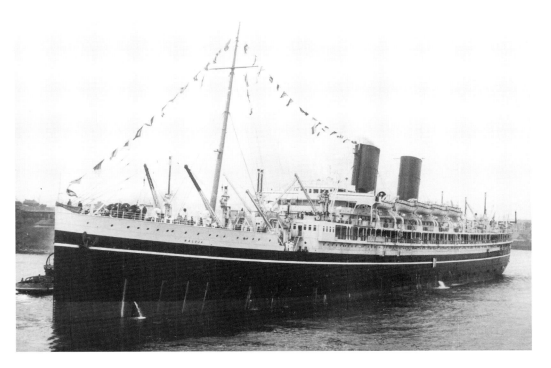

Dressed overall and in her new post-Second World War livery, the *Maloja* looks impressive in Sydney Harbour. (Orient Heritage Collection, 10356/Henderson & Cremer)

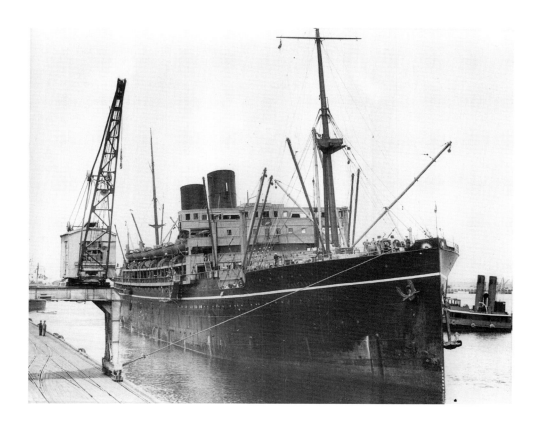

Chitral 1925–1953, 15,248 gross tons. The *Chitral* was the last ship in the 'C' class. She survived the Second World War whilst serving as an armed merchant cruiser and a troopship. After the war *Chitral* joined her fleet mates *Mooltan*, *Maloja* and *Ranchi* in the emigrant service to Australia. (Orient Heritage Collection, 051/Henderson & Cremer)

Ranchi 1925–1953, 16,650 gross tons. Built for the Bombay mail service, the *Ranchi* narrowly survived the Second World War, and afterwards joined the fleet of emigrant carriers on the Australian route. (Orient Heritage Collection, 10597/Henderson & Cremer)

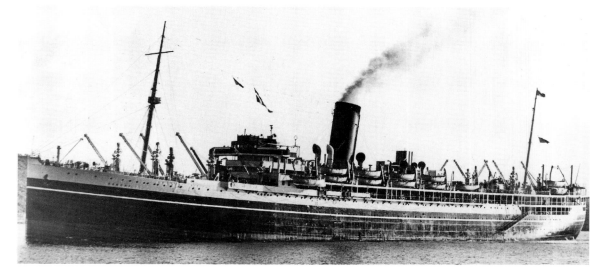

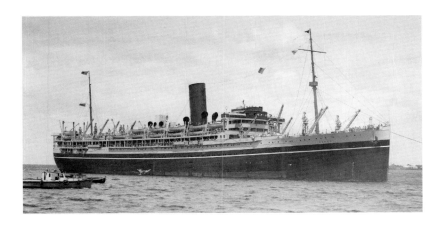

An impressive starboard view of the *Ranchi* on one of her post-Second World War voyages to Australia. (The Pictures Collection, State Library of Victoria)

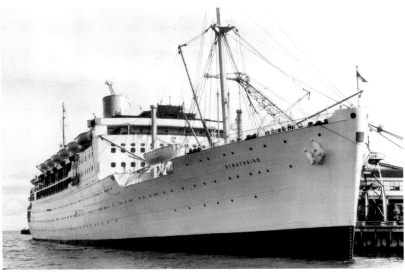

Strathaird 1932–1961, 22,544 gross tons. A striking view of the *Strathaird* after her post-Second World War refit, when the dummy first and third funnels were removed. (Orient Heritage Collection, 040/Henderson & Cremer)

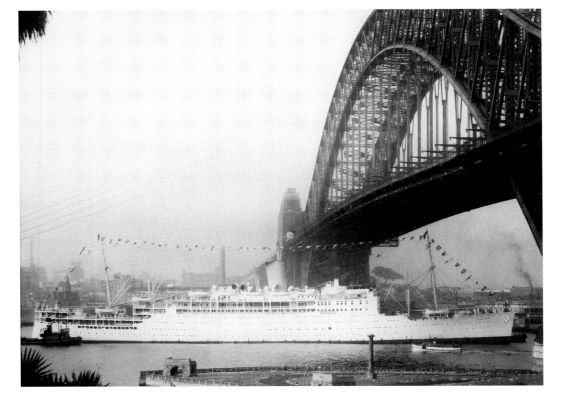

An early morning arrival on 4 February 1954. *Strathaird*, looking resplendent and dressed overall, has just passed and saluted the Royal Yacht *Gothic* which had brought HM Queen Elizabeth II to Sydney the day before. (Orient Heritage Collection, 10059/Henderson & Cremer)

Stratheden 1937–1964, 23,722 gross tons. Dressed overall, *Stratheden* is alongside Lyttelton wharf on a cruise to New Zealand in December 1961. (Orient Heritage Collection, 10628/Henderson & Cremer)

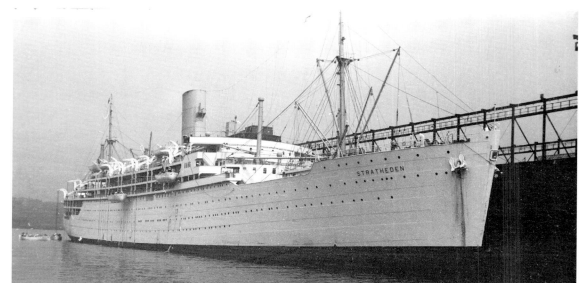

In 1950 the *Stratheden* was chartered by the Cunard Line to undertake four return voyages on the north Atlantic. This view shows the ship alongside in New York. (Orient Heritage Collection, P&O_377/Henderson & Cremer)

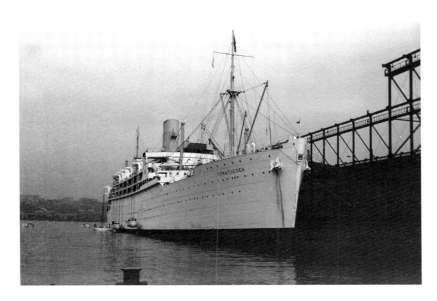

Another view of the *Stratheden* in New York under the Cunard flag, with boat drill underway. (Orient Heritage Collection, P&O_376/Henderson & Cremer)

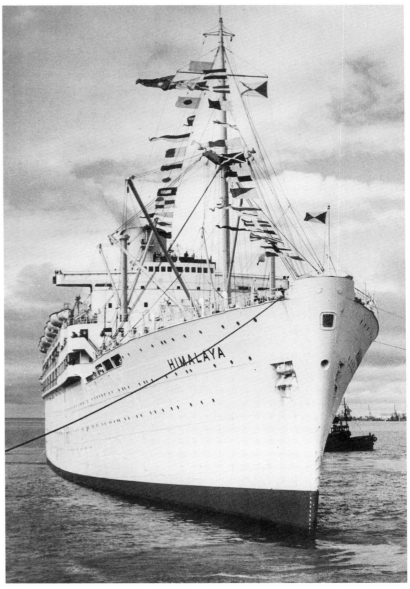

While it was expected that 70,000 emigrants would apply for the service per annum, the high wages and low cost of living in Australia attracted many more, with some 400,000 applications in the first year of the scheme. In fact, the programme was so successful that European lines such as the Chandris Line and Flotta Lauro Line established emigration services on this route, while Cunard's *Georgic* operated services until 1950.

Cruising was re-established by P&O in 1950 when, between them, *Chusan* and *Himalaya* completed six cruises from British ports. The following year this was increased to nine cruises. In Australia the *Himalaya* made the first post-war cruise in December 1954.

Lack of investment in Australian and New Zealand ports during the 1940s led to a loss of revenue caused by slow turnarounds. This was largely attributed to poor infrastructure, as well as a workforce that was not motivated in the post-war years. Government intervention was sought to rectify the situation.

In 1953, the Australian immigration quotas were reduced under the new Liberal government, led by Prime Minister Robert Menzies. This change in policy left P&O with an excess of tonnage. Thus, *Ranchi* and *Chitral*,

Himalaya III 1949–1974, 27,955 gross tons. *Himalaya* was much larger and more expensive than any pre-war P&O ship. She became an immediate success, and made the company's first trans-Pacific voyage in 1958. (Orient Heritage Collection, 10318-RCH/Henderson & Cremer)

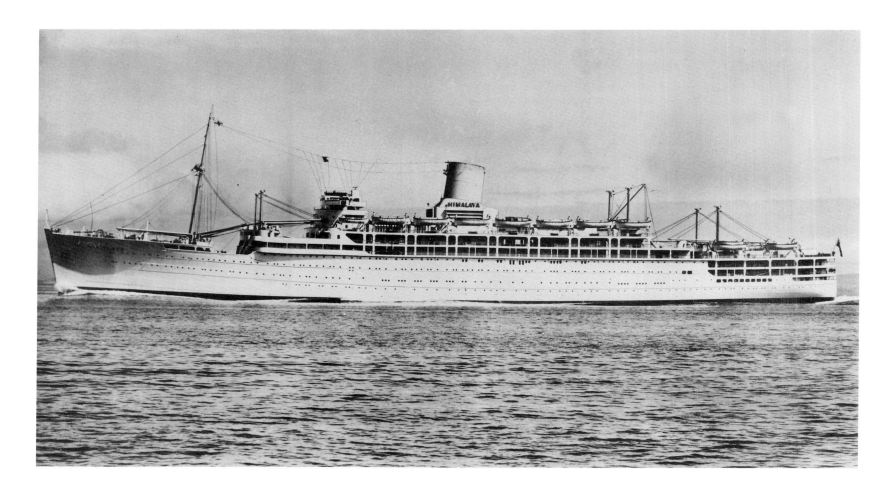

An early port side view of *Himalaya* showing her original funnel. (Orient Heritage Collection, 10319/Henderson & Cremer)

along with *Mooltan* and *Maloja*, were withdrawn from service and broken up. Passenger traffic now returned to pre-war trends, with seasonal patterns re-established. Despite this adjustment in immigration numbers, the service remained a viable and important one for P&O, and continued between 1953 and 1968, with a peak in 1968 of 600,000 new arrivals from Great Britain.

During February 1954, in a signal that aviation was becoming more of a competitive threat, P&O's subsidiary, General Steam Navigation Company, acquired a controlling shareholding in Britavia Ltd. Britavia was an independent aviation company, which owned Silver City Charter Airways and Aquilla Airways, a flying boat service from Southampton to Madeira and the Canary Islands.

THE ART OF
ENTERTAINMENT

O n board today's P&O cruise ships, there is a team dedicated to the amusement and entertainment of the passengers aboard. Overseen by an entertainment director, the programme includes a myriad of activity, ranging from enrichment lectures to sporting events and high-quality production shows.

However, for much of the history of cruising this was not the case. As late as the 1950s, company-organised entertainment was unheard of. Aboard the ship, the Purser's Office would publish a list of possible events for the voyage, but it was up to a passenger committee to see that these activities were organised and carried out. Soon after the ship had commenced its voyage, and after lifeboat drill had concluded, passengers were called together and asked to elect from amongst them an entertainment committee. Whoever was elected as chairman would then select a secretary and a treasurer. A small group of committee members were also selected. This group was ably assisted by two or more crewmembers, supplied by P&O for the purpose. The treasurer was responsible for collecting the cover charge that was made for entrants to the various competitions that were held. This fee was used to purchase prizes, which were bought from the ship's shop or on land at a port-of-call.

13

P&O-ORIENT

Since P&O's 1918 acquisition of 51 per cent of the Orient Line, the two lines had been operating side by side, separated from each other albeit, with many crossovers. The two lines maintained independent liveries, house flags and crews; however, they coordinated their operations so as to ensure minimal cannibalisation on the same routes, particularly those to Australia.

Throughout the 1950s, the increasing costs of fuel, general operations and building new tonnage was making further expansion for both P&O and the Orient Line unviable. New ships had to be larger, with a greater passenger and cargo capacity to recoup outlays. These ships also had to be faster, to shorten the return voyages and thus increase earnings. As a result, P&O and Orient Line co-ordinated their new-builds, basing their ships on the same general hull design. To this end, P&O constructed the 28,000 ton *Himalaya*, and the *Iberia* and *Arcadia*, both 30,000 tons. Meanwhile the Orient Line had also constructed three liners: the 28,472 *Orcades*, the 27,632 ton *Oronsay* and the 28,790 ton *Orsova*.

As both lines grew their post-war tonnage, P&O and Orient Line announced plans for the construction of their largest and fastest liners yet. These plans resulted in P&O's *Canberra*, and Orient Line's *Oriana*; regarded as two of the finest liners of their day. Despite being built at separate yards (*Canberra* was constructed at the Harland and Wolff shipyard in Belfast, while *Oriana* was the work of Vickers-Armstrongs at Barrow-in-Furness, Newcastle), and sporting vastly different appearances, *Canberra* and *Oriana* were designed to share certain specifications.

Both liners shared similar dimensions, though *Canberra* was the larger of the two, at just over 45,000 gross registered tons, compared to *Oriana's* 41,910. Both ships carried over 2,000 passengers and, most importantly, the two liners were able to achieve speeds in excess of 27 knots, making them the fastest liners ever deployed on the Australian service. Externally, the design of the two liners could not have been more different. *Canberra's* design was futuristic and clean, with her twin funnels placed side by side, and positioned at the aft of the superstructure – a design reminiscent of the Shaw, Savill & Albion liner, *Southern Cross*. The P&O liner sported a clearly swept stern, clutter free decks, a sheltered boat deck and a bridge set just aft of the forward superstructure.

Oriana, while having a commanding profile, had a design that followed the traditional Orient Line layout with her bridge set amidships, just forward of the funnel. A second funnel, of different dimensions and shape, was added three-quarters aft. *Oriana's* mast was set forward of the bridge, while her inboard lifeboat deck ran the entire length of the superstructure. *Oriana's* stern consisted of four open decks, below an enclosed wraparound deck, which gave the ship a unique appearance.

Oriana entered service in 1960, followed by *Canberra* in 1961. Both liners were placed on the Australian service, operating in cooperation with one another to ensure that both ships were

Himalaya showing the adjustments made to prevent soot falling on the decks from her funnel. (Orient Heritage Collection, 10320/ Henderson & Cremer)

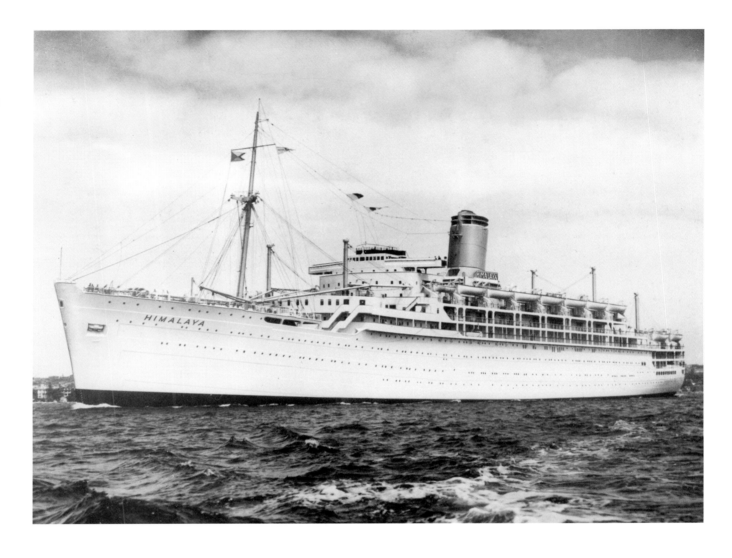

not competing for the same passengers, cargo and mails, and initially they turned a tidy profit for their respective owners.

However, since the Boeing 707 had made its first commercial service in 1958, the dynamic of passenger shipping operations, and indeed mail services, had begun to change. While that initial airliner service concentrated on the prestigious transatlantic service throughout the 1960s, P&O and Orient Line felt the impact of jet propelled aviation. The impact on passenger services was exacerbated for P&O by the changing dynamics of cargo operations. Throughout the 1960s, containerisation grew in popularity to become the mainstream form of cargo transport. For P&O, this meant their extensive and ageing fleet of cargo carriers were obsolete, and costly to operate.

By 1965, P&O were acquiring container ships. This was achieved through a series of joint venture operations, to help spread the cost, and reduce the risk to each company. Further diversification in the 1960s saw P&O commence ferry services, through the acquisition of a number of existing

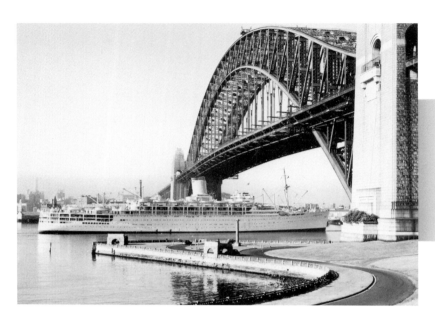

Slow Going

While *Canberra* and *Oriana* could achieve 27 knots, early P&O ships travelled much slower, covering little more than 200 nautical miles a day. These early steamers had canvas sails and often achieved a lesser daily progress if winds were unfavourable.

A traditional position for photographing ships, and the famous Sydney Harbour Bridge shows *Himalaya* making her way to a Pyrmont berth. (Orient Heritage Collection, 11301/Henderson & Cremer)

North Sea and cross-Channel ferry companies. However, the passenger shipping division continued to experience financial strain.

In 1961, P&O and Orient Line officially merged to form P&O-Orient. This move was an attempt to stem the losses of the long-distance passenger shipping operations by creating economies of scale within one, united company. Since the partnership began in 1918, the two companies had continued as two entirely separate entities. Though their passenger services around the world were parallel they had maintained separate management, offices and staff. In essence, everything was duplicated, and by merging the two entities they were able to significantly reduce running costs.

Orient Line ships were pulled into the P&O family, with the P&O house colours and flag being applied to all of these vessels. The company maintained the name P&O-Orient for only five years before reverting to the name P&O in 1966. This merge was not sufficient to stop the haemorrhaging of long-distance passenger shipping services, which were suffering at the hand of aviation services.

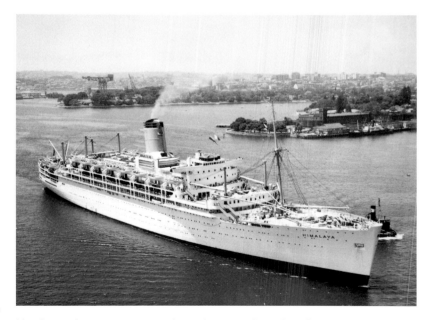

Himalaya makes an impressive sight as she passes Bennelong Point, now the home of the Sydney Opera House. (Orient Heritage Collection, RCH048/Henderson & Cremer)

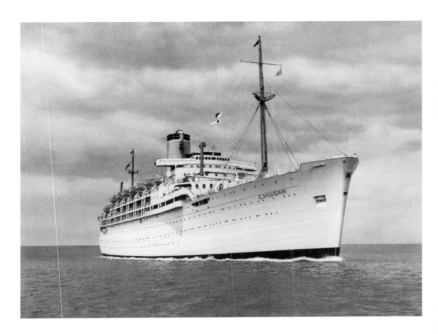

Chusan III 1950–1973, 24,215 gross tons. The last ship built by P&O for their traditional London–India–Eastern service. She made the last of those scheduled voyages in 1970. (P&O Heritage, 10307/Henderson & Cremer)

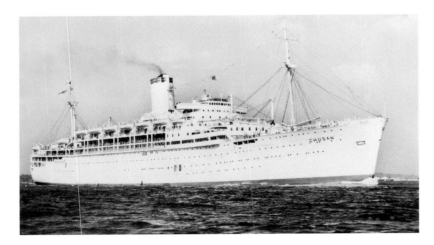

A P&O-issued postcard, showing an impressive starboard view of *Chusan*. (P&O Heritage, 10306/Henderson & Cremer)

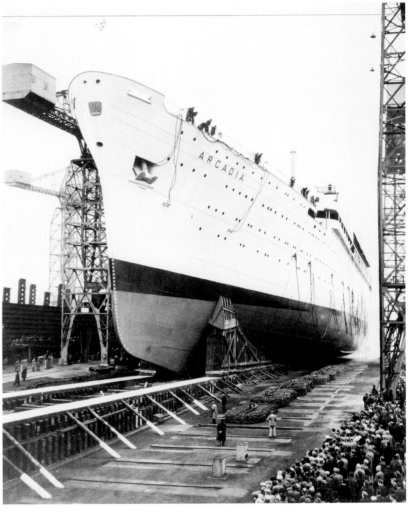

Arcadia II 1954–1979, 29,734 gross tons. Launch day, 14 May 1953. An incredibly popular ship, the *Arcadia* made history as the pioneer of big-ship cruising in Alaskan waters. (Orient Heritage Collection, P&O_269/Henderson & Cremer)

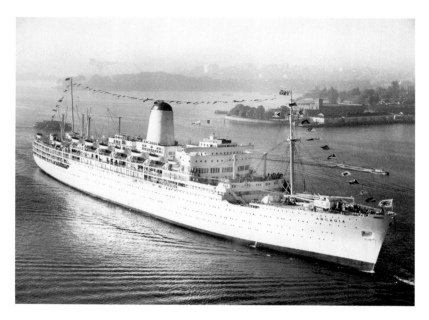

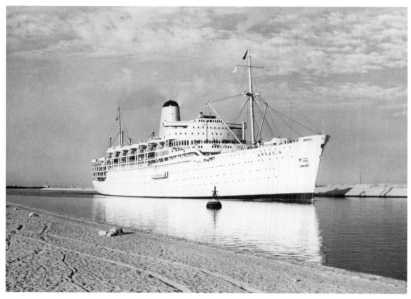

Dressed overall, and looking every inch the great liner she was, the *Arcadia* makes her stately entry into Sydney. (Orient Heritage Collection, P&O_262)

An early image of *Arcadia* transiting the Suez Canal. (P&O Heritage, P&O_293/Henderson & Cremer)

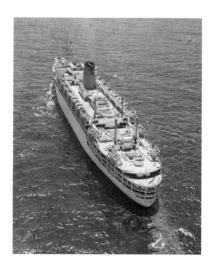

Left: A bird's eye view of the *Arcadia* on a South Pacific cruise from Sydney. (Orient Heritage Collection, 02418-RCH/Henderson & Cremer)

Right: An interesting image of *Arcadia* off the Needles. (Orient Heritage Collection, P&O_292/Henderson & Cremer)

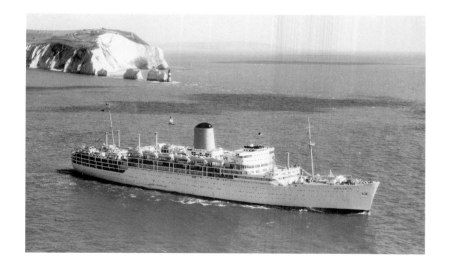

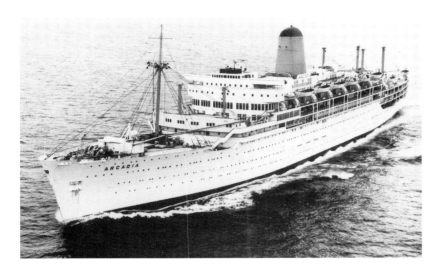

Arcadia, shown to advantage from this aerial view. (Orient Heritage Collection-10041/Henderson & Cremer)

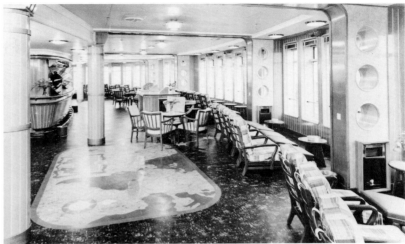

Arcadia's superb observation lounge, always a popular rendezvous with its sweeping views over the bow and out to sea. (P&O Heritage, 10265/Henderson & Cremer)

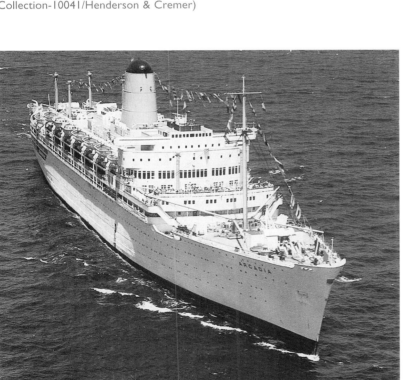

• DID YOU KNOW? •

A P&O liner carrying the Royal Mail always had right of way over other vessels.

Dressed overall, another great view of Arcadia. She finished her life as one of Australia's favourite cruise ships. (Orient Heritage Collection, 02403-RCH/ Henderson & Cremer)

In fact, the jet heavily impacted the highly important Australian service. Australia's national airline, Qantas, was the first airline outside of the United States of America to acquire Boeing 707s. From July 1959, the airline commenced jet services, with the first service from Sydney to London starting in September. The following month, Qantas commenced jet services to India. P&O-Orient's bread and butter passenger service was under siege.

The situation facing P&O-Orient worsened in 1966, when a dispute between British seamen, and the shipping companies resulted in the devastating 'British seamen's strike'. The strike was a result of industrial unrest

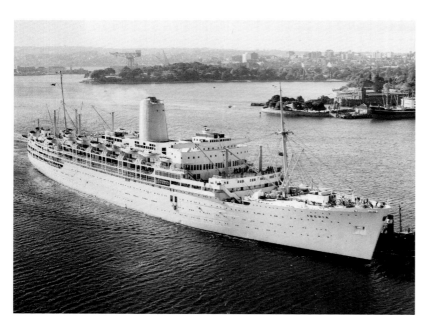

Iberia II 1954–1972, 29,614 gross tons. The stylish *Iberia*, elegant in every way, makes a stunning sight in Sydney Harbour. (Orient Heritage Collection, P&O_263/ Henderson & Cremer)

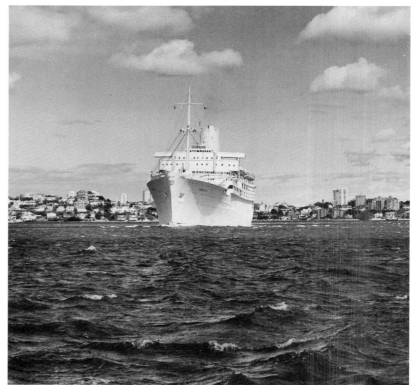

A classic view of *Iberia* making her way in Sydney Harbour. (Orient Heritage Collection, 10323/Henderson & Cremer)

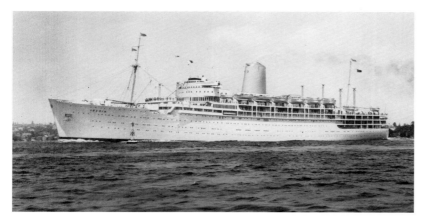

A port side view of *Iberia*, a magnificent but unfortunate ship constantly plagued with mechanical problems. (Orient Heritage Collection, 10273/Henderson & Cremer)

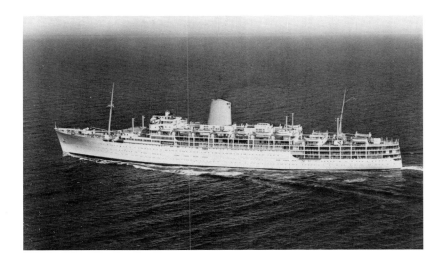

A port side view of the *Iberia* at sea. The *Iberia* served for only eighteen years before being withdrawn from service in 1972. (Orient Heritage Collection, 10324/ Henderson & Cremer)

The elegance of *Iberia* is shown in this view of her first-class lounge. (P&O Heritage, 10330/Henderson & Cremer)

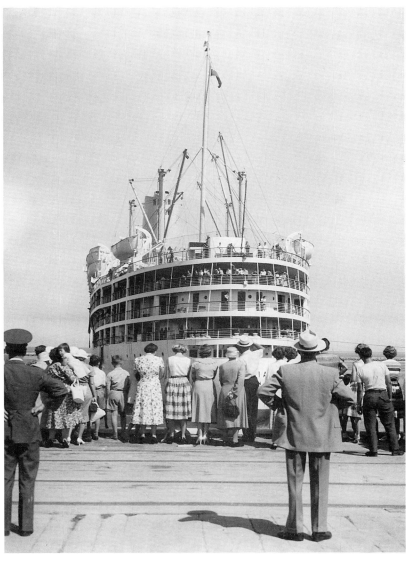

An unusual view of the stern decks of *Iberia*, shown here as she sails from Adelaide. (Orient Heritage Collection, 10329/Henderson & Cremer)

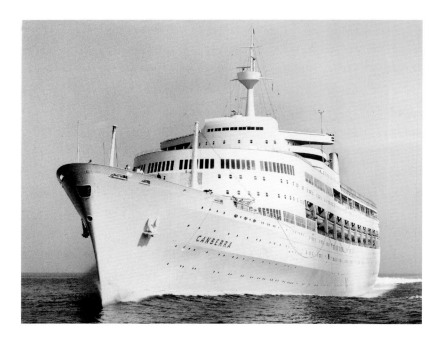

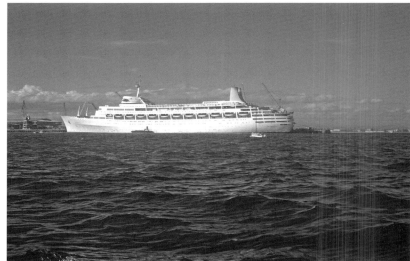

A port side view of the *Canberra* on her maiden arrival at Melbourne. (Orient Heritage Collection, P&O_379/Henderson & Cremer)

Canberra 1961–1997, 45,733 gross tons. A dramatic view of the *Canberra*, the ship that shaped the future for P&O. (P&O Heritage, P&O_341/Henderson & Cremer)

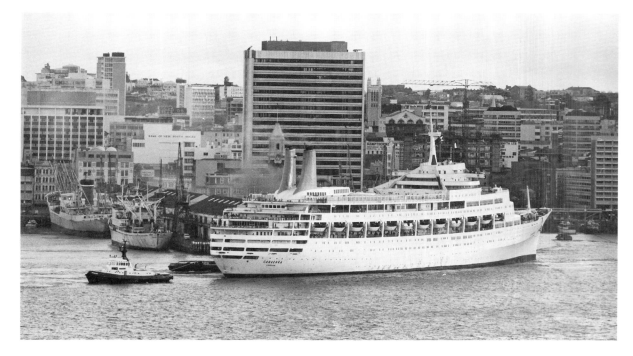

An early photograph of *Canberra* on one of her many calls at Auckland, New Zealand. (Orient Heritage Collection, 18287/Henderson & Cremer)

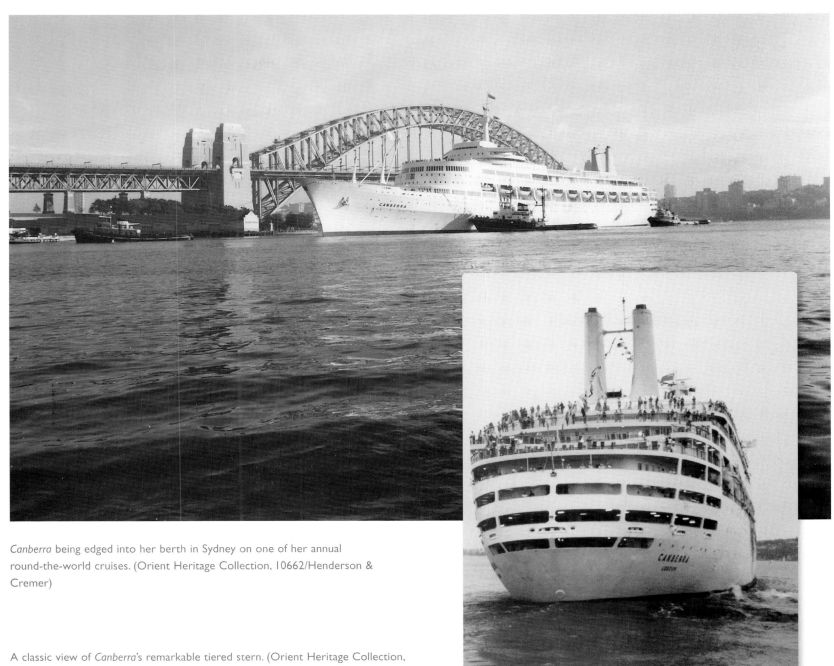

Canberra being edged into her berth in Sydney on one of her annual round-the-world cruises. (Orient Heritage Collection, 10662/Henderson & Cremer)

A classic view of *Canberra*'s remarkable tiered stern. (Orient Heritage Collection, 10291/ Henderson & Cremer)

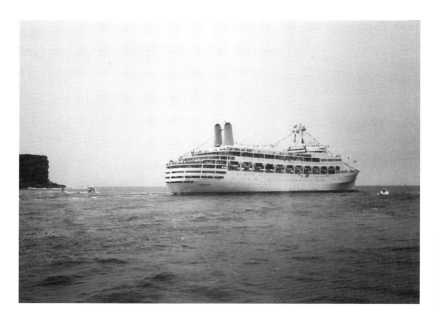

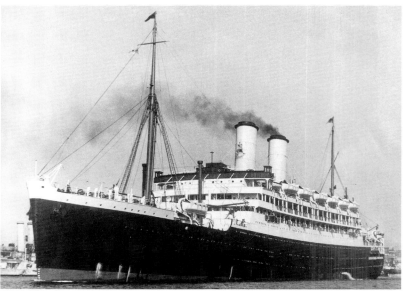

Canberra passes through Sydney Heads for the final time, the bunting is coming down but will not be forgotten. (Orient Heritage Collection, 10290/Henderson & Cremer)

Orontes II 1929–1962, 20,186 gross tons. The last of the Orient Line's famous 20,000 ton steamers, built in the 1920s, *Orontes* came under the flag of the new P&O-Orient Lines in 1960. (Orient Heritage Collection, 10506/Henderson & Cremer)

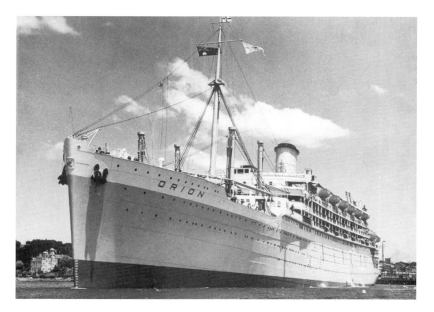

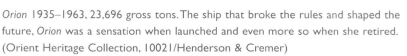

Orcades III 1948–1973, 28,396 gross tons. *Orcades* in the P&O colours which she adopted in 1964. (Orient Heritage Collection, 10415/Henderson & Cremer)

Orion 1935–1963, 23,696 gross tons. The ship that broke the rules and shaped the future, *Orion* was a sensation when launched and even more so when she retired. (Orient Heritage Collection, 10021/Henderson & Cremer)

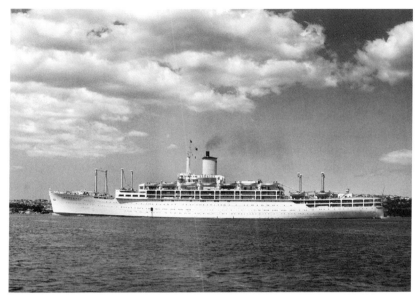

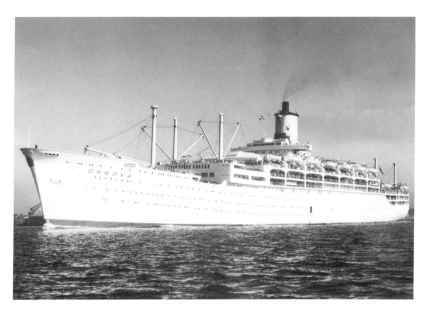

Oronsay II 1951–1975, 27,632 gross tons. The unmistakable lines of an Orient liner, bridge amidships and a simple but functional mast. (Orient Heritage Collection, 049/Henderson & Cremer)

Orsova II 1954–1974, 28,790 gross tons. The eye-catching lines of the Orient Liner *Orsova* now in P&O service. (Orient Heritage Collection, 10547/Henderson & Cremer

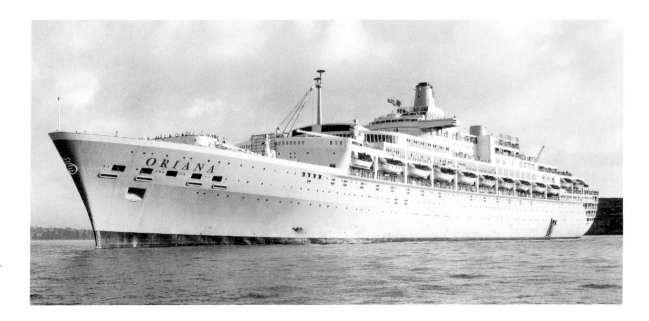

Oriana 1960–1986, 41,915 gross tons. The last Orient liner, a masterpiece in the company's progressive design of their ships. (Orient Heritage Collection, 045/ Henderson & Cremer)

on a grand scale. The workers were demanding a 17 per cent pay increase, as well as a shorter working week. Having just negotiated a 13 per cent increase the previous year, the shipping companies refused the latest demand. The result was the worst shipping strike in British maritime history. The action saw British shipping grind to a halt, and had lasting implications on passenger shipping. It signalled the beginning of the end for many passenger shipping lines. Although they survived the crisis, P&O-Orient were heavily impacted when *Canberra* and *Arcadia*, along with many other ships of the P&O-Orient fleet, became stranded in Southampton and unable to earn their keep.

In 1967, following the Arab-Israeli (Six Day) War, the Egyptian military closed the Suez Canal to all shipping by way of a blockade. The canal remained closed until 1975. This had significant and lasting implications for P&O's worldwide service, especially their services to India and the Far East. As a result of the Suez Canal closure, P&O cancelled line voyages to the Far East in 1969 and to India in 1970.

As Qantas and other airlines added more jet services, things worsened for P&O. Once Boeing 747s entered regular service in 1968, there was little that shipping companies could do to maintain yield on line voyages. This meant a dramatic change in their operations was needed, with a far greater emphasis on cruising.

Throughout the 1970s, P&O were desperately reorganising their business. This period led to the retirement of vessels, including the Orient Line's *Orcades*, *Orsova* and *Oronsay*, as well as P&O's *Himalaya* and *Iberia*. Realising that the long-distance passenger shipping market was lost to the jet, P&O sent *Canberra* to America. Here, she was sent cruising and was marketed by the Cunard Line, which was a well-established brand in the United States.

However, *Canberra* was poorly received – her British interior and class-orientated system did not appeal to Americans. In fact, so unsuccessful was she, that P&O opted to have her laid up after only a few poorly patronised cruises and cancelled all future voyages. On 1 June 1973, it was announced that the *Canberra* would be removed from service permanently.

Fortunately, following the success of their new cruise ship, *Spirit of London*, the company decided to convert the much larger *Canberra* for cruising. After a ten-week refurbishment, she entered service as a full time cruise ship in 1974, operating out of Southampton.

Oriana was refurbished in 1973 as a one-class cruise ship. She was sent to Australia where she operated voyages out of Sydney, replacing *Arcadia* which was retired in 1979. Also in 1974, P&O acquired the American Princess Cruises brand. Princess Cruises formed the basis of the future direction for the organisations cruising division, with the focus shifting from converting further P&O liners, to building new cruise ships and making new acquisitions for Princess.

In 1977, P&O was renamed P&O Cruises. With the focus now on cruising, P&O Cruises set about expanding its cruising fleet, and retiring the last of their former ocean liner tonnage until, by 1986, only *Canberra* remained.

P&O-PRINCESS

Following the 1974 acquisition of Princess Cruises, P&O invested in international cruise ships for the American brand. The two lines were strongly connected, with giant P&O lettering placed on the sides of all of the Princess Cruises ships, while Princess' growth occupied most of P&O's cruising focus for the coming decades. The acquisition was in response to the success of the P&O cruise ship, *Spirit of London*, which had been launched on 11 May 1972. With a taste for modern cruise ships, Princess was seen as the perfect platform for expansion into new markets.

In a bold move, P&O purchased *Island Princess* and *Sea Venture* in 1975. While *Island Princess* retained her name, *Sea Venture* was renamed *Pacific Princess*. The two 19,300 gross registered ton vessels were then used in the ABC Television romantic situation comedy, *The Love Boat*. The show went on to become one of America's (and the world's) most successful television series of that decade, running from 1977 through to 1986. The 249 episodes, each fifty-two minutes long, were focused on life aboard the *Pacific Princess*, though, in reality, *Island Princess* was also used for filming. The show gave Princess instant brand recognition the world over.

In 1979, the newly acquired *Sea Princess* (formerly the Swedish liner *Kungsholm*) was placed in the Australian market to replace the withdrawn *Arcadia*. The Australian cruising scene was, at that time, dominated by Sitmar's *Fairstar*, which was offering a 'no frills' casual cruise experience that the Australian public loved. So popular was *Fairstar*, that she had become embedded in the national psyche by the time *Sea Princess* arrived. *Sea Princess* failed to make inroads into the market, and so was withdrawn from the Australian market in March 1982 and returned to the UK.

In 1982, the P&O flagship *Canberra* was called into military service during the Falklands War. The 44,800 gross registered ton vessel was pulled from passenger service at the conclusion of her world cruise, and hurriedly converted into a troopship. The wartime refurbishment involved her mid-ships sun bathing deck and the space forward of the bridge being rearranged into a series of helicopter decks. No more than forty-eight hours after the refurbishment began, *Canberra* was ready to deploy. When she left Southampton, she carried with her 3,000 troops comprising of Royal Marines and the Parachute Regiment.

Other P&O ships joined *Canberra*, including the *Uganda*, which was used as a hospital ship. The P&O-owned North Sea Ferries' *Norland* and *Elk* were also sent to the Falklands, carrying troops and provisions. In addition, several ships from P&O's cargo operation were sent south for replenishing duties. *Norland* and *Canberra* performed the first landings of British troops at San Carlos, during the night of 20 May 1982, and throughout the following days the P&O vessels were in considerable danger of Exocet missile strike as the Argentine Air Force responded to the British defence of the islands.

Fortunately, the P&O vessels survived the war and, before they were released from service, *Canberra*, *Uganda* and *Elk* participated in the relocation of over 6,000 Argentinean prisoners of war. Following this, the ships returned to Southampton where they received a hero's welcome. In fact, when *Canberra* arrived home on 11 July 1982, there were an estimated 35,000 people lining the shores, while a considerable number had taken to small boats and pleasure craft to witness her return, along with the Prince of Wales arriving on board by helicopter.

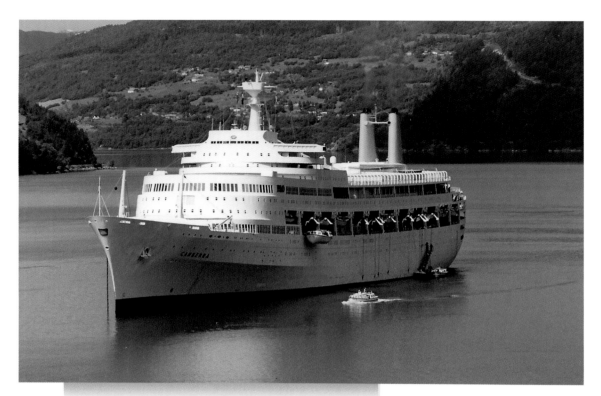

A P&O cruise to the fjords of Norway, aboard P&O's *Canberra*. (Andrew Sassoli-Walker)

• **DID YOU KNOW?** •

P&O ships each carried a ship's cat.

A more formal time

Today P&O passengers enjoy a casual on-board experience. However, in days gone by, things were a lot more formal. Captain Bennett of the *Macedonia* was enraged one evening when he observed a group of some twenty gentlemen remove their jackets in the dining room. Astonished at this breach of protocol, the captain sent a message inviting the same gentlemen to put their coats back on. Most did, but a few refused and aggravated the situation by retiring, coatless, to the music room. The following day, Captain Bennett issued a notice decrying the action and stating that it would not be tolerated, and if it happened again the miscreants would be denied admission to the formal areas, or removed.

P&O expanded its Princess Cruises fleet throughout the 1980s with new-build tonnage. In November 1984, a new 44,348 gross registered ton cruise ship arrived in Southampton. Here, she was named *Royal Princess* by HRH Princess Diana. The ship became a mainstay of Princess' American operation, and proved very popular with repeat guests.

The former Orient liner *Oriana* was retired in 1986. Following a brief layup in Pyrmont, *Oriana* was sold to Japanese interests, who intended to use her as a floating hotel in Osaka. An unsuccessful venture, she finally ended up in China as a hotel ship until she was scrapped in 2004 after partially sinking in a severe storm.

In 1987, P&O's newly acquired ferry, *Herald of Free Enterprise*, capsized after her bow doors failed to close. The disaster cost the lives of 193 people, and resulted in a lengthy, costly and damaging inquiry, which uncovered serious problems in the ferry operation. The following months and years saw P&O concentrate on improving the efficiencies of its ferry service, particularly

in light of the forthcoming Channel Tunnel train service, which opened to passengers in late 1994.

When P&O purchased Sitmar in 1988, they added considerable tonnage to their cruising operation. Sitmar's fleet of cruise ships were diverse in style, and included three large vessels in the planning phase. The acquisition included the ageing *Fairsea* and *Fairwind*, which were originally built for the Cunard line as *Sylvania* and *Carinthia*. These ships had been virtually rebuilt during the early 1970s, and were transferred to Princess Cruises, renamed *Dawn Princess* and *Fair Princess* respectively.

The newest ship then operating for Sitmar was the 1983-built, 22,120 ton, 1,212 passenger, *Fairsky*. Remarkably, she had been completed with steam turbine engines, despite diesel having well and truly superseded steam technology by the 1980s. She too was transferred to Princess, becoming *Sky Princess*.

In Australia, P&O had acquired Sitmar's *Fairstar*, and with it, gained instant dominance in the South Pacific market. *Fairstar* remained, by far, the most popular ship for Australian cruisers, having seen off all competitors, including P&O's *Sea Princess*. *Fairstar* was unlike her fleet mates and very little had been spent on her in the way of refurbishments in the years leading up to the P&O acquisition. Thus, P&O formed an Australian cruising arm, P&O Holidays, with the sole purpose to operate *Fairstar*.

The Sitmar purchase also gave P&O access to three spectacular new ships; *Star Princess*, *Crown Princess* and *Regal Princess*. While *Star Princess'* design was boxy and angular, renowned Italian designer Renzo Piano was tasked with designing her larger fleet mates. Piano incorporated a 'dolphin like' dome atop the ship's bridge, giving the sister ships a unique design unseen aboard a cruise ship at that time.

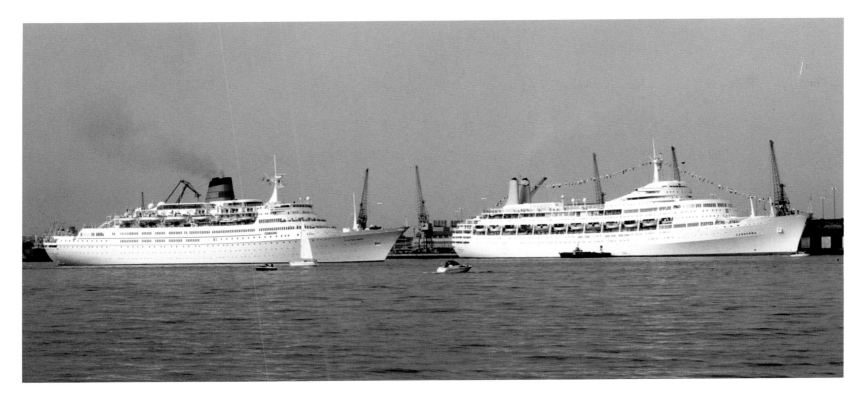

Two classic liners at Southampton; Cunard's *Vistafjord* (left) and P&O's *Canberra*. (Andrew Sassoli-Walker)

Throughout the 1990s *Canberra*'s steam turbine propulsion system was costly and difficult to maintain and repair. As such, a replacement was commissioned with the Mayer Werft yard in Papenburg, Germany. The 69,153 gross registered ton *Oriana* entered service in 1995 and with *Canberra* due to retire in 1997, P&O took the opportunity to stage a number of events where both ships would be present. This commenced with the 8 April 1995 maiden arrival of *Oriana* into Southampton, where her elder fleet mate escorted her into the port.

On 30 September 1997, after an emotional and well-patronised farewell season, *Canberra* retired from P&O service. She was emptied of all valuable assets in Southampton before sailing to the scrap yard in Pakistan.

In 1997, P&O Holidays retired the much-loved *Fairstar* after another emotional farewell season. She was replaced by *Fair Princess*, which was transferred to P&O Holidays. While she retained her Princess Cruises' name, she was given the traditional buff-coloured funnel. Princess' fleet grew further with the addition of two new liners, *Dawn Princess* and *Sun Princess*. At over 77,000 gross registered tons, these vessels were larger than *Oriana*, and could accommodate over 2,000 passengers each. They were so successful that two further ships in the series were subsequently ordered. Following *Canberra*'s departure from P&O, *Oriana* was paired with *Victoria*, the former *Sea Princess*. However, as a result of *Oriana*'s successful introduction, a larger fleet mate, *Aurora*, was ordered.

At 76,000 gross registered tons, *Aurora*'s design was a blend of the lessons learned from recent new-builds. Her stern shared the terraced appearance of *Oriana*, while her superstructure was rather more 'built up' and resembled that of *Dawn* and *Sun Princess*. Officially named on 27 April 2000 by HRH the Princess Royal, the ship suffered an embarrassing breakdown during her maiden voyage. However, she has since settled into a regular schedule of world cruises and voyages from Southampton and is a popular member of the P&O fleet.

In 1998 and 1999, Princess added two new cruise ships to their fleet, each over 108,000 gross registered tons. Named *Grand Princess* and *Golden Princess*, these vessels were the largest passenger ships ever built when they entered service. Known as the 'Grand' class, this design has become so successful that it has been used on Princess and P&O ships for over a decade.

Throughout the early years of the twenty-first century, P&O changed the structure of its business. In 2000, it separated the cruising arms from the rest of the P&O Company, and created P&O-Princess plc. P&O-Princess represented a large portion of the cruise market, and was primarily competing with the ever-growing Carnival Corporation. Carnival had gained a foothold in the British market in 1998, when it acquired Cunard Line, but it also had a strong presence throughout Europe, with Costa Crociere and Holland America Line, as well as the extremely successful Carnival Cruise Lines in the United States.

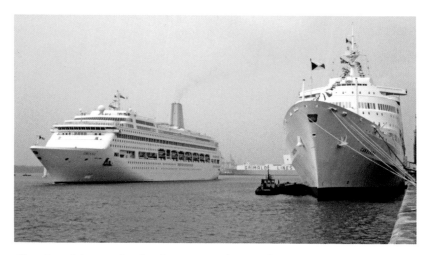

Changing of the guard at Southampton, as the new *Oriana* passes the retiring *Canberra* (Andrew Sassoli-Walker)

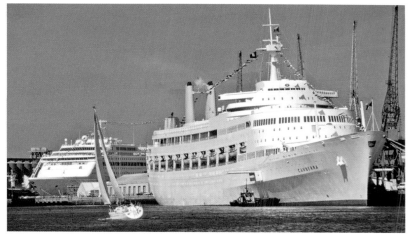

Canberra and *Oriana* together in 1997. (Andrew Sassoli-Walker)

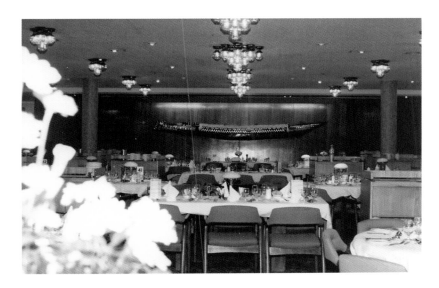
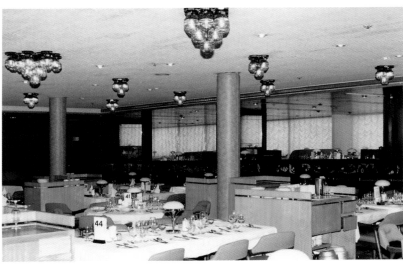

The main dining room aboard *Canberra*. (Andrew Sassoli-Walker)

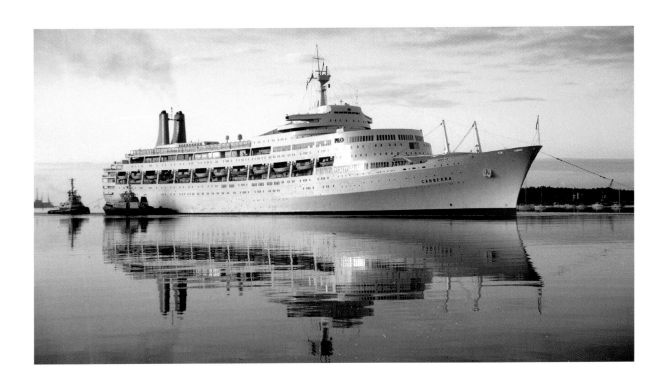

Classic lines of the *Canberra*. (Andrew
Sassoli-Walker)

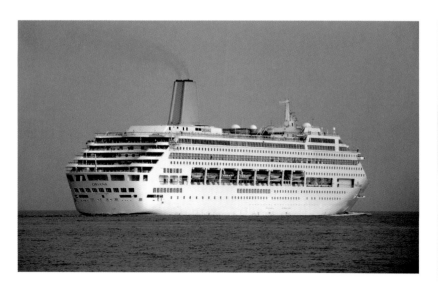

A stern view of the *Oriana* departing Southampton. (Andy Fitzsimmons)

Canberra being de-stored in Southampton, prior to scrapping. (Andrew Sassoli-Walker)

The steam turbines aboard *Canberra* were not as clean as modern diesels. (Andrew Sassoli-Walker)

Oriana departs Southampton with *Canberra* in the background. (Andrew Sassoli-Walker)

Two ships from two P&O brands: *Aurora* and *Royal Princess*. (Andrew Sassoli-Walker)

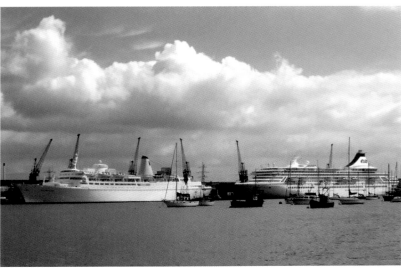

Stark comparison – the modern lines of *Royal Princess* (right) next to the classic *Victoria*. (Andrew Sassoli-Walker)

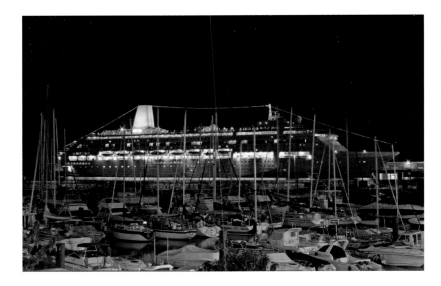

A beautiful shot of *Oriana* awaiting passengers at night. (Andrew Sassoli-Walker)

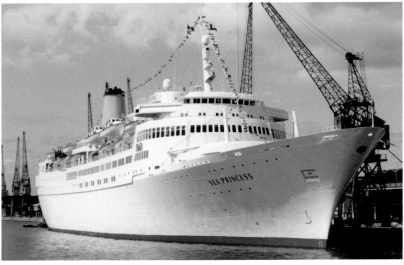

The P&O *Victoria* was originally built as an ocean liner and operated for a time as the *Sea Princess* for the P&O-owned Pricess Cruises. (Andrew Cooke)

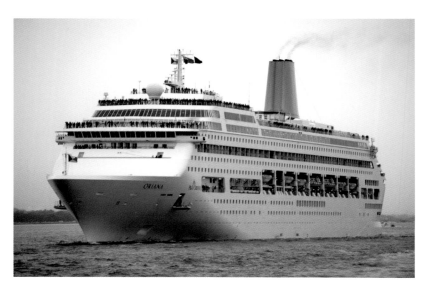

Oriana has maintained a classic and timeless appearance. (Andrew Cooke)

P&O's Australian cruise ship *Pacific Sun*. (Gavin Harper)

P&O sought to grow its British service by repositioning Princess' ships to the UK. To that end, *Sea Princess* and *Ocean Princess* were renamed *Adonia* and *Oceana*. They joined *Oriana*, *Aurora*, *Victoria* and *Arcadia* (ex. *Star Princess*). The increase in tonnage allowed the ageing *Victoria* to retire in 2002.

P&O-Princess continued to invest in its subsidiaries, including the newly formed Ocean Village brand. This move, into the leisure cruise market, resulted in *Arcadia* being renamed *Ocean Village One*.

In January 2002, Carnival Corporation made a bid for P&O-Princess. At an estimated value of £3.5 billion the bid was accepted and, by April 2003,

the merger was completed. P&O as an independent British cruise ship operation was no more.

At the time of the acquisition, the remainder of P&O, which included ports, land, ferries, cargo and bulk carrier divisions, was purchased by DP World, and continues to exist to this day, officially known as P&O Steam Navigation Co., the original firm established in 1827. Aside from its extensive physical assets, DP World also owns the P&O brand, house flag and livery, though this is used by the Carnival-owned cruising division on a gentleman's agreement.

15

P&O TODAY

Following the merger with Carnival Corporation in May 2003, P&O-Princess was reorganised as Carnival UK plc. At the time of the merger, P&O's fleet consisted of four liners based in Britain, and one ship operating in Australia. The British vessels were *Oriana*, *Aurora*, *Adonia* and *Oceana*, while in Australia *Pacific Sky* was the sole vessel operating for the P&O Cruises brand.

At the time of the merger, P&O-Princess had several subsidiaries, including AIDA, A-Rosa, Swan Hellenic and Ocean Village, each of which was retained as a separate brand under Carnival Corporation's management, with the exception of A-Rosa, which was sold to a private buyer.

Princess Cruises' fleet was separated from P&O, and the P&O logo was removed from these vessels. While Princess' head office remained in Santa Clarita, California, P&O's headquarters was moved from Westminster in London to Southampton.

The first new-build for P&O Cruises UK, under Carnival management, was the 83,781 gross registered ton *Arcadia*. Built by Fincanteri Porto Marghera, Italy, *Arcadia* is a 'Vista' class ship – a design created by fellow Carnival brand, Holland America Line. However, *Arcadia*'s design is not only owed to Holland America Line, but also Cunard Line, which entered the Carnival fold in 1998. Cunard had originally taken possession of Hull No. 6078 in 2003, intending to name her *Queen Victoria* as a running mate for the iconic *Queen Elizabeth 2* (*QE2*), and the hugely popular *Queen Mary 2* (*QM2*) which had entered service in January 2004.

However, following the success of *QM2*, whose design incorporated a lot of the ocean liner elements popular aboard *QE2*, the decision was made to alter the Vista class design for a new *Queen Victoria*, which was laid down in 2005. Thus, the well-advanced Hull 6078 was transferred to P&O to become *Arcadia*. Because of the Cunard influence on her construction, *Arcadia* sports a Cunard-styled mast, loosely based on a design pioneered by *QE2*. *Arcadia*'s funnel was also intended to have an appearance similar to that aboard *QE2* and *QM2*; however, the Cunard-style cowling and scoop were not fitted on *Arcadia*, allowing her to maintain a similar appearance to other P&O ships.

In 2004, the Australian P&O Cruises' fleet was bolstered with the addition of *Pacific Sun*. Originally built for Carnival Cruise Lines as *Jubilee*, the 47,262 gross registered ton vessel was the largest ship dedicated to the Australian market at the time.

Arcadia entered service with the UK brand in 2005 amid much fanfare. The first new-build for P&O since *Aurora*, she was the largest ship created for the line at the time of her maiden voyage.

As Carnival Corporation continued to invest in the Australian brand, P&O Cruises Australia added *Pacific Star* to their fleet. At 35,109 gross registered tons, she had commenced operations as *Tropicale* for Carnival Cruise Lines in 1986 as that brand's first ever new-build. *Pacific Star* was given an 'Aussie' refit (where American style bars and lounges were recreated to reflect Australian tastes) before entering service in 2005.

That same year, in a bid to regain its place in 'small ship' cruising, the 44,500 gross registered ton *Royal Princess* was transferred to the P&O UK brand. The ship was renamed *Artemis*, the Greek word for 'Diana' – as a tribute to Princess Diana who had christened the ship as *Royal Princess* in 1984.

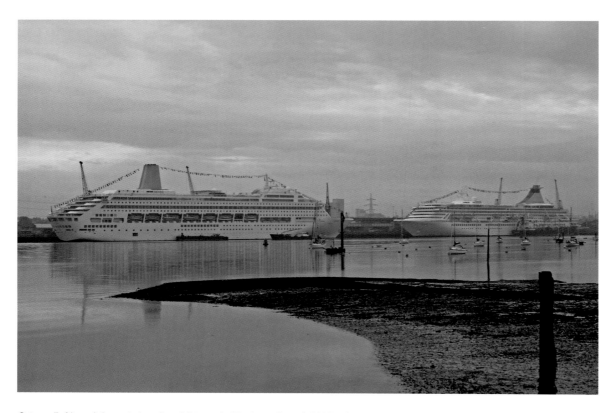

Oriana (left) and *Artemis* (ex. *Royal Princess*). (Andrew Sassoli-Walker)

Cheers! You're on a P&O Cruise! (Andrew Sassoli-Walker)

In 2006 the much-loved *Pacific Sky* left the Australian fleet. Her age and steam turbine propulsion system meant that she was costly to maintain and repair. The ship had suffered a series of embarrassing breakdowns, which expedited her removal from service. She was replaced in 2007 by the 70,200 gross registered ton *Pacific Dawn* which had been built in 1991 as the *Regal Princess*. *Pacific Dawn* brought about a new era for P&O in Australia. Her size and scale meant she could offer amenities for passengers that the previous tonnage could not, including a vast array of balcony (veranda) accommodation, and a speciality restaurant run by Australian celebrity chef, Luke Mangan.

In 2008, *Pacific Star* was moved to the Carnival brand, Costa Crociere Cruises, to concentrate on Italian cruising. This move briefly reduced the P&O Australia fleet to two ships, before it returned to three the following year with the addition of *Pacific Jewel*.

Sister ship to *Pacific Dawn*, *Pacific Jewel* shared an identical exterior profile. Originally built as *Crown Princess*, she had been operating for the Ocean Village brand. In 2008, the brand was flagged for closure as a result of the global financial crisis, and the two vessels operating for this brand were moved to P&O Cruises Australia in 2009 and 2010 respectively.

While Australian operations were expanding, the UK brand had big ship cruising well and truly on the agenda, with P&O Cruises UK adding two ships of over 100,000 gross registered tons between 2008 and 2010. Built at Fincanteri Monfalcone, Italy, the 116,017 gross registered ton *Ventura*, and her sister ship, the 115,055 gross registered ton, *Azura*, were both of the Princess Cruises' 'Grand' class design.

While particular care had been taken to disguise *Arcadia*'s Cunard origins, little effort was made to modify the exterior profile for *Ventura* and

Oriana is the fastest of the modern P&O cruise ships. (Andrew Sassoli-Walker)

Oriana's terraced aft deck is popular with passengers. (Andrew Sassoli-Walker)

Oriana (right) with *QE2* in Southampton. (Andrew Sassoli-Walker)

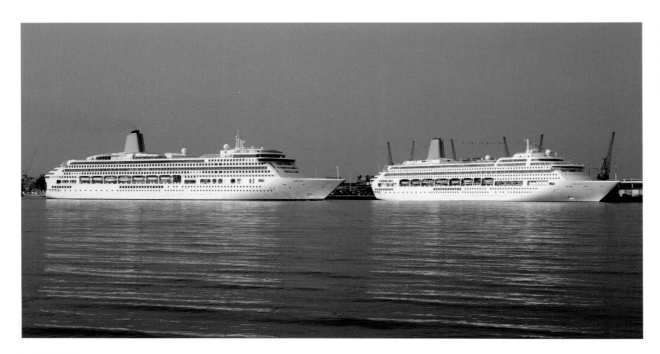

Sisters, not twins – this image shows the similarities and differences of P&O's *Oriana* and her newer, larger sister *Aurora*. (Andrew Sassoli-Walker)

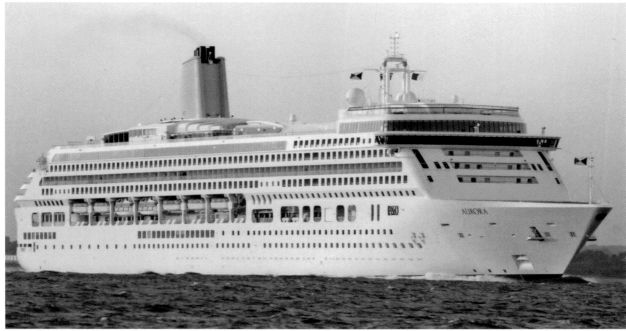

Aurora strikes a rather imposing image from this angle. The design was influenced by *Oriana* as well as newer Princess Ships such as *Dawn Princess*. (Andrew Sassoli-Walker)

The classic stern structure of *Aurora* is clearly evident here. (Andrew Sassoli-Walker)

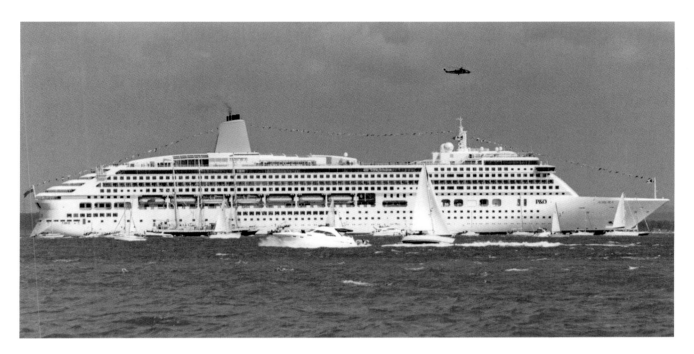

The departing *Oriana* (foreground) passes *Aurora*. (Andrew Sassoli-Walker)

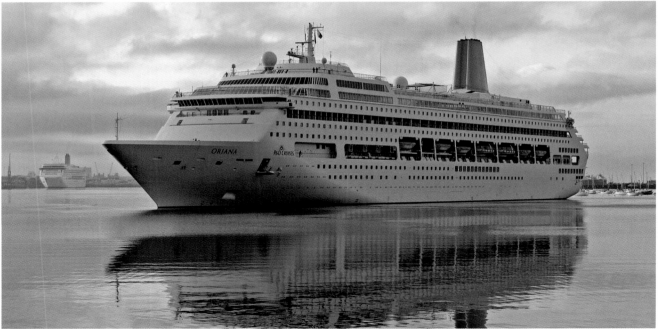

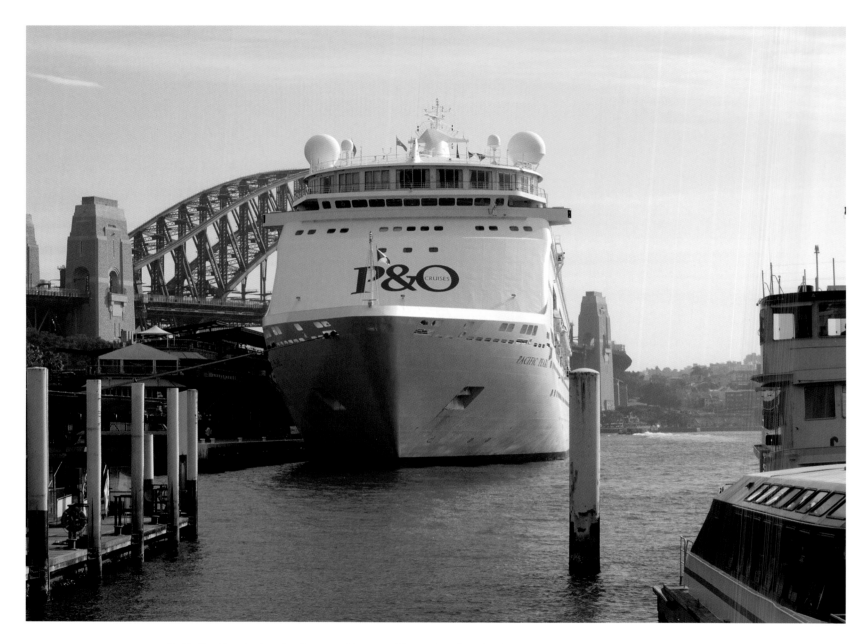

Pacific Pearl berthed at the Overseas Passenger Terminal at Circular Quay in Sydney Harbour. (Frame & Cross)

Sydney has long been the home of Australian P&O Cruises. This view of the Sydney Harbour Bridge was taken from the aft decks of *Pacific Pearl*. (Frame & Cross)

The Sydney Opera House viewed from *Pacific Pearl*. (Frame & Cross)

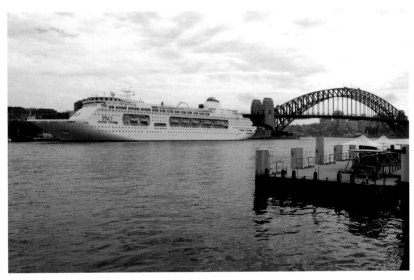

Pacific Pearl at rest in Sydney. (Frame & Cross)

• DID YOU KNOW? •

While the British P&O Cruises fleet has been re-registered in Hamilton, Bermuda, the Australian fleet remain registered in London, England.

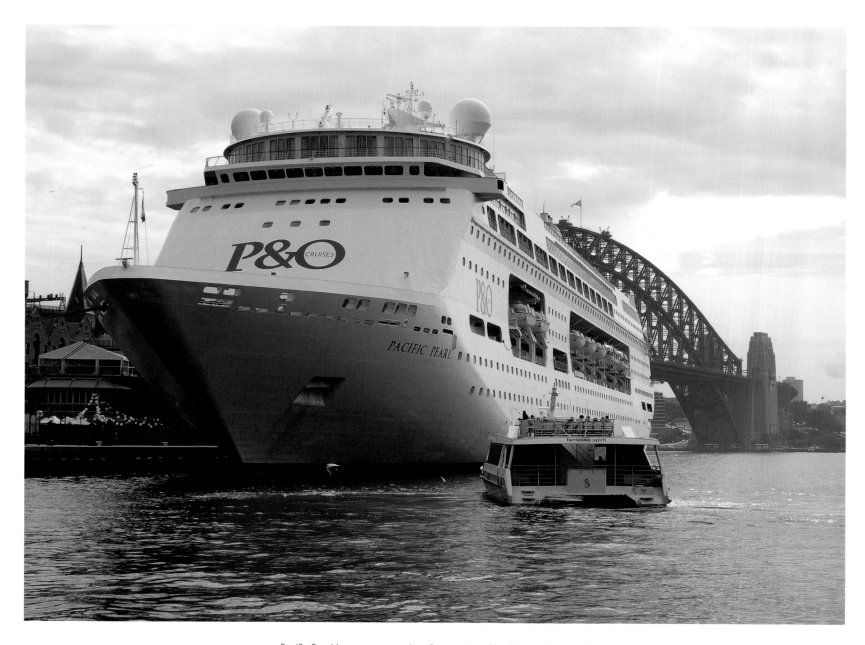

Pacific Pearl has a commanding forward profile. (Frame & Cross)

The atrium aboard *Pacific Jewel* has been 'Australianised' with new colours and hues. (Frame & Cross)

Azura. To that end, they both sport the large, Princess-style funnel, with a buff-coloured P&O funnel-shaped panel attached to the side, and with this exception, could be mistaken for a Princess' 'Grand' class vessel.

While designed to appeal to the mass market (*Oriana* and *Aurora* being smaller, more intimate and thus more popular with traditional P&O cruisers), these ships perform a valuable function within the P&O UK fleet. Their high capacity (*Ventura* carries over 3,500 passengers at maximum capacity) means they are money-makers for P&O, offering excellent economies of scale and securing a firm base from which the line can grow.

In Australia, the fleet increased to four ships, with *Pacific Pearl* entering service in 2010, following the closure of Ocean Village. That same year, in a long overdue first, a woman took command of a P&O flagged passenger liner. Captain Sarah Bretton was in command of P&O Cruises UK's *Artemis*, before transferring to P&O Cruises Australia to take command of *Pacific Pearl*.

In 2011, *Artemis* moved to Artania Shipping, where she was renamed *Artania*. She had been sold in 2009, and leased back to P&O. Upon leaving the P&O fleet, she was refurbished and leased to Phoenix-Reisen.

A new addition to the P&O fleet in 2011 saw the line retain its 'small ship' offering. The 30,200 gross registered ton *Adonia* was originally built in 2001 as *R-Eight*, for the now defunct Renaissance Cruises. Her small scale and intimate on-board atmosphere makes her popular with repeat guests.

On 3 July 2012 P&O officially celebrated its 175th anniversary. In a grand event held in Southampton, all seven ships of the British P&O Cruises fleet rendezvoused in the port at the same time. This symbolic gesture was mirrored with a series of events held in Sydney, to mark the occasion with the Australian fleet. The event was officially overseen by HRH the Princess Royal who had named both *Aurora* and *Oceana*. P&O's then UK managing director, Carol Marlow, said, 'As one of our esteemed godmothers,

Preparing for another shore excursion: A tender boat is lowered during a cruise.
(Frame & Cross)

Dining Late

It is said that, in earlier years, if a passenger arrived late in the dining room of a P&O ship, then their steward would start their meal at the same course that the captain was presently on. So, if you were late to the extent that the captain was on the third or fourth course, then that is where your meal started, the preceding courses were not for you!

Princess Anne's presence and the congregation of our entire fleet to celebrate 175 years of heritage will go down in British maritime history and provide long-lasting memories.' That afternoon, all seven UK-based ships departed the port in tandem, offering a spectacular parade down Southampton Water never before seen in P&O's history.

On 15 May 2013, P&O Cruises UK celebrated the keel-laying ceremony for their new flagship. Named *Britannia*, the 141,000 gross registered ton ship is the largest ship built for the line to date. In fact, at that tonnage, she is second only in size to Cunard's *Queen Mary 2* within the Carnival Corporation fleet. While based on the Princess Cruises' 'Royal Class', *Britannia*, much to the delight of P&O loyalists, has been completed with twin P&O-style funnels, and classic P&O interiors. P&O UK have recently ended a long tradition of painting their funnels in buff colour. *Britannia*, along with all ships in the British-based P&O fleet will now sport blue funnels with a stylised union flag livery on the bow. With renewed tonnage, a growing market share in Britain and dominance in the Australian cruise market, the P&O Cruises

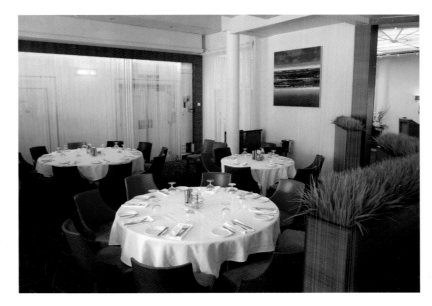

The main dining room aboard P&O Cruises' *Pacific Jewel*. (Frame & Cross)

name remains strong, with two additional vessels joining the fleet. Named *Pacific Eden* and *Pacific Aria*, the former Holland America Line ships joined the fleet in 2015 allowing P&O to expand its presence in Australia.

While it may be considered small compared to its heyday – as the premier Royal Mail line to India, Australia and the Far East – P&O Cruises has adapted to a changing landscape, and has become a significant brand within the Carnival Corporation family.

Throughout its history, P&O survived by remaining relevant; be it the negotiation of mail contracts, the commencement of branch line services, a move into cargo, or the consolidation of services, and careful expansion in the cruising market, the line has prospered. So long as P&O strives to remain relevant to the needs of the current and future passenger, we should see the red, blue, yellow and white quartered flag flying above a P&O Cruises ship for centuries to come.

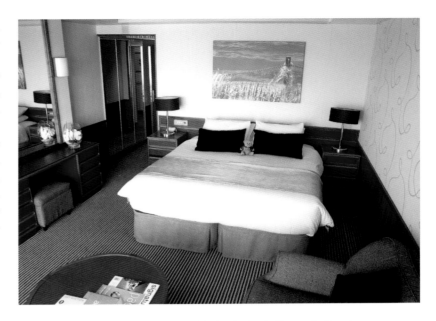

A standard balcony cabin aboard P&O's *Pacific Pearl*. (Frame & Cross)

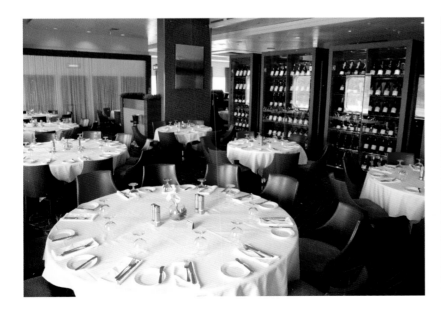

The main dining room aboard *Pacific Jewel*. (Frame & Cross)

Food is always popular aboard. This image taken aboard *Pacific Jewel*. (Frame & Cross)

P&O's Australian ships offer outdoor entertainment, including circus performances. (Frame & Cross)

Outdoor pool areas are popular during cruises. This image taken aboard *Pacific Jewel* shows the giant movie screen used for 'movies under the stars'. (Frame & Cross)

P&O's Australian fleet offer sports activities aboard including rock climbing walls. (Frame & Cross)

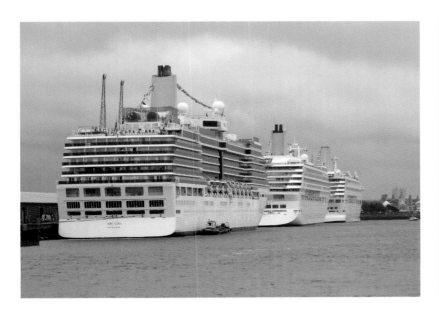

Arcadia, *Aurora* and *Oriana* during P&O's 175th anniversary event. (Andrew Cooke)

P&O's *Ventura*, *Arcadia* and *Aurora* sailing in a line from Southampton. (Andrew Cooke)

The P&O UK fleet depart Southampton in tandem during the 175th anniversary celebrations. (Andrew Cooke)

Adonia, *Ventura*, *Arcadia*, *Aurora* & *Oriana* departing Southampton. (Andrew Cooke)

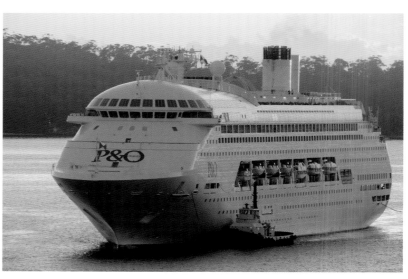

Oriana, *Azura* and *Oceana* at P&O Cruises' 175th anniversary event. (Andrew Cooke)

P&O Cruises' *Pacific Jewel*. (Patricia Dempsey)

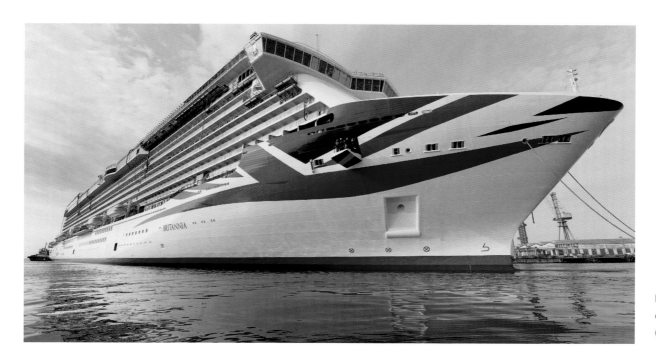

P&O UK's new flagship, Britannia, complete with the line's new livery. (James D. Morgan / P&O Cruises)

P&O's *Pacific Jewel* alongside Circular Quay in Sydney. (Patricia Dempsey)

APPENDIX I

Early Postcards

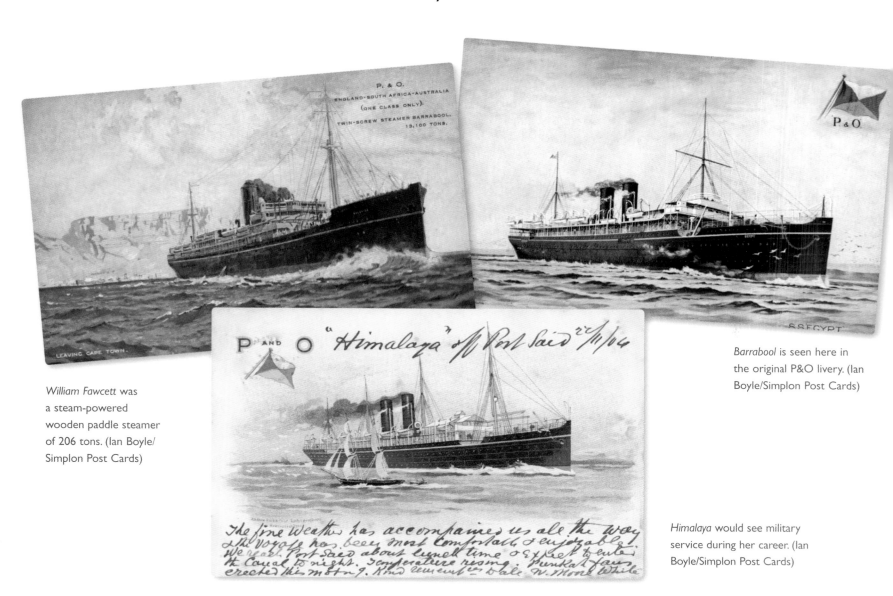

William Fawcett was a steam-powered wooden paddle steamer of 206 tons. (Ian Boyle/Simplon Post Cards)

Barrabool is seen here in the original P&O livery. (Ian Boyle/Simplon Post Cards)

Himalaya would see military service during her career. (Ian Boyle/Simplon Post Cards)

APPENDIX 2

Brochures and Advertisements – from the Henderson & Cremer Collection.

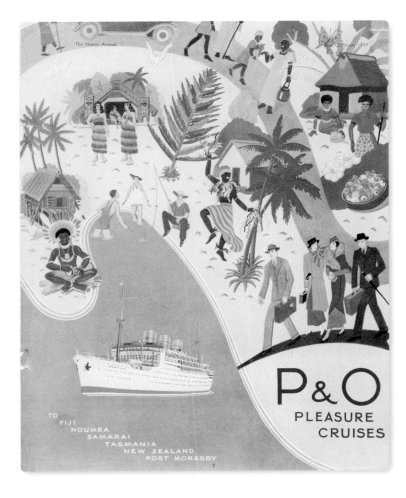

THE NEW STRATHMORE

R.M.S. Strathmore.

24,500 TONS

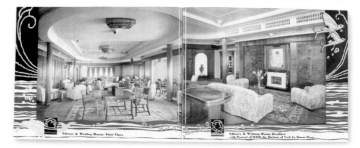

Library & Waiting Room—First Class

Library & Waiting Room Fireplace
with Portrait of H.R.H. the Duchess of York by Simon Elwes

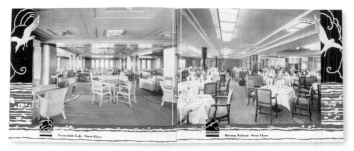

Verandah Cafe—First Class

Dining Saloon—First Class

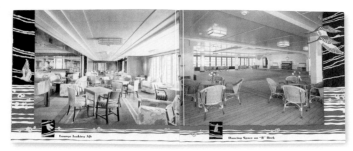

Lounge looking Aft

Dancing Space on "B" Deck

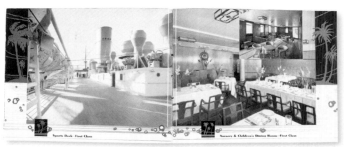

Sports Deck—First Class

Nursery & Children's Dining Room—First Class

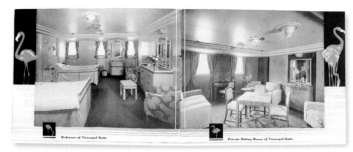

Bedroom of Viceregal Suite

Private Sitting Room of Viceregal Suite

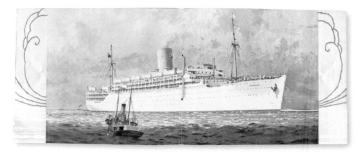

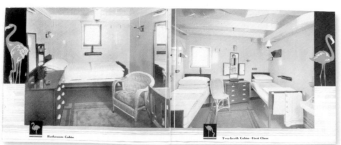

Bathroom Cabin

Two-berth Cabin—First Class

THE NEW STRATHMORE

P&O

STRATHAIRD STRATHNAVER

THE · WHITE · SISTERS

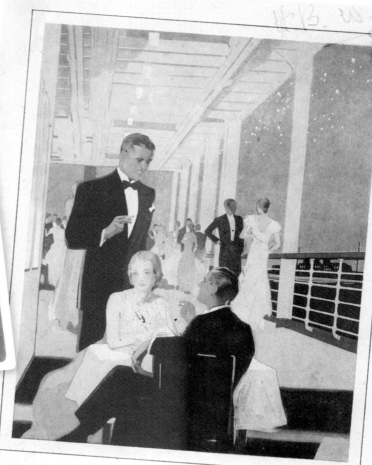

B . I . MENU

P&O *Pleasure Cruises*

to FIJI · PAPUA · NOUMEA · TASMANIA · NEW ZEALAND

P&O CRUISES

To the Mediterranean, Black Sea, Iceland, Norway and B...

MAGIC NIGHTS...MERRY DAYS.

P & O CRUISES

For accommodation apply:
P. & O., 14 COCKSPUR STREET, S.W.1.
130 LEADENHALL STREET, E.C.3.
AUSTRALIA HOUSE, STRAND, W.C.2.

WE'LL LOOK AFTER YOU ON THE

P & O

P & O CRUISES, 14, COCKSPUR ST., S.W.1
130, LEADENHALL STREET, E.C.3.
AUSTRALIA HOUSE, STRAND, W.C.2
OR AGENTS.

L.A.

P & O CRUISES IN 1938, WILL CARRY FIRST CLASS PASSENGERS ON THE RAJPUTANA, AND THE VICEROY OF INDIA AND FIRST AND TOURIST ON THE STRATHAIRD STRATHMORE, STRATHEDEN, STRATHALLAN – THE FINEST CRUISING FLEET AFLOAT.

THE IDEAL HOLIDAY – A P&O CRUISE

What is necessary for the ideal holiday? Sunshine, companionship, comfort, good food and interesting places to be seen? All these qualities can justly be claimed for a P. & O. cruise.

The splendid new "Strath" steamers and the luxurious "Viceroy of India" permit you to cruise in comfort, well looked after, and amid that companionship which is so marked a feature of life at sea.

And as for interesting places—Rome, Venice, Naples, Athens, Istanbul, Helsingfors, Iceland—who has not ardently desired to see them? A glance at this brochure will tell you how it can be done.

EASTER CRUISE to TASMANIA by R.M.S. NARKUNDA

A DELIGHTFUL seven days' Cruise offering the full enjoyment of the Easter vacation aboard a modern P. & O. Liner.

Days and nights at sea, in which the sports, pastimes and social life of a great Liner are happily blended, may be fully enjoyed.

Passengers will have the opportunity of visiting Melbourne and Hobart.

R.M.S. "NARKUNDA"
LEAVES SYDNEY ON MARCH 29th,
AND RETURNING ON APRIL 5th.

FARES:
FIRST SALOON ONLY
FROM 11 to 12 GUINEAS
all State of Exchange

MACDONALD, HAMILTON & CO. 247 GEORGE STREET, SYDNEY

P&O ROYAL MAIL LINERS

ADVANCE PUBLICATION NOTICE

"MEMORIES—MAINLY MERRY"
By MARCUS MARKS

Mr. Marcus Marks is the late Supervisor of "Hansard" of the Parliament of New Zealand and Government Printer. In the Dominion, Mr. Marks has the reputation of being one of the finest raconteurs of after-dinner stories.

Many well-known Australian and New Zealand political personalities are mentioned in this delightful collection of Memories. There's a smile on every page.

"MEMORIES—MAINLY MERRY," by Marcus Marks. On sale at the end of February at all booksellers and newsagents, or direct from THE BULLETIN ... all State ... Chambers, 14 Panama Street, Wellington, N.Z.

AN ENDEAVOUR PRESS BOOK

Buy Australian Books
A list of Books already Available and to be Published will be sent with respect to the Australian Book Publishing Co. ... George Street, Sydney.

✕ "Bulletin" Service Coupon (See Page 34)
31/2/38

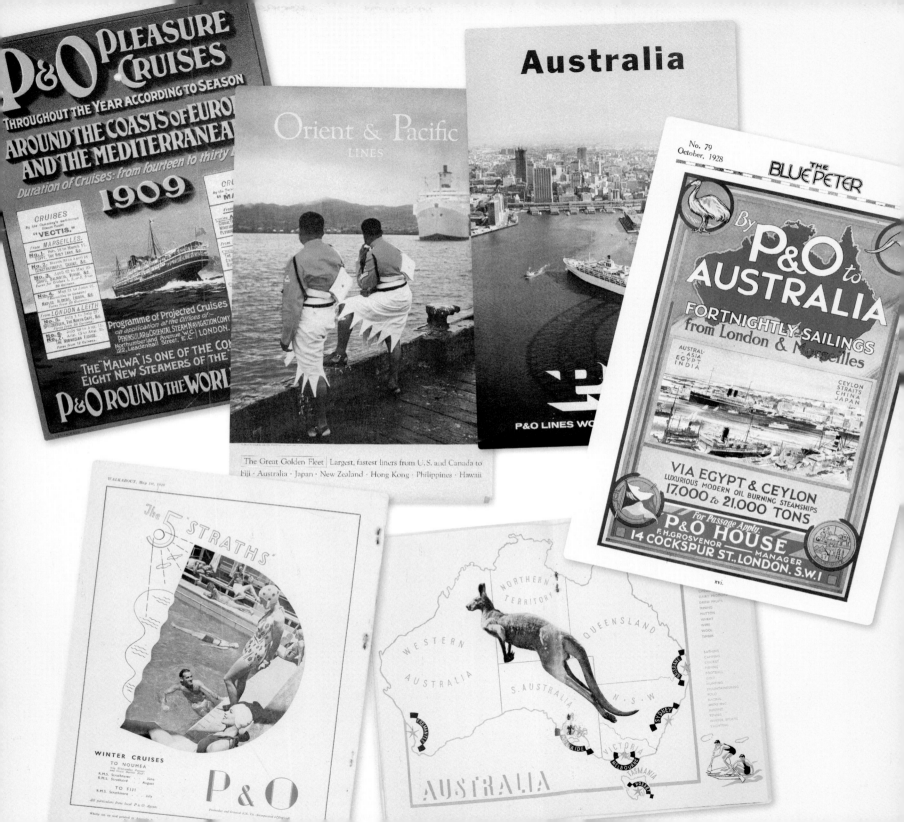

APPENDIX 3

P&O Ships List

P&O Ships used on the Australia service. Listed in order of use in Australia.

Ship	In P&O Service	Australian Service	Trips To Aust.	Gross Tons	Capacity			% of Capacity		Notes
					First	Second	One	1st	2nd	
Chusan	1852–1861	1852–1854	6	700						Built by Miller, Ravenhill & Co. Ltd, Walker-on-Tyne. Iron, 9.5 knots, single screw, 800ihp. 1857 troopship. 1860 troopship.
Formosa	1852–1870	1852	1	637						Built by Smith & Rodger, Govan. Iron, 8 knots, single screw, 800ihp. 1861 chartered French troopship.
Shanghai	1851–1862	1853	2	546	40					Built by Miller, Ravenhill & Co. Ltd, Blackwall. Iron, 8 knots, single screw, 100ihp. Company's first sea-going screw steamer. 1860 troopship. 1861 French charter.
Madras	1852–1874	1854–1866	22	1,185	80	nil				Built by Todd & MacGregor, Glasgow. Iron, 9.5 knots, single screw, 745ihp. 1852 trooping. 1857 troopship during Indian Mutiny. 1867–68 troopship Abyssinian War
Norna	1853–1871	1854	2	970						Built by Todd & MacGregor, Glasgow. Iron, 10 knots, single screw, 624ihp. 1867–68 troopship Abyssinian War.
Salsette	1858–1871	1859–1865	10	1,491	90	30		75	25	Built by Todd & MacGregor, Glasgow. Iron, 11 knots, single screw, 1,550ihp. 1867–68 troopship Abyssinian War.

Ship	In P&O Service	Australian Service	Trips To Aust.	Gross Tons	Capacity			% of Capacity		Notes
					First	Second	One	1st	2nd	
Emeu	1859–1873	1859–1860	3	1,538	80	nil				Built by R. Napier & Sons, Govan. Iron, 12 knots, single screw, 300ihp. 1854 sold to Cunard. 1858 purchased by P&O.
Benares	1858–1868	1859–1862	7	1,491	90	30		75	25	Built by Todd & MacGregor, Glasgow. Iron, 12 knots, single screw, 1,373ihp. May 1868 ran aground in China Sea and lost.
Malta	1848–1876	1859–1870	11	1,217	18	18		50	50	Built by Laird & Co., Birkenhead. Iron paddle, 10 knots, 1,217ihp. 1858, lengthened, re-engined, re-rigged.
Columbian	1859–1865	1859	2	2,180	150					Built by W. Simons & Co. Ltd, Glasgow. Iron, 12.5 knots, single screw, 2,116ihp. Launched 1855 for European & Columbian Co. 1859 purchased by P&O. 1865 sold in part payment for *Mongolia*. 1866 purchased by P&O.
Northam	1858–1868	1859–1865	21	1,330	97	30		76	24	Built by Summers, Day & Co., Southampton. Iron, 13.5 knots, single screw, 1,514ihp.
Bombay II	1852–1878	1859–1868	27	1,186						Built by Todd & MacGregor, Glasgow. Iron, 10 knots, single screw, 750ihp.
Ottawa	1857–1872	1860	1	1,275	100					Built by John Laird, Sons & Co., Birkenhead. Iron, 10 knots, single screw, 700ihp. 1854 owned by Canadian Steam Navigation Co. 1854 Crimean War service. 1857 Purchased by P&O. 1867–68 troopship Abyssinian War.
Jeddo	1859–1866	1860–1865	5	1,631						Built by John Laird, Sons & Co. Iron, 13 knots, single screw, 960ihp. 1866 ran aground and lost south of Bombay.
Behar	1858–1874	1860–1872	5	1,603						1855 built by John Laird, Sons & Co. Iron, 11 knots, single screw, 900ihp. 1858 purchased by P&O.
Ellora	1859–1876	1865–1874	5	1,574						1855 built by John Laird, Sons & Co. Iron, 12.5 knots, single screw, 1,055ihp. 1858 purchased by P&O.

Ship	In P&O Service	Australian Service	Trips To Aust.	Gross Tons	Capacity			% of Capacity		Notes
					First	Second	One	1st	2nd	
Geelong	1866–1887	1866–1871	22	1,584	29					1865 built by Wm Denny & Bros, Dumbarton. Iron, 11.5 knots, single screw, 1,200ihp. 1865 purchased by P&O. 1881 troopship.
Avoca	1866–1882	1866–1867	22	1,482	60	21		74	26	Built by Wm Denny & Bros, Dumbarton. Iron, 11 knots, single screw, 250ihp. 1874 refit and re-engined. 1882 troopship during Egypt campaign.
Rangoon	1863–1871	1870–1871	5	1,776						Built by Samuda Bros, Blackwall. Iron, 12 knots, single screw, 1,870ihp. 1871 on rocks and lost outside Point de Galle.
Malacca	1866–1882	1871	1	1,584						Built by Denton, Gray & Co., Hartlepool. Iron, 11.5 knots, single screw, 1,200ihp.
Nubia	1854–1877	1871–1875	12	2,096						Built by John Laird, Sons & Co., Birkenhead. Iron, 11 knots, single screw, 1,422ihp. 1854 Crimean War transport.
Bangalore	1867–1886	1871–1880	19	2,063	123	36		77	23	Built by Wm Denny & Bros, Dumbarton. Iron, 10 knots, single screw, 2,255ihp. 1875 refit and re-engined etc. 1878 troopship. 1885 troopship Egypt campaign.
Baroda	1864–1881	1872–1874	10	1,874	150	40		79	21	Built by Thames Iron Works & Shipbuilding Co., Blackwall. Iron, 11 knots, single screw, 2,486ihp.
Tanjore	1865–1888	1872–1880	16	2,245	118	30		80	20	Built by Thames Iron Works & Shipbuilding Co., Blackwall. Iron, 13 knots, single screw, 2,090ihp.
Mooltan	1860–1880	1873	1	2,257	112	37		79	21	Built by Thames Iron Works & Shipbuilding Co., Blackwall. Iron, 12 knots, single screw, 1,734ihp.
Sumatra	1867–1886	1873–1876	4	2,202	180	60		75	25	Built by Wm Denny & Bros, Dumbarton. Iron, 14 knots, single screw, 2,277ihp.
China	1859–1882		8	2,009						1855 built by John Laird, Sons & Co., Birkenhead. Iron, 11.5 knots single screw, 1,488ihp. 1858 purchased by P&O.

Ship	In P&O Service	Australian Service	Trips To Aust.	Gross Tons	Capacity			% of Capacity		Notes
					First	Second	One	1st	2nd	
Pera	1855–1859	1873–1875	7	2,014	126	36		78	22	Built by C.J. Mare & Co., Blackwall. Iron, 11 knots, single screw, 12.5 knots.
Golconda	1863–1881	1874–1875	3	1,909						Built by Thames Iron Works & Shipbuilding Co., Blackwall. Iron, 10 knots, single screw, 2,112ihp. 1867–68 troopship Abyssinian War.
Ceylon	1858–1881	1874–1875	3	2,110	130	30		81	19	Built by Samuda Bros, Poplar. Iron, 13 knots, single screw, 2,054ihp.
Mongolia	1865–1888	1875	1	2,799	130	41		76	24	Built by Scott & Co., Cartsdyke. Iron, 10 knots, single screw, 1,705ihp.
Assam	1875–1895 1881 refit	1876–1884	21	3,033	144 81	68 28		68 74	32 26	1873 Built by Caird & Co. Ltd, Greenock. 12 knots, single screw, 2,920ihp. 1875 purchased by P&O.

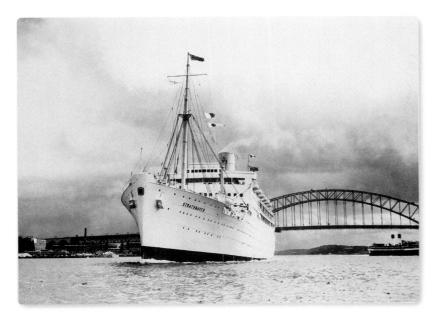

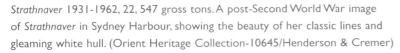

Strathnaver 1931-1962, 22, 547 gross tons. A post-Second World War image of *Strathnaver* in Sydney Harbour, showing the beauty of her classic lines and gleaming white hull. (Orient Heritage Collection-10645/Henderson & Cremer)

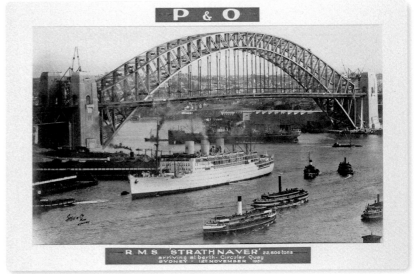

A crowded harbour scene shows *Strathnaver* on her maiden arrival in Sydney in 1931, the black-hulled steamer passing behind is the Branch Line ship *Balranald*. (Orient Heritage Collection-40009/Henderson & Cremer)

Ship	In P&O Service	Australian Service	Trips To Aust.	Gross Tons	Capacity			% of Capacity		Notes
					First	Second	One	1st	2nd	
Travancore	1867–1880	1877	1	1,900	85	34		71	29	Built by John Key & Sons, Kirkcaldy. Iron, 12 knots, single screw, 1,428ihp. 1880 lost south of Otranto on voyage to Venice.
Siam	1875–1895 1881 refit	1877–1883	15	3,026 3,068	144 81	68 28		68 74	32 26	1873 built by Caird & Co., Greenock. Iron, 12 knots, single screw, 2,920ihp. 1875 purchased by P&O.
Indus II	1871–1885	1880–1885	10	3,462	129	50		72	28	Built by Wm Denny & Bros, Dumbarton. Iron, 13 knots, single screw, 2,368ihp. 1885 lost on shoal south of Trincomalee, Ceylon.
Deccan	1868–1889 1884 refit	1880	1	3,128 3,429	182 85	82 20		69 81	31 19	Built by Wm Denny & Bros, Dumbarton. Iron, 13.75 knots, single screw, 2,584ihp. 1882 troopship Egypt campaign. 1884–86 trooping.
Malwa	1873–1894 1875 refit	1880–1882	5	2,933 2,957	143 95	42 16		77 86	23 14	Built by Caird & Co., Greenock. Iron, 10.5 knots, single screw, 2,735ihp. 1874 brought home the body of David Livingston.
Hydaspes	1872–1898 1885 refit	1880–1882	8	2,984 2,996	126 108	49 24		72 82	28 18	Built by Wm Denny & Bros, Dumbarton. Iron, 12 knots, single screw, 2,052ihp. 1882 troopship Egypt campaign.
Kaisar-I-Hind	1878–1897 1884 refit	1882–1887	6	4,023 4,008	176 141	64 50		73 74	27 26	Built by Caird & Co., Greenock. Iron, 15 knots, single screw, 3,800ihp. First P&O steamer fitted with refrigerating machinery. 1893 trooping.
Rosetta	1880–1900	1880–1879	6	3,502	81	30		73	27	Built by Harland & Wolff, Belfast. Iron, 13.5 knots, single screw, 2,890ihp. 1885 armed merchant cruiser during diplomatic tension with Russia.
Khedive	1871–1897 1884 refit	1880–1885	3	3,742 3,868	164 139	53 44		76 76	24 24	Built by Caird & Co., Greenock. Iron, 13 knots, single screw, 2,695ihp.
Bokhara	1873–1892 1874	1880–1881	4	2,932 2,955	133 105	56 16		70 87	30 13	Built by Caird & Co., Greenock. Iron, 12 knots, single screw, 2,037ihp. 1884 transport Suez to Suakin during Egyptian War. 1892 ashore and lost in the Pescadores.
Cathay	1872–1895 1884 refit	1880–1884	7	2,983	130 108	49 24		73 82	27 18	Built by Wm Denny & Bros, Dumbarton. Iron, 13 knots, single screw, 2,086ihp.

Ship	In P&O Service	Australian Service	Trips To Aust.	Gross Tons	Capacity			% of Capacity		Notes
					First	Second	One	1st	2nd	
Rohilla	1880–1900 1884 refit	1880–1882	4	3,511 3,387	81 100	30 32		73 76	27 24	Built by Caird & Co., Greenock. Iron, 14 knots, single screw, 3,386ihp.
Peshawur	1871–1900 1884 refit	1880–1885	5	3,782 3,906	164 139	53 42		76 77	24 23	Built by Caird & Co., Greenock. Iron, 11 knots, single screw, 2,962ihp.
Brindisi	1880–1899 1884 refit 1889 refit	1880	1	3,553 3,474 3,505	94 94 50	48 29 nil		66 76	34 24	Built by William Doxford & Sons, Sunderland. Iron, 13.5 knots, single screw.
Kashgar	1874–1889	1881	1	2,621	80	40		67	33	1873 built by James Laing, Sunderland. Iron, 11 knots, single screw, 2,101ihp. 1874 purchased by P&O. 1886 trooping.

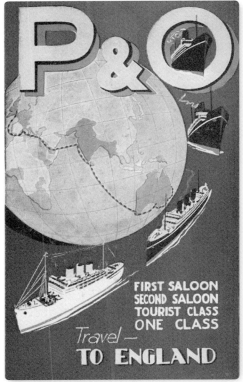

A 1933 Australian brochure for the P&O services to England. (Orient Heritage Collection/ Henderson & Cremer)

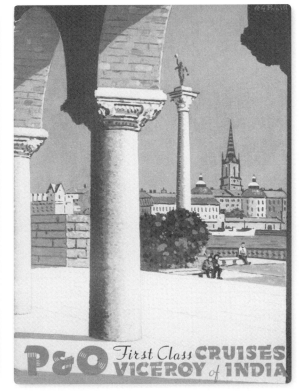

One of the many brilliantly illustrated brochures advertising P&O cruises from the the UK. (P&O Heritage Collection/ Henderson & Cremer)

Ship	In P&O Service	Australian Service	Trips To Aust.	Gross Tons	Capacity			% of Capacity		Notes
					First	Second	One	1st	2nd	
Venetia	1873–1893	1881	2	2,726	51	30		63	37	Built by Wm Denny & Bros, Dumbarton. Iron, 12 knots, single screw, 1,944ihp. 1885 transport to the East.
Ravenna	1880–1898 1888 refit	1881–1889	4	3,340 3,257	81 67	30 19		73 78	27 22	Built by Wm Denny & Bros, Dumbarton. First ship built by P&O. Steel, 14 knots, single screw, 3,342ihp.
Rome	1881–1912 1885 refit 1904 refit	1881–1903	48	5,010 4,879 3,141	187 148 150	146 100 nil		56 60	44 40	Built by Caird & Co., Greenock. Iron, 14.5 knots, single screw, 4,677ihp. First real attempt to counter the Orient Line's arrival on the Australian trade in 1877. 1891 new triple engines, 6,000ihp. 1904 became P&O's first cruise ship Vectis.
Carthage	1881–1903 1885 refit	1881–1892	24	5,013 4,885	153 147	46 100		77 60	23 40	Built by Caird & Co., Greenock. Iron, 15 knots, single screw, 4,600ihp, four cylinder compound inverted tandem engine. 1900–01 transport/hospital ship Boxer Rebellion
Surat	1866–1894 1874 refit	1881–1887	2	2,578 3,142	174	44		80	20	Built by C.A. Day & Co., Northam, Southampton. Iron, 12.5 knots, single screw, 2,516ihp. 1882 troopship Egyptian campaign.
Mirzapore	1871–1897	1881–1884	5	3,763	140	44		76	24	Built by Caird & Co., Greenock. Iron, 11 knots, single screw, 3,182ihp.
Shannon	1881–1901 1884	1882–1899	16	4,189 4,077	120 163	48 58		71 74	29 26	Built by Harland & Wolff, Belfast. Last P&O ship built with iron hull. 14.5 knots, single screw, 4,400ihp.
Clyde	1881–1901 1884 refit	1882–1887	11	4,136 4,099	123 136	48 60		72 69	28 31	Built by Wm Denny & Bros, Dumbarton. 15 knots, single screw, 5,240ihp.
Sutlej	1882–1900 1884 refit	1882–1886	7	4,205 4,164	120 140	48 60		71 70	29 30	Built by Barrow Shipbuilding Co. Ltd, Barrow-in-Furness. 15 knots, single screw, 5,240ihp. 1898 trooping to South Africa.
Verona	1879–1899 1887 refit	1882	1	3,069 3,130	130 95	54 32		71 75	29 25	Built by Caird & Co., Greenock. Iron, 12.5 knots, single screw, 3,202ihp.
Ancona	1879–1899 1883 refit 1888 refit	1882	1	3,081 3,142	130 86 91	54 30 32		71 74 74	29 26 76	Built by Caird & Co., Greenock. Iron, 12.5 knots, single screw, 3,202ihp.
Ballaarat	1882–1904 1889 refit	1882–1897	36	4,764 4,748	160 163	48 77		77 68	23 32	Built by Caird & Co. Ltd, Greenock. 14 knots, single screw, 4,312ihp. 1900 troopship Boxer Rebellion

Ship	In P&O Service	Australian Service	Trips To Aust.	Gross Tons	Capacity			% of Capacity		Notes
					First	Second	One	1st	2nd	
Siam	1875–1895 1881 refit	1883	2	3,026 3,068	144 81	68 28		68 74	32 26	Built by Caird & Co., Greenock. Iron, 12 knots, single screw, 2,920ihp.
Nizam	1873–1893	1883	1	2,725	96	30		76	24	Built by Wm Denny & Bros, Dumbarton. Iron, 12.5 knots, single screw, 1,956ihp. 1882 troopship Egyptian campaign.
Parramatta	1882–1903 1883 refit	1883–1897	35	4,771 4,886	160 119	48 77		77 61	23 39	Built by Caird & Co., Greenock. 15 knots, single screw, 4,437ihp.

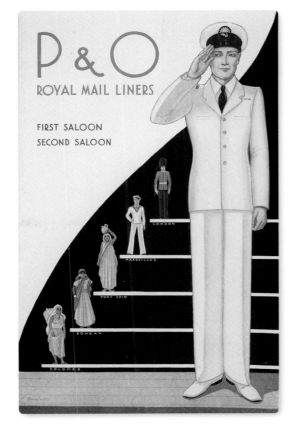
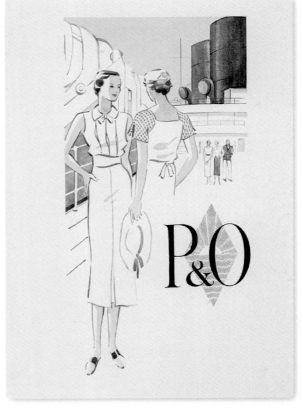

P&O advertising in brochures and posters etc., was frequently the work of superb artistry as these two images show. (Orient Heritage Collection/Henderson & Cremer)

Ship	In P&O Service	Australian Service	Trips To Aust.	Gross Tons	Capacity			% of Capacity		Notes
					First	Second	One	1st	2nd	
Australia	1870–1889	1883	2	3,648	180	75		71	29	Built by Caird & Co., Greenock. Iron, 11 knots, single screw, 2,626ihp. Last P&O ship to have clipper bow. 1884 troopship Egyptian War.
Pekin II	1871–1897 1884 refit	1883–1885	3	3,777 3,909	168 141	50 42		77 77	23 23	Built by Caird & Co., Greenock. Iron, 12 knots, single screw, 2,695ihp.
Thames	1882–1901 1884 refit	1883–1887	4	4,113 4,078	120 138	46 60		72 70	28 30	Built by J&G Thompson, Clydebank. 15 knots, single screw, 4,500ihp.
Valetta II	1884–1903	1884–1897	33	4,911	154	75		67	33	Built by Caird & Co. Ltd, Greenock. 14 knots, single screw, 4,999ihp. First P&O ship with electric light, first saloon. 1900 munitions transport Boxer Rebellion.
Ganges III	1882–1898 1884 refit	1884–1886	1	4,196 4,168	120 140	46 60		72 70	28 30	Built by Barrow Shipbuilding Co. Ltd, Barrow-in-Furness. 14 knots, single screw, 4,500ihp. 1885 hospital ship in Egyptian campaign.
Khedive	1871–1897 1884 refit	1885	1	3,742 3,868	164 139	53 44		76 76	24 24	Built by Caird & Co., Greenock. Iron, 13 knots, single screw, 2,695ihp.
Massilia II	1884–1903	1885–1897	30	4,908	154	75		74	26	Built by Caird & Co., Greenock. 16 knots, single screw, 5,250ihp. 1885 armed merchant cruiser during diplomatic tension with Russia.
Thibet	1874–1895 1884 refit	1885	1	2,593	59 53	24 24		71 69	29 31	Built by Gourlay Brothers & Co., Dundee. Iron, 11 knots, single screw, 2,016ihp. 1875 transport officers/men from Suez to Suakin to relieve Sudanese garrison.
Tasmania	1884–1887	1885–1886	4	4,488	111	42		73	27	Built by Caird & Co. Ltd, Greenock. 14 knots, single screw, 4,195ihp. 1887 wrecked south of Corsica.
Chusan II	1884–1906 1885 refit	1885–1888	3	4,636 4,348	107 105	44 47		71 69	29 31	Built by Caird & Co. Ltd, Greenock. 14 knots, single screw, 4,143ihp.
Coromandel	1885–1905 1886 refit	1885–1890	4	4,499 4,359	111 107	44 45		72 70	28 30	Built by Caird & Co. Ltd, Greenock. 15 knots single screw, 4,200ihp. First P&O with triple expansion engines. 1895/96 transport and hospital ship Ashanti War.
Bengal II	1885–1906	1887	2	4,499	111	44		72	28	Built by Caird & Co. Ltd, Greenock. 15 knots, single screw, 4,200ihp.

Ship	In P&O Service	Australian Service	Trips To Aust.	Gross Tons	Capacity			% of Capacity		Notes
					First	Second	One	1st	2nd	
Britannia	1887–1909	1887–1908	52	6,525	230	156		60	40	Built by Caird & Co. Ltd, Greenock. 16.5 knots, single screw, 7,000ihp. 1894 troopship to India, and again 1895/96 and 1896/97.
Victoria	1887–1909	1888–1909	49	6,522	230	160		59	41	Built by Caird & Co. Ltd, Greenock. 16 knots, single screw, 7,000ihp. 1894 troopship to India, and again 1895/96 and 1896/97.
Rosetta	1880–1900	1888–1889	3	3,502	104	32				Built by Harland & Wolff, Belfast. Iron, 13.5 knots, single screw, 2,890ihp. 1885 armed merchant cruiser during diplomatic tensions with Russian.
Oceana	1888–1912	1888–1905	46	6,610	250	159		61	39	Built by Harland & Wolff Ltd, Belfast. 16.5 knots, single screw, 7,000ihp.
Arcadia	1888–1915	1888–1904	44	6,603	250	159		61	39	Built by Harland & Wolff Ltd, Belfast. 16.5 knots, single screw, 7,000ihp.
Ravenna	1880–1898 1888 refit	1889	1	3,340 3,257	81 67	30 19		73 78	27 22	Built by Wm Denny & Bros, Dumbarton. Iron, 13 knots, single screw, 3,342ihp.
Oriental	1889–1915 1914 refit	1891–1903	6	4,971	170 142	96 96		64 60	36 40	Built by Caird & Co. Ltd, Greenock. 15.5 knots, single screw, 6,000ihp.
Himalaya II	1892–1922	1891–1908	45	6,898	265	144		65	35	Built by Caird & Co. Ltd, Greenock. 18 knots, single screw, 10,000ihp. 1914 armed merchant cruiser. 1916 sold to Admiralty? Possibly re-purchased?
Australia II	1892–1904	1892–1904	33	6,901	265	144		65	35	Built by Caird & Co. Ltd, Greenock. 17 knots, single screw, 10,000ihp. 1904 stranded and lost at entrance to Port Phillip.
China II	1896–1928	1896–1920	38	7,899	320	160		67	33	Built by Harland & Wolff Ltd, Belfast. 18 knots, single screw, 11,000ihp 1914 naval hospital ship. 1919 returning troops to India/Australia.
India II	1896–1915	1898–1911	38	7,911	317	152		68	32	Built by Caird & Co. Ltd, Greenock. 18 knots, single screw, 11,000ihp. 1915 armed merchant cruiser. 1915 sunk.
Peninsular	1888–1909	1898	2	5,294	170	96		64	36	Built by Caird & Co. Ltd, Greenock. 15 knots, single screw, 6,000ihp.

Ship	In P&O Service	Australian Service	Trips To Aust.	Gross Tons	Capacity			% of Capacity		Notes
					First	Second	One	1st	2nd	
Moldavia	1903–1918	1903–1915	35	9,500	350	160		69	31	Built by Caird & Co. Ltd, Greenock. 16.5 knots, twin overlapping screws, 12,000ihp. 1915 armed merchant cruiser. 1918 sunk.
Mongolia II	1903–1917	1904–1917	40	9,505	348	166		68	32	Built by Caird & Co. Ltd, Greenock. 16.5 knots, twin screws, 12,000ihp. 1917 sunk.
Marmora	1903–1918	1904–1914	24	10,509	377	187		67	33	Built by Harland & Wolff Ltd, Belfast. 17 knots, twin screw, 13,000ihp. 1914 armed merchant cruiser. 1918 sunk.
Macedonia	1904–1931	1904–1923	22	10,512	377	187		67	33	Built by Harland & Wolff Ltd, Belfast. 18 knots, twin screws, 13,000ihp. 1914 armed merchant cruiser/troopship.
Egypt	1897–1922	1904–1915	4	7,912	314	212		60	40	Built by Caird & Co. Ltd, Greenock. 16 knots, single screw, 11,000ihp. 1915 hospital ship.
Mooltan II	1905–1917	1906–1917	33	9,621	348	166		68	32	Built by Caird & Co. Ltd, Greenock. 18 knots, twin screw, 13,000ihp. 1917 sunk.
Morea	1908–1930	1909–1922	27	10,890	407	200		67	33	Built by Barclay, Curle & Co. Ltd, Whiteinch. 16 knots, twin screw, 13,000ihp. 1915 ambulance transport Australian Expeditionary Force. 1917 armed merchant cruiser.
Malwa II	1908–1932	1909–1922	30	10,883	400	200		67	33	Built by Caird & Co. Ltd, Greenock. 18 knots, twin screw, 13,000ihp. 1917 troopship.
Mantua	1909–1935	1909–1922	11	10,885	400	200		67	33	Built by Caird & Co. Ltd, Greenock. 16.5 knots, twin screw, 13,000ihp.
Persia	1900–1915	1909–1915	3	7,951	320	160		67	33	Built by Caird & Co. Ltd, Greenock. 17 knots, single screw, 11,000ihp. 1915 sunk.
Narrung	1910–1913	1910–1913	7	5,078	50	plus				Built by Sunderland Shipbuilding Co. Ltd, Sunderland. 13 knots, single screw, 3,000ihp. Previously Blue Anchor Line 1896–1910.

Ship	In P&O Service	Australian Service	Trips To Aust.	Gross Tons	Capacity			% of Capacity		Notes
					First	Second	One	1st	2nd	
Wakool	1910–1913	1910–1913	7	5,004	50	plus				Built by Sunderland Shipbuilding Co. Ltd, Sunderland. 11 knots, single screw. Previously Blue Anchor Line 1898–1910.
Wilcannia	1910–1914	1910–1914	10	4,953	50	plus				Built by Sunderland Shipbuilding Co. Ltd, Sunderland. 13 knots, single screw. Previously Blue Anchor Line 1899–1910.
Commonwealth	1910–1923	1910–1921	21	6,616	nil	450				Built by Barclay, Curle & Co. Ltd, Glasgow. 13.5 knots, twin screw, 4,000ihp. Previously Blue Anchor Line 1902–1910. 1917 transport.
Geelong II	1910–1916	1910–1916	12	7,951	nil	700				Built by Barclay, Curle & Co. Ltd, Glasgow. Previously Blue Anchor Line 1904–1910. 14 knots, twin screw, 4,150ihp. 1914 transport. 1916 sunk.
Ballarat II	1911–1917	1911–1917	8	11,120	nil	nil	1,100			Built by Caird & Co. Ltd, Greenock. 14 knots, twin screw, 9,000ihp. 1914 transport/troopship. 1917 sunk.
Maloja	1911–1916	1912–1916	11	12,431	450	220		67	33	Built by Harland & Wolff Ltd, Belfast. 19 knots, twin screw, 14,000ihp. 1916 sunk.
Medina	1911–1917	1912–1917	14	12,350	450	220		67	33	Built by Caird & Co. Ltd, Greenock. 16.5 knots, twin screw, 14,000ihp. 1911 requisitioned as Royal Yacht to take George V and Queen Mary to India, Durbar. 1917 sunk.
Beltana	1912–1930	1912–1930	28	11,120	nil	nil	1,100			Built by Caird & Co. Ltd, Greenock. 14 knots, twin screw, 9,000ihp. 1917 transport.
Benalla	1913–1930	1913–1930	27	11,118	nil	nil	1,100			Built by Caird & Co. Ltd, Greenock. 14 knots, twin screw, 9,000ihp. 1914 transport.
Berrima	1913–1930	1913–1930	26	11,137	nil	nil	1,100			Built by Caird & Co. Ltd, Greenock. 14 knots, twin screw, 9,000ihp. 1914 armed merchant cruiser. 1914 troopship.

Ship	In P&O Service	Australian Service	Trips To Aust.	Gross Tons	Capacity			% of Capacity		Notes
					First	Second	One	1st	2nd	
Borda	1914–1930	1914–1930	22	11,136	nil	nil	1,100			Built by Caird & Co. Ltd, Greenock. 14 knots, twin screw, 9,000ihp. 1914 transport.
Khyber	1914–1931	1914–1931	10	8,964	80	68		54	46	Built by Cammell, Laird & Co. Ltd, Birkenhead. 14 knots, twin screw, 7,000ihp. 1917 troopship.
Arabia	1898–1916	1915	3	7,903	320	160		67	33	Built by Caird & Co. Ltd, Greenock. 18 knots, single screw, 11,000ihp. 1916 sunk (controversial).
Karmala	1916–1932	1915–1928	7	8,983	80	68		54	46	Built by Cammell, Laird & Co. Ltd, Birkenhead 15 knots, twin screw, 9,000ihp. 1914 HQ ship for Indian Forces to East Africa. 1918 troopship. 1919 repatriating Australian troops. 1927 transport for Shanghai troubles.
Khiva II	1914–1931	1916–1925	4	8,947	80	68		54	46	Built by Cammell, Laird & Co. Ltd. 14 knots, twin screw, 7,000ihp. 1917 troopship/transport.
Kashgar II	1914–1932	1916	3	8,840	71	66		52	48	Built by Caird & Co. Ltd, Greenock. 15 knots, twin screw, 9,000ihp. 1914 troopship/transport.
Kaisar-I-Hind II	1914–1938	1916–1919	4	11,430	315	233		57	43	Built by Caird & Co. Ltd, Greenock. 18.5 knots, twin screw, 14,000ihp.
Salsette II	1908–1917	1916–1917	2	5,842	140	120		54	46	Built by Caird & Co. Ltd, Greenock. 20 knots, twin screw, 10,000ihp. 1917 sunk.
Kashmir	1915–1932	1916–1919	2	8,841	78	68		67	33	Built by Caird & Co. Ltd, Greenock. 14 knots, twin screw, 7,000ihp. 1916 troopship/transport.
Sardinia	1902–1925	1917–1919	2	6,574	90	70		56	44	Built by Barclay, Curle & Co. Ltd, Glasgow. 14 knots, twin screw, 4,500ihp. 1918 torpedoed but survived.

Ship	In P&O Service	Australian Service	Trips To Aust.	Gross Tons	Capacity			% of Capacity		Notes
					First	Second	One	1st	2nd	
Mongara	1914–1917	1917	1	8,203	66	63		51	49	Built by Swan, Hunter & Wigham Richardson, Wallsend. British India Steam Navigation Co. ship 14.46 knots, twin screw, 4,400ihp. 1914 transport. 1917 chartered to P&O. 1917 sunk.
Somali	1901–1923	1917–1919	2	6,708	78	66		56	44	Built by Caird & Co. Ltd, Greenock. 14 knots, twin screw, 4,500ihp. 1911 troopship. 1913 troopship. 1914 troopship.
Manora	1914–1932	1917	1	7,875	43	29		60	40	Built by Barclay, Curle & Co. Ltd, Glasgow. British India Steam Navigation Co. ship. 12.98 knots, twin screw, 4,050ihp. 1914 troopship.
Karagola	1917–1948	1917	1	7,053	58	64		48	52	Built by Swan, Hunter & Wigham Richardson, Newcastle-upon-Tyne. British India Steam Navigation Co. ship. 16 knots, twin screw, 6,800 ihp. Licensed for 1,050 deck passengers. 1917 troopship. WWII troopship/transport.
Delta III	1905–1929	1919	2	8,089	160	80		67	33	Built by Workman, Clark & Co. Ltd, Belfast. 16 knots, twin screw, 8,000ihp. WWI hospital ship/transport/troopship.
Plassy	1901–1924	1919	2	7,342	114	57		67	33	Built by Caird & Co. Ltd, Greenock. 16 knots, twin screw, 6,500ihp. WWI troopship/hospital ship etc.
Dongola	1905–1926	1919–1925	2	8,038	150	100		60	40	Built by Barclay, Curle & Co. Ltd, Glasgow. 15.5 knots, twin screw, 8,000ihp. WWI hospital ship/transport.
Devanha	1906–1928	1919–1925	1	8,092	160	80		67	33	Built by Caird & Co. Ltd, Greenock. 15.5 knots, twin screw, 8,000ihp. WWI troopship/hospital ship.

Ship	In P&O Service	Australian Service	Trips To Aust.	Gross Tons	Capacity			% of Capacity		Notes
					First	Second	One	1st	2nd	
Soudan	1901–1925	1919	1	6,695	78	64		55	45	Built by Caird & Co. Ltd, Greenock. 14 knots, twin screw, 4,500ihp. Seasonal troopship. 1914 naval hospital ship.
Malta II	1895–1922	1918–1919	1	6,064	78	62		56	44	Built by Caird & Co. Ltd, Greenock. 14.5 knots, twin screw, 4,500ihp. Boer War troopship/transport. 1917 troopship.
Naldera	1920–1938	1920–1938	27	15,825	426	247		63	37	Built by Caird & Co. Ltd, Greenock. 17.5 knots, twin screw, 18,000ihp. First P&O ship with three funnels.
Narkunda	1920–1942	1920–1939	55	16,227	426	247		63	37	Built by Harland & Wolff Ltd, Belfast. 17 knots, twin screw, 15,300ihp. 1935 second cabins converted to tourist. 1941 troopship. 1942 sunk.
Baradine	1921–1936	1921–1936	38	13,144	nil	nil	1,227			Built by Harland & Wolff Ltd, Belfast. P&O Branch Line. 13.5 knots, twin screw, 9,500ihp.
Ballarat II	1921–1935	1922–1934	31	13,033	nil	nil	1,249			Built by Harland & Wolff Ltd, Greenock. P&O Branch Line. 13.5 knots, twin screw, 9,500ihp.
Barrabool	1922–1936	1922–1936	36	13,148	nil	nil	1,234			Built by Harland & Wolff Ltd, Belfast. P&O Branch Line. 13.5 knots, twin screw, 9,500ihp.
Balranald	1922–1936	1922–1936	35	13,039	nil	nil	1,227			Built by Harland & Wolff Ltd, Greenock. P&O Branch Line. 13.5 knots, twin screw, 9,500ihp.
Bendigo	1922–1936	1922–1936	35	13,039	nil	nil	1,227			Built by Harland & Wolff Ltd, Belfast. P&O Branch Line. 13.5 knots, twin screw, 9,500ihp.
Moldavia II	1922–1938 1930 refit	1922–1937	38	16,543	237 nil	525 nil	840	31	69	Built by Cammell, Laird & Co. Ltd, Birkenhead. 16 knots, twin screw, 13,250ihp.

Ship	In P&O Service	Australian Service	Trips To Aust.	Gross Tons	Capacity			% of Capacity		Notes
					First	Second	One	1st	2nd	
Kalyan	1915–1931	1922	1	8,987	79	68		54	46	Built by Cammell, Laird & Co. Ltd, Birkenhead. 15.5 knots, twin screw, 9,000ihp. 1915 troopship. 1918/19 hospital ship north Russia.
Mongolia III	1923–1950	1923–1937	38	16,504	231	180		56	44	Built by Sir W.G. Armstrong, Whitworth & Co. Ltd, Newcastle-upon-Tyne. 16 knots, twin screw, 13,250ihp. 1928 second class designated 'third cabin'. 1938 chartered to New Zealand Shipping Co.
Mooltan III	1923–1954 1929 refit 1948 refit	1923–1953	67	20,847 20,952	327 356 nil	329 336 nil	1,030	50 51	50 49	Built by Harland & Wolff Ltd, Belfast. 16 knots, twin screw, 13,300ihp. 1939 armed merchant cruiser & transport.
Maloja II	1923–1954 1948 refit	1924–1953	66	20,837	327 nil	329 nil	1,030	50	50	Built by Harland & Wolff Ltd, Belfast. 16 knots, twin screw, 13,300ihp. 1939 armed merchant cruiser & transport.
Cathay II	1925–1942	1925–1939	36	15,104	203	103		66	34	Built by Barclay, Curle & Co. Ltd, Glasgow. 16 knots, twin screw, 13,437ihp. 1939 armed merchant cruiser. 1942 troopship. 1942 sunk.
Comorin	1925–1941	1925–1939	34	15,116	203	103		66	34	Built by Barclay, Curle & Co. Ltd, Glasgow. 16 knots, twin screw, 13,000ihp. 1939 armed merchant cruiser. 1941 sunk.
Chitral	1925–1953 1948 refit	1925–1952	40	15,248	203 nil	10 nil	740	66	34	Built by Alexander Stephen & Sons Ltd, Glasgow. 16 knots, twin screw, 13,000ihp. 1939 armed merchant cruiser.
Ranpura	1925–1944	1929	1	16,601	305	282		52	48	Built by R&W Hawthorn, Leslie & Co. Ltd, Newcastle-upon-Tyne 16.5 knots, twin screw, 15,000ihp. 1939 armed merchant cruiser.
Strathnaver	1931–1962 1950 refit 1954 refit	1931–1961	67	22,547	498 573 nil	670t 496t nil	1,252	43 49	57 51	Built by Vickers-Armstrongs Ltd, Barrow-in-Furness. 21 knots, twin screw, 28,000shp. 1939 troopship.

Ship	In P&O Service	Australian Service	Trips To Aust.	Gross Tons	Capacity			% of Capacity		Notes
					First	Second	One	1st	2nd	
Strathaird	1932–1961 1947 refit 1954 refit	1932–1961	69	22,544	498 573 nil	670t 496t nil	1,252	43 49	57 51	Built by Vickers–Armstrongs Ltd, Barrow-in-Furness. 22 knots, twin screw, 28,000shp. 1939 troopship.
Carthage II	1931–1961	1932–1936	2	14,304	177	214		45	55	Built by Alexander Stephen & Sons Ltd, Glasgow. 18 knots, twin screw, 14,000shp. 1939 armed merchant cruiser.
Corfu	1931–1961	1932–1935	3	14,293	177	214		45	55	Built by Alexander Stephen & Sons Ltd, Glasgow. 18 knots, twin screw, 14,000shp. 1939 armed merchant cruiser.
Strathmore	1935–1963 1949 1961	1937–1963	55	23,428	445 497	665	1,200	40	60	Built by Vickers–Armstrongs Ltd, Barrow-in-Furness. 20 knots, twin screw, 24,000shp. 1940 troopship.
Stratheden	1937–1964 1947 refit 1961 refit	1937–1963	63	23,722	448 527 nil	563t 453t nil	1,200	40 54	60 46	Built by Vickers–Armstrongs Ltd, Barrow-in-Furness. 20 knots, twin screw, 24,000shp. Sunk in 1942. 1940 troopship.
Strathallan	1938–1942	1938–1939	5	23,722	448	563t		40	60	Built by Vickers–Armstrongs Ltd, Barrow-in-Furness. 21 knots, twin screw, 24,000shp. 1942 – sunk.
Ranchi	1925–1953 1948 refit	1948–1952	16	16,650	312 nil	275 nil	950			Built by R&W Hawthorn, Leslie & Co. Ltd, Newcastle-upon-Tyne. 17 knots, twin screw, 15,000shp. 1939 armed merchant cruiser.
Himalaya III	1949–1974 1963 refit	1949–1974	73	27,955	758 nil	401t nil	1,416	65	35	Built by Vickers–Armstrongs Ltd, Barrow-in-Furness. 22 knots, twin screw, 42,550shp.
Chusan II	1950–1973 1959 refit 1966 refit	1963–1972	10	24,215	474 464 455	514t 541t 517t		48 46 47	52 54 53	Built by Vickers–Armstrongs Ltd, Barrow-in-Furness. 23 knots, twin screw, 42,500shp.
Arcadia II	1954 1973 refit	1954–1980	52	29,734	670 nil	735t nil	1,350			Built by John Brown & Co. (Clydebank) Ltd. 22 knots, twin screw, 42,500shp.
Iberia II	1954 1966 refit	1954–1972	43	29,614	697 651	735t 733t		49 47	51 53	Built by Harland & Wolff Ltd, Belfast. 22 knots, twin screw, 42,500shp.

Ship	In P&O Service	Australian Service	Trips To Aust.	Gross Tons	Capacity			% of Capacity		Notes
					First	Second	One	1st	2nd	
Orontes II	1960–1962 1930's refit 1948 refit 1953 refit	1960–1961	7	20,186	500 463 502 nil	nil 518t 618t nil	1,123 1,372	31 47 45	69 53 55	Built by Vickers-Armstrongs Ltd, Barrow-in-Furness, for Orient Line, 1929–1960 18 knots, twin screw, 20,000shp. 1930s converted to first and tourist classes. 1940 troopship. 1960 Orient Line merged with P&O.
Oronsay II	1960–1975 1971 refit	1960–1975	34	27,632	668 nil	833t nil	 1,400			Built by Vickers-Armstrongs Ltd, Barrow-in-Furness, for Orient Line, 1951–1960. 22 knots, twin screw, 42,500shp. 1960 Orient Line merged with P&O.
Orion	1960–1963 1947 refit 1958 refit 1961 refit	1960–1963	11	23,696	486 546 342 nil	653t 706t 722t nil	 1,697	43 44 32	57 56 68	Built by Vickers-Armstrongs Ltd, Barrow-in-Furness, for Orient Line, 1935–1960 21 knots, twin screw, 24,000shp. 1958 refit had ship converted to a two-class tourist ship. 1960 Orient Line merged with P&O.
Orcades III	1960–1973 1964 refit	1960–1972	36	28,396	770 nil	742t nil	 1,635	51	49	Built by Vickers-Armstrongs Ltd, Barrow-in-Furness, for Orient Line, 1948–1960. 22 knots, twin screw, 42,500shp. 1960 Orient Line merged with P&O.
Orsova II	1960–1974	1960–1973	31	28,790	685	800t		46	54	Built by Vickers-Armstrongs Ltd, Barrow-in-Furness, for Orient Line, 1954–1960. 22 knots, twin screw, 42,500shp. 1960 Orient Line merged with P&O.
Oriana	1960–1986 1973 refit	1960–1985	51	41,915	638 nil	1496t nil	 1,640	30	70	Built by Vickers-Armstrongs Ltd, Barrow-in-Furness, for Orient Line, 1954–1960. 27.5 knots, twin screw, 65,000shp.
Canberra	1961–1997	1961–1996	51	45,733	538	1,650		27	73	Built by Harland & Wolff Ltd, Belfast. 27.5 knots, twin screw, 85,000shp.

BIBLIOGRAPHY

Primary Source

P&O Steam Navigation Company Board Minutes: *The Peninsular and Oriental Steam Navigation Company Board Minutes*, P&O.

The majority of this body of work was created by carefully studying the original minutes from the P&O Board meetings. The minutes are part of the Henderson & Cremer collection, and span from the inception of the company, until the 1950s. The collection of minutes during this period is complete, and is the only known copy in Australia.

Books

Cable, B., *A Hundred Year History of the P&O* (London: Ivor Nicholson and Watson Limited, 1937).

Dawson, P. and B. Peter, *P&O at 175: A World of Ships and Shipping since 1837* (Ferry Publications, 2012).

Harcourt, F., *P&O and the Australian Trades: 1870–1914* (Perth, Australia: Richard Fares Enterprises, 1993).

Howarth, D. and S. Howarth, *The Story of P&O* (London: George Weidenfeld & Nicholson Limited, 1986).

Kendall, F.R., *Dearest Mother: Extracts from the letters of F. R. Kendall* (Whitley: GB Publications Ltd, 1987).

Maber, J., *North Star to Southern Cross* (Prescot: T. Stephenson & Sons Ltd, 1967).

Miller, W.H., *SS Canberra* (Stroud: Tempus, 2007).

Padfield, P., *Beneath the House Flag of the P&O* (London: Hutchinson, 1981).

Sassoli-Walker, A., and S. Poole, *P&O Cruises: Celebrating 175 years of Heritage* (Stroud: Amberley, 2011).

Newspapers

'P&O Cruises', *Sydney Morning Herald*, 12 December 1913.

'P and O', *South Australian Register*, 28 November 1861.

'Steam to Australia', *Sydney Morning Herald*, 8 February 1951.

'The Dignity of an Admiralty Agent', *Bendigo Advertiser*, 22 August 1860.

Websites

http://www.poheritage.com/ – P&O Heritage website, a stunningly accurate, exceptionally complete P&O website managed by Suzie Cox.

http://www.sscanberra.com/ – An exceptional website about the Canberra.

http://www.simplonpc.co.uk/ - One of the most extensive collections of maritime photography and art.

Picture Credits

Henderson & Cremer, Ian Boyle (Simplon Post Cards), James D. Morgan / P&O Cruises, The State Library of New South Wales, the collections of Andrew Cooke, Andrew Sassoli-Walker, Andy Fitzsimmons, Gavin Harper, Patricia Dempsey, Frame & Cross.

The Pictures Collection from the State Library of Victoria including:

Australia, 1870, H91.108/1614
Peshawur, 1871, H91.250/364
Rohilla, 1880, H82.166//92
Himalaya II, 1892, H91.325/602
India II, 1896, H91.108/1575
China II, 1896, H91.108/1582
Arabia, 1898, H91.108/1407
Mongolia II, 1903, H91.108/1581
Marmora, 1903, H91.325/1254
Mooltan II, 1905, H91.108/1576
Salsette II, 1908, H91.325/1419
Salsette II, 1908, H91.108/1583
Medina, 1911, H91.325/94
Benalla, 1913, H91.108/1792
Naldera, 1920, H91.325/1591
Narkunda, 1920, H91.325/1474
Baradine, 1921, H91.108/1782
Mongolia III, 1923, H91.325/100
Mooltan III, 1923, H91.108/2151
Mooltan III, 1923, H91.108/1621
Cathay II, 1925, H91.32/1253
Cathay II, 1925, H91.108/1401
Comorin, 1925, H91.325/102
Ranchi, 1925, H91.325/989
Corfu, 1931, H91.325/1252
Carthage II, 1931, H91.108/47
Strathaird, 1932, H91.250/75
Strathallan, 1938, H91.250/67